모든 것이 나누어졌다

Everything Divided

KB022107

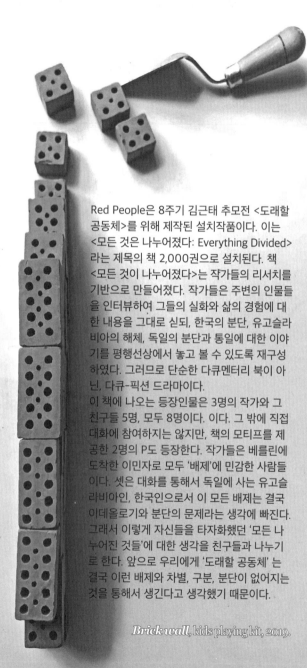

Red People은 8주기 김근태 추모전 <도래할 공동체>를 위해 제작된 설치작품이다. 이는 <모든 것은 나누어졌다: Everything Divided>라는 제목의 책 2,000권으로 설치된다. 책 <모든 것이 나누어졌다>는 작가들의 리서치를 기반으로 만들어졌다. 작가들은 주변의 인물들을 인터뷰하여 그들의 실화와 삶의 경험에 대한 내용을 그대로 싣되, 한국의 분단, 유고슬라비아의 해체, 독일의 분단과 통일에 대한 이야기를 평행선상에서 놓고 볼 수 있도록 재구성하였다. 그러므로 단순한 다큐멘터리 북이 아닌, 다큐-픽션 드라마이다.

이 책에 나오는 등장인물은 3명의 작가와 그 친구들 5명, 모두 8명이다. 이다. 그 밖에 직접 대화에 참여하지는 않지만, 책의 모티프를 제공한 2명의 P도 등장한다. 작가들은 베를린에 도착한 이민자로 모두 '배제'에 민감한 사람들이다. 셋은 대화를 통해서 독일에 사는 유고슬라비아인, 한국인으로서 이 모든 배제는 결국 이데올로기와 분단의 문제라는 생각에 빠진다. 그래서 이렇게 자신들을 타자화했던 '모든 나누어진 것들'에 대한 생각을 친구들과 나누기로 한다. 앞으로 우리에게 '도래할 공동체' 는 결국 이런 배제와 차별, 구분, 분단이 없어지는 것을 통해서 생긴다고 생각했기 때문이다.

Brick wall, kids playing kit, 2019.

목 차

Contents

Rijeka sewer, press frottage on the music paper, 2016.

서문

Red people은 남한의 연극 연출가 이은서(Eunseo Yi), 유고슬라비아 출신 크로아티아 드라마터그 안드레이 미르체프(Andrej Mircev), 유고슬라비아 출신 세르비아 예술가 니콜레타 마르코비치(Nikoleta Markovic)의 협업 리서치 과정의 결과로 만들어진 설치 작품이다.

이 작품은 8주기 김근태 추모전 <도래할 공동체>를 위해 제작되었고, <모든 것은 나누어졌다: Everything Divided>라는 제목의 책 2,000권으로 설치된다. 책은 작가와 친구들의 대화를 통해 만들어졌다. 이는 실화와 삶의 경험을 바탕으로 한 다큐-픽션 드라마이다. 책은 갤러리 안으로 들어가는 통로에 설치 되어 관객이 '자연스럽고, 당연한 방식'으로 전시 공간에 진입하는 것에 개입한다. 책이 쌓인 곳의 양쪽 벽에는 1985년 김근태가 고문을 견뎌내야 했던 3주 간의 참혹한 시간에 세계(서독과 동독, 남한과 북한, 유고슬라비아)에서 일어났던 다양한 사건들의 타임라인 포스터가 붙게 된다. 책으로 막힌 통로를 보고, 관객은 장애물을 없애고 자유롭게 공간 안으로 들어가게끔 자극 받는다. 관객들은 책을 집어 들고 가져감으로써 벽을 무너뜨릴 수 있다. 또한 지식의 상징인 책을 무상으로 가져가는 행위를 통해 책에 담긴 역설을 재현하고 재배치하는 역할을 할 수 있다. 이 책은 그 자체로 '사람들의 일상에 담긴 이데올로기 프레임'이라는 정지적 함의를 가질 뿐만 아니라 베를린 장벽과 DMZ가 평행하게 가는 것처럼 느껴질 정도로 유사한 이데올로기 전략의 복잡성을 다루려는 시도였다. 이 지점에서 작품은 풀리기 시작했다.

'책을 읽는다.' 는 것은 또 다른 층위에서 '책으로 만들어진 장벽'의

숨겨진 의미를 담고 있다. 이는 양 벽의 타임라인과 책 장벽을 연결하는 역할을 갖고 있기 때문이다. 관객은 책을 가져가는 행위를 통해서 참여하게 되고, 관객은 타임라인으로 만들어진 시간대의 길을 말 그대로 '통과하게' 된다. 이로써 '타임 터널 안' 관객은 전환을 맞이한다. 이는 흩어져 있는 한 시간대(1980년대)에 발생한 역사적 사실과 세계 사건의 내부를 말 그대로 '걷게 함으로써', 관객에게 그 사건을 다시 읽게 만든다.

우리는 다음과 같은 질문을 하기 시작했다. '베를린 장벽의 붕괴, 두 한국의 통일, 유고슬라비아의 해체는 어떤 연관이 있는가?, 이것은 누구에게는 과거로서, 다른 사람에게는 미래로서, 그리고 이 셋 모두에게 현재로서 질문을 하게 만드는 유대감, 공통점에서 오는 느낌인가?'

우리는 그 때 전 세계에서 발생했던 역사적인 사건을 모두 수집해서 역사적인 연속성 안에서 작동하는 이념의 아젠다를 드러내고, 눈에 보이게 만들었다. 이 뒤에 흐르고 있던 아젠다는 무엇이었는가? 이것이 우리에게 어떠한 영향을 미쳤고, 우리 작업의 정치학이라는 측면에서 어떠한 의미가 있는 것일까?

이 자료들은 대부분 인터넷이나 공개된 공식 문서들에서 찾은 것인데, 이는 1980년대의 시대정신을 성공적으로 반영한다고 생각하는 주류적 관점의 입장이다. 거기에 나타나 있듯, 전 세계의 눈은 누구나 쉽게 볼 수 있었던 아프리카와 중동의 폭력적인 정치 변화 쪽을 향했지만, 그 아래에는 눈에 잘 띄지 않는 냉전이라는 음모가 있었다. 이는 대중문화에서도 명백하게 발견된다. 할리우드 영화나 책에서 쉽게 찾을 수 있는 스파이 이야기가 바로 그것이다. 그러나 특별히 주목할 만한 것은 이 강력한 반공 분위기와 경쟁적인 정치, 사회, 경제 질서가 공산주의와 사회주의를 불신하게 만드는 명확한 의제로 설정되었다는 것이다.

이러한 역사적 내러티브를 읽어나가면 김근태가 경찰로부터 잔인하게 폭력에 노출될 수 밖에 없었던 이유가 드러난다. 이를 통해 반공의 수사법은 서구로부터 수입 되었고, 많은 다양한 상황에서 배제, 분열, 과도한 침략과 폭력, 분리, 소외, 궁극적으로 거부와 고립에 대한 핑계로 사용되었다는 것이 명백해졌다.

지금 유럽은 이민자, 수용, 젠트리피케이션, 실업, 빈곤을 야기하는 우파들의 폭력적인 포퓰리즘, 경제 위기에 직면해있다. 이로 부터 피할

수 없는 질문이 생긴다. '이러한 전략에 담긴 이데올로기는 무엇인가?, 작가들이 추적하고, 풀어내고자 했던 이데올로기의 흐름이라는 측면에서, 파시즘과 공산주의가 동일한 것이라고 선언한 <유럽의 양심과 공산주의에 관한 프라하 선언(2008)Prague Declaration on European Conscience and Communism>과 같은 합법화는 어떠한 관계를 가지는가? 이에 관하여 끊임없이 대화를 건네는 것이 이 책의 목적이다.

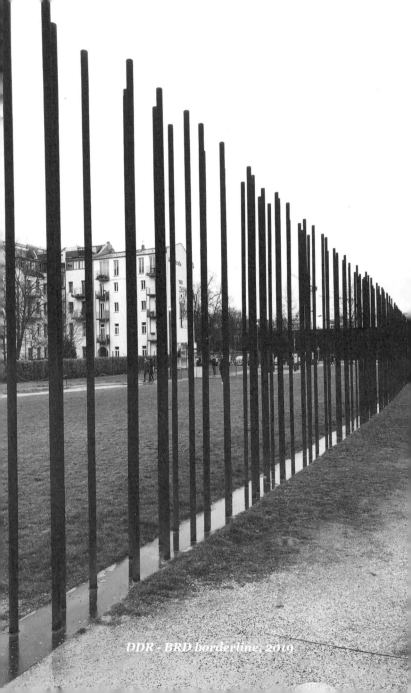

DDR - BRD borderline, 2019

프롤로그

N	말해야할 게 있는데… *(책상 가까이 다가오면서)* 우리 지금 녹음하고 있어.
Y	지금?!
E	응.
N	너 오기 전부터 녹음하고 있었어. 근데 …
Y	그런건가…
N	왜 녹음을 하냐면
Y	몰래 카메란가?

모두 웃는다.

N	왜… 왜 녹음을 하냐면
A	니가 말하는 모든 것들이 … 너를 옭아매는 증거로 사용될 수… *(모두 웃는다.)*
N	암튼, 녹음한다는 걸 얘기해주고 싶었어 … 니가 동의한다면. 만약에 동의 안하면, 녹음은 안 할게.
Y	괜찮아. 근데 나 엄청 의식된다.

모두 웃는다.

N	왜 녹음을 하냐면, 아이디어가 생각이 났을 때 … 기억하기 쉽게 하려고. 그럼 잊어버리지 않을 수 있잖아.
Y	너네 작업 때문에 그런 거 아니야? *(모두 무언가를 중얼거린다.)* 이게 그 일부가 되는거야? 작업 자체가 아니라?
N	다는 아니고. 일단 니가 오케이 안하면 안하면 작업에 넣진

않을 거고… 들어가진 않을 거야… 이건 잊어버리지 않으려고
하는 거고. 그리고 니가 원하면 없애버릴 수도 있고…
(Y 웃는다)… 그래. 우린 사실 그런 걸 하고 싶었는데.
본격적으로 시작하기 전에 짧게 소개하자면, 우리는 박 선생님
을 인터뷰하고 싶었어, 그 분은 하고 싶지 않다고 하더라고.
그게… 책을 만들자고 하게 된 이유지. 원래는 다른 게 있었는데.
내가 너한테 DMZ 얘기 한 거 기억 나? 프로타쥐하고…
(Y: 응, 응…) 처음엔 그렇게 시작했고, 그 후에 라디오 드라마
아이디어가 나왔고, 그 다음에 빨치산 대장의 흉상을 만들어
보자…근데 결국엔 이렇게 하기로 했어. 왜냐하면, 많은 사람
들의 경험담을 듣게 되었거든…그러니까, 그 분이 뭐라고
했더라? '나는 원하지 않는다.' *(E에게)* 이거 말해도 돼? 그 문장
말해도 되겠지?

E 응 … 그럼.

N 그 분이 그렇게 말했어. 자기 이야기가 예술에 이용되는 건
싫다고. 그러니까…이건 다양하게 이해될 수 있는 말인데, 나는
이게 예술에 대한 비판이라고 생각을 했어 - 나도 예술에
대해서 되게 비판적이거든 - 하지만 아마 그 분하고 나는 다른
입장에서 생각하고 있는 거 같아. 그래서 그 분 입장에서
이해해보고 싶어서 얘기를 나누러 갔지. 근데 대답이 없더라
고… 뭔가 약간 퉁명스러웠달까, 한발짝 물러서는 것 같기도
하고. 그 때 알았어…우리가 하려고 하는 이 방식이 불편할
수도 있겠다. 그런 거 있잖아. 서양 사람들은 이렇게 당혹
스러울 때도 '편안하다'고 느끼기도 하니까… 나는 그런 편이
아닌데 …이건 약간 모르겠더라고…무례한 게 아닐까…
아니면, 공공적인 공간에서 얻게 되는 상징적인 파워 같은 것
때문은 아닐까…그런 생각을 하게 되더라고…

Y 너네 작품 주제가 뭐였지? 잊어버렸어.

모두가 웃는다.

N 아, 잊어버렸구나…

E 아, 아… *(웃는다)*.

Y …분단된 국가들에 대한 경험…

N 통일.

A 그리고 그것에 관한 모든 문제들.

웃는다.

Railway tracks in Osijek, Croatia 2019.

1장.
나는 존재하지 않는
나라에서 태어났다.

A 그래, 좋아, 약간 반 정도만 프로같다…그래…근데 이건 책에
 안 들어 갈거지? 아니, 넣어야…

N 그건 우리가 결정할 수 있지…이걸 좀 웃기게 만들 수도 있어…
 가끔…따옴표도 넣고(E: 그럼, 그럼…)…뭐랄까…재미있는
 농담도 넣고…*(E 웃는다.)* 우리가 하고 싶은대로 하는 거지.
 근데 난 더 말 안할래. 나 또 말 너무 많이 하는 거 같아.

짧은 침묵. E만 웃고 있다.

A 그냥, 이렇게, 침묵…계속. *(E 웃는다)* 베케트 있잖아…베케트가
 그런 아름다운…인물들이 아무 말 하지 않고, 생각에 푹 빠지는
 …(E: 아하…)…말들 사이의 고요…이런 거 완전 아시아스럽
 지…아니면, 이게 아시아에 대한 내 판타지 인가?…
 (E 웃는다)…고요, 깊게 생각함, 분명함…*(E 웃는다)*…갈등도
 없고, 모든 것이 평화롭고…그에 비해서 서양은…

N 우리는 침묵을 깰 거야!*((We break the silence!)*

*N은 광고 제작사인 하이마트와 독일 DIY 마켓 호른바흐의 아시아
여성 차별적인 광고에 대항했던 아시아 여성들의 구호를 외친다.
E는 알아채고 웃는다.*

E 그건…너의 판타지야, 내 생각엔…*(웃는다)*
A 식민지 판타지 인가?
N 응.
E 응, 응…
A 오, 오케이. 그래. 그…나도 그부분에서 고민이 있긴 한데,

난 너네 문화에 대해서 아무 것도 아는 것이 없더라고. 난 아무 것도 몰라. 그래서 지금은 우리가 같이 작업하고 있는 게 너무 재밌다고 생각해 *(E 웃는다)*…말하자면…우리는 이런 모든 정치적, 이데올로기적인 이슈에 문제제기를 하고 싶은 거잖아. 그래서…한편으로는…그렇게 생각해. …어떻게 그걸 할 수 있을까…? 내가 널 모르는데 … 그리고 난 내가 살고 있는 이곳에 대해서도 많이, 아니 충분히…모르는 것 같아…물론, 어떨 때는 내 고유의 문화, 그게 뭐든지 간에… 그것에 대해서도 더 알아야 할 것 같기도 하고. 이런 고민이 들더라고… 모르는 것의 실체에 대해서.

N 다른 거는…? 또…?

A 다른 거! 그래, 그래…근데…있잖아. 그 다른 것도 다 내 안에 있는 거잖아. 다 내 안에 있어…그것들은 정복 을 필요로 하지…그렇지 않으면 또 다른 것들에 의해서 정복 당할 위험이 있으니까…초자아는 모든 것을 알려고…또 아는 척 하려고 하잖아…모든 걸 진두지휘하고, 모든 걸 알고 있으려고 해. 내가 한국 친구한테 왕가위에 대해서 물은 적이 있는데… 왜냐하면…난 그 사람이 한국 영화 감독이라고 생각했거든… 그러고 나서 찾아봤는데, 중국 사람이었던 거야, 이런… *(E 웃는다)* 이런 실수, 정말 바보같다고 생각했어.
(E: 그렇지, 그렇지…)그렇잖아…우리한테는, 내 말은, 백인 남성입장에 서면…난 늘 문제가 생겨…지금 완전 고백 하는 건데, 얼마 전까지만 해도 말 못한 거야…아시아 쪽에서 온 사람들은 다 똑같이 생겼다고 생각했어…(E: 그래…) 구분을 못했어. 지금은, 조금, 구분할 수 있어…근데 이것도 말하자면 …인종차별적 시각 아닌가? 나 지금 좀 명확히 하는 중이야 …그러니까…모든 스테레오타입에 대해서 …

N 많이 들어 본 말 중에 아프리카계-미국인이란 말 있잖아… 지젝(Zizek)이 그랬지. '아프리카계 미국인이란 말, 그 자체가 인종차별적이다.

A 그치, 그치, 그치…

N 그건 단지 '덜 모욕적일' 뿐이라고 말했지. 깜둥이라고 하는 것보다…

A … 아프리카계-미국인.

N 그래…알겠어…근데 나도 비슷한 생각을 하는데…우리가 지금 녹음을 하고 있고, 이게 우리 작업의 일부가 될거니까…우리

작업에서 중요한 건 작업 안에서의 포지션인 것 같아. 그래서 나는 유고슬라비아의 경험이라는 포지션이 어쩌면 백인의⋯ 아무 것도 모르는 포지션을⋯

A ⋯피식민지 국가로서의 포지션.

N 아니. 아니. 내 말은 이해할 수 있는 포지션을 제공한다는 의미에서 말이야. (A: 아하.) 왜냐하면, 니가 말한 것처럼, 우리는 몰라. 다른 말로 한다면, 우리는 유고슬라비아의 경험만 갖고 있다는 거지⋯(제 3의 노선).

A ⋯그 사이지⋯

N ⋯비민족국가의 경험이지⋯그⋯뒤에⋯

A ⋯ 뒤에.

N ⋯ 이어진.

A 어쩌면⋯정체성 정치(identity politics) 포지션이 아니라⋯

N 나한테는 그게 중요해⋯밑줄 그어야 하는 때가 있잖아⋯? 어떤 문장에 밑줄을 긋거나, 어떤 줄에 밑줄을 그어야 하는 거⋯그런 건데⋯이건 단순히 정체성 문제거나 인종문제는 아닌 것 같아⋯(목구멍으로 꿀꺽 침을 삼키는 소리) 뭘 모른다는 문제도 아니고⋯우리는 그냥 추측하는 거니까⋯'아시아 사람이라는 게 뭘까?'하는 문제에 대해서⋯호른바흐 데모 때도 그랬잖아. 내가⋯거기에 도와주러 갈 때⋯도움이 되려면 먼저 이해가 있어야 한다고 생각했어⋯서포트를 하려면, 내가 어떤 포지션에 있어야 하는가⋯그런 이해도 있어야 하고, 그래서 내가 뭔가⋯이런 생각도 할 필요가 있었지. 사람들은 분명히⋯내가 아시아 여성 대표로서 가는 게 아니었기 때문에, 내가 뭘 하는지⋯의식하더라고. '난 어떤 입장에서 뭘 말하고 있는지?' 그런 생각을 계속 했는데, 자기반영, 자아 비판⋯이런 것들이었어. 그 이상은 아니야.

A 그리고 연대.

N 그리고! 그리고, 그래⋯ 그냥! (웃는다) 그냥 연대!

A ⋯오직 연대!

N 오직 연대⋯(웃는다) 그래⋯그리고⋯니가 유고슬라비아의 입장이라면 반제국주의, 반식민주의, 반자본주의, 비동맹정책운동의 포지션으로 가는 거지⋯이게 우리가 몇 년 동안 작업해왔던 것이기도 해. 맞지? 크로아티아와 세르비아로 돌아와서도 그랬고. 우리가 다룰 수 있는 문제이기도 하고⋯한국만이 아니라⋯영토는 '하나'지만 나누어진 사람들에 대한 현대 이데올로기 정책과 전략의 벽

에 대한 거지. 한국은 … 이 거대한 통일 한국을 만드는 밀레니얼
이벤트는 영토에 상관 없이, 사람들을 하나로 만드는 거 아닐까.
(자신의 순진한 생각에 히죽히죽 웃는다.)

E 웃는다.

N 그래서, 이런 점에서 나는 이 존재하지 않는 국가라는 것이
정말 흥미롭다고 생각해. 이건 존재했던 것에 대한 갈망인가?
(A:…소속되고자 하는 갈망이지)…이건 역사수정주의의
…관점에서 읽힐 수 있는데, 노스텔지어가 주요 수단이 됐으
니까.
그래서 되돌아 간 거야…제국주의 시대로…불편한 것들은
모두 지워져버렸어, 역사 속에서는 큰 부분을 차지했던
것들도. 어떤 사람들은 그 때, 거기에서 태어났는데…
그래서 지금 위험한 거야. 만약에 우리가 영리하다면
노스텔지어도, 그걸 부정하는 것도 아닌 것에 대해서 얘기할
수 있겠지, 더 도전 거리는 되겠지만.
몇 가지 질문들, 예를 들어서…우리 이런 명제들에 대해 얘기
해 볼 수 있지 않을까… '유고슬라비아의 코소보, 알바니아,
세르비아 사람들이 각각 같은 입장인가? 알바니아에 있는
마케도니아 사람, 코소보 알바니아 사람의 입장이 같을까?
그리고 그리스는?' …비슷한 일이 세 나라 사람들이 살았던
보스니아에서 일어났는데… 어떻게 말해야할까, 주요한 국적
들…보스니, 크로아티아인 그리고 세르비아인. 이 세 국적의
사람들이 섞여 있었어.
또 세르비아 북부에는 많은 소수자 그룹이 살고 있었는데…
그 중 하나가 독일 슈바벤사람이…이 사람들은 보이보디나
(Vojvodina)에 살았지…근데 2차 세계 대전이 끝나고 나서,
이 사람들은 엄청 차별 받았어, 전쟁이나 나치 독일하고
아무 관련이 없는데도 말이야. 그건 좋은 점이긴 하지만, 큰
과제를 안겨주었어. 그래서 우리는 조심해야해. 반드시 이런
점을 생각해야 해.

A 그럼 다른 제목이 필요하겠네. 나 이 제목 너무 좋은데
'우리는 문제가 있다.' (E 웃으며 기침한다)

N … 콜록. 콜록, *'우리는 문제가 있다.'* (E: 맞아…).

(…)

A 난 4시까지 일해야 돼…

E 4시? 그럼 4시 이후면…

A 4시 이후는 괜찮아. 5시쯤…

E 5시 …

A 응 …

E 토요일이 좋겠다. 월요일엔 학교 가야 되니까…

A 응, 응…

E 그래. 문자 보낼게.

A 토요일…

E 나 가야 되겠다.

Mr. Park's problem x-ray photo, 2018.

2장.
우리는 문제가 있다.

1.

N과 E는 Y를 맞이하러 일어선다. 이야기가 짧게 끊긴다. E는 Y에게 한국말로 짧은 통화를 한다. 침묵. 부드러운 바이올린 소리만 흘러 나오고 있다. 모두, Y가 오는 길에 본 죽은 비둘기 이야기를 한다.

Y 안녕! 어떻게 지냈어?

A 넌 어떻게 지냈어.

Y 좋았지, 너는?

A 우리는 방금까지…

N 일단, 먼저 앉아. *(혼잣말로: 내가 이렇게 가야겠다…)* 제가 이쪽을 권해도 될까요, 왜냐면 거기 자리가 너무 좁아서… *(E는 웃으며 자기 옆자리를 권한다.)* 그리고 *(짐볼을 보여 주며)* 전 여기에 앉을게요.

E 아, 아니야, 여기도 괜찮아…

N 진짜야?

E 나는 작잖아. *(웃으며)* 작은 몸, 큰 마음.

N 세상에서 제일 큰 마음.

E 제일 큰 마음을 가졌지.

N *(Y에게)* 아침 먹었어?

Y 아니. 이것 때문에 안 먹었어… *(피검사의 흔적을 보여준다).*

N 그래 … 걱정되더라. 자, 물 마실래?

Y 고마워.

N 차 아니면 커피?

Y 커피있어?

N 응. 터키식 커핀데 괜찮아?

Y	그럼, 당연하지. 사실 더 좋아, 완벽해!
N	오케이, 곧 갑니다!
A	투르스카 카파(Turska kafa).
N	어땠어? 아팠어?
Y	아니, 그냥 정기 피검사 였어.
N	아, 그렇구나.
Y	내일 다시 가야 해. 와! 이거 진짜 맛있어 보인다··· 게다가 창의적이네.
E	···참깨 넣은 거.
A	꿀도 넣었어.
N	너희에게 해주고 싶었어, 원하면 뮤즐리 넣어도 돼···뮤즐리 먹는지 모르겠네···
E	벌써 충분해.
N	충분해···? 그래···요거트랑 꿀 섞을래? 니가 가지고 온 거 있잖아 *(콩으로 만든 과일 요거트를 보여주며)*, 넌 내 마음을 읽은 것 같아. *(E 웃는다)*
Y	비둘기한테 무슨 일이 있었던 거야?
N	몰라.
Y	방금 죽은 건가? 아니면 너네도 아침에 봤어?
N	오늘 아침에, 오면서...
A	비둘기가 죽었구나.
Y	응, 죽었어. 근데 뭐에 맞아서 죽은 거 같아. 자연적으로 죽은 것 같아 보이지 않았거든. 새들은 자연사 할 때, 자기가 죽을 걸 안데···*(다른 이들이 웅성웅성 한다.)* ···응, 응··· 그래서···
E	아···
N	정말?
Y	응, 나 죽은 새들을 많이 봤는데···그 새들은 되게 평화로웠거든. 근데 이 새는···뭐에 맞았거나 *(N, 무거운 눈빛)*··· 뭘 잘 못 먹었거나. 자연스러워 보이지 않았어.
A	이상해 보일 수 있지, 그렇지 않을 수도 있고 ···

(Y가 웃는다)

N	아, 야. 야····그만, 그만, 동정심 좀 가져라. (괴롭히는 목소리)

(E 웃는다)

A	동정심 있었어…난, 그니까, 충격 먹어서…뭐냐면, 왜 새가 죽었을까? 결국…
N	E… *(E에게 무언가를 준다)*
E	아, 고마워.
Y	맞다, 너 칼스루에(Karlsruhe)에 자리 얻었다며, 그치? (A: 응) 멀다…
A	멀지. 그치. 근데 좋은 건…나…2주에 한 번씩만 가…그래서 (Y: 아… 그래.) 한 달에 두 번 이틀만 가는 거지.(Y: 아 …)
N	어디 말하는 거야?
A	칼스루에. *(E 웃는다.)*
N	그거 정말…재밌지.
A	최고지.

(식기와 수저들이 움직이는 소리가 들린다.)

N	뭐 더 필요한…?
Y	아니, 나 다 있어. 포크도… 있고
N	오케이, 좋아! 왜냐면 여기 더 있거든. 어제…*(포크떨어지는 소리, 잠시 대화가 끊긴다)*일을 하고 싶어서, 다 준비를 하고, 하루 종일 일을 했지. 근데 엉덩이가 아파오기 시작해서 걸어야겠더라고. 걷다가 다시 돌아오니까 남편이랑 아들도 오고, 저녁 먹고 침대로 갔는데…'일 해야 돼' 란 생각을 하다가… 그 때가 8시 10분쯤이었는데, 8시 반 되니까 완전히 쓰러졌지. 침대에서. 자버렸어. 그리고 아침에 6시 좀 전에 일어났어. 이 바보*(Y와 E는 웃는다)*그랬지. 완전 쓰러지다니. 왜 그런지 모르겠어. 나 요즘에 너무 피곤해. 아마…
Y	…날씨 때문에?
N	응…그럴 수 있지 않을까? 너네도 비슷한 거 느껴?
E	난 머리가 너무 아프더라고…그래서 엄청 잤어…지난 이틀 동안…
N	아, 그렇구나…그래…뭔가 이상한 없겠지 뭐…왜냐면 난 괜찮다고 생각하긴 하는데, 혹시나 피검사 같은 걸 해야하나 했거든.
Y	그래. 괜찮은 생각이야. 정기적으로 검사하는 거 좋잖아. 근데 나도 비슷하게 느낀 게, 이번 주엔 정말 아무 것도 하고 싶지가 않더라.
N	맞아, 맞아. 나만 그런게 아니었네.
E	겨울엔 비타민 D 먹어줘야 돼.

Y	…
N	그래, 다…그런 말 하더라. 그래서… *(비타민 D 를 보여준다.)* 근데 나한테 별 도움은 안 되더라고…난 태양이 필요해.
E	나 이빨 흔들리고 있어. 여기. 아래…쪽에. 남편은 벌써 2개 빠졌고
Y	아…!
A	오 마이 갓!
E	… 2년 동안. 우리는…아마 그게…
Y	… 독일이라서!
E	독일이라서! *(모두 웃는다)*
N	그게 비타민 D가 부족해서 그런 건가…? 그럴 수 있겠네… 그래서 사람들이 우리 여기 처음 왔을 때 비타민 D, 비타민 D 했구나…
Y	사랑니 말하는 거야?
E	*(한국어로 설명한다)* … 아니, 그냥 아랫니 .
Y	*(걱정하는 목소리로)* 아, 와. 오 마이 갓.
E	나도 조심해야 돼.
N	그런 거 있는데 ... 젤리같이 생겨서, 치아에…힘을 주는…
A	나 쓰는 거 말하는 거지…
N	…강하게 만들어 주는 거지…
A	그래서 그렇게 비쌌구나… 그런 거 다 계산해서. *(Y 웃는다)*
N	이름이 뭐더라…생각해보자. 어른 것도 있고, 애들 것도 있어.
E	아, 강화제.
N	응, 거기에 칼슘이랑 비타민…아 아니 비타민 아니고 미네랄도 첨가 되어 있고.
E	아 …그거 엘멕스에서 나온…?
N	맞아!
E	우리도 있어.
N	있어? 잘 됐네!
Y	치약이잖아, 그치? 엘멕스는…
E	응, 응. (한국어로 설명한다)
N	젤같은 건데…근데…자주 쓰지는 말라고 했어. 일주일에 한 번인가, 그치?
E	응, 응, 일주일에 한 번.
N	우리 애도 쓰는데…애들이 단 걸 많이… *(E에게)* 뭐 필요해?
E	응?
N	뭐 필요해, 뭐 줄까? *(웃는다)*
E	니가 필요해. *(웃는다)*

N 내가 필요하구나… *(모두 웃는다, 수저 소리만 난다)* 그런
 거지 "좋은 와이프니까…앉아 있지 말고"

E 웃는다… 모두 날씨나 여러가지들에 대해서 이야기 나눈다.

N 말해야할 게 있는데… *(테이블로 다가온다)*

2.

N 우리는 문제가 있다! … 이게 우리의 아이디어야.
E 아아, 우리는 문제가 있지. 맞아..
N '이게 우리의 아이디어' 라고 했잖아. 아직 진행하지는 못한.
 어떻게 해야할까? 이게 지금 우리의 아이디어이고, 이걸로
 인터뷰를 진행하고 싶은데, 예술이…
E 음…
N …특별히 섬세한 이 순간에.
E 음…
N *(계속해서)*…왜냐면 예술도 …
A 아, 아, 아…
N 예술도 이렇게 권력을 도용하기도 하잖아. 모든 것으로부터.
 개인적으로, 나는 아티스트가 아이디어를 주어야 한다고
 생각하진 않아…
A 무료로! *(모두 웃는다.)*
N … 아니, 그 말이 아니고! 왜냐하면, 이건 비…비정기적인,
 아니면 반정기적인 시장 공간이잖아. 그래서 자본은 언제나
 예술의 창의성이나, 상상력, 비전에 숨어서 그것을 감히 상품화
 하려고 하지. 팔거나 이익을 얻으려고. 그래서 우리의 아이디어가
 …유토피아 같은 아이디어라고 생각했어. 공동체에서 온
 생각들, '조심' 스럽지 않게 전달된 생각들. 근데…어떻게 조심
 해야할까? 달리 말하면, 이 아이디어들이 가치있는 건, 이게
 공유되기 때문이고, 질문을 내포할 가능성이 있기 때문이잖아.
 그리고 이게 내가 우리의 책에서 할 수 있다고 생각…
A 음, 나는…지금, 니 말을 들으면서…이 형식이 좋은 거 같아.
 -우리는 문제가 있다 …
N 음…
A …그리고 물론,이런 걸 물어볼 수도 있는데, 내적으로…말이야
 …우리 정말로 서로의 포지션에 대해서 이해하고 있나?

N	바로 그거야!
A	나는 내 포지션에 대해서 이해하고 있나?
E	음…
N	그렇지.
A	그럼 나는 젠더 불평등에서도 이해하고 있나? 나는 문화적 차이에 대해서도 이해하고 있나?
N	음…
A	있잖아…왜냐하면…이건 내가 좌파에 대해서 생각하는 거랑 같지는 않을 거거든…
N	맞아!
A	… 그리고 니가… *(E에게)* 그러니까 니가 말한 문제라고 하는 섹시한 화제에 대해서, 우리는 정말로 그 전체에 대해서 인식하고 있을까.
N	음…
A	그건 문제가 아닐거야…하지만 그건…문제를 앞에서 약간 밀어내는 거지…앞으로 밀어내는 것…모든 것이 부드러워야 하고, 쉬워야 한다고 말하는 건 아니고…그냥 재미로…우리 문제를 막 끄집어내서…자세히 설명해보면 어떨까…그것도 좋은 연극적 방법이 아닐까…
N	음…
A	… 문제를 다루고 있는 그 지점에서…
E, N	음…
A	… 그리고 너는 문제를 문제시 하는 거지.
E	음…
N	… 그래, 왜냐면 넌 사실…
A	왜냐하면 문제는 모든 것을 위한 규제력 있는 원칙이니까… 그러면 '그래서, 뭐가 문제야?' 라고도 할 수 있잖아. 사실 내가 잘 모르겠는 건…문제가 어디서 오냐는 거지…세상의 문제가… 게다가, 장벽도 하나의 문제잖아!
N	하지만 장벽은…
A	…하나의 가능성으로, 말이야. 그러면 문제는 가능성으로서의 문제이기도 하지.
N	하지만 장벽은, 장벽은…문제를 '푸는' 수단이기도 하잖아.
A	음.
E	음, 음.
N	그래…그리고 분단은…DMZ의, 이데올로기 사이에 있는 분단이지…그래서, *(말하면서 동시에 먹고 있다.)* 내가 이해한 건

…*(꿀꺽 삼키는 소리)*…장벽이 이데올로기를 나누고 있다는 것?
그리고 이제 사람들은 하나가 되려고 하지. 이데올로기에
무슨 일이 일어나고 있는 걸까? 왜냐하면 여기서 내가 느낀 건
베를린 장벽이 무너지고, 동베를린 사람들은 2등 시민이
되었다는 거거든. 그 사람들이 살아왔던 이데올로기 패러다임에
신자유주의, 소비지상주의가 겹쳐지고 있잖아. 이 지역에
이런 스무스한 전복이 수십 년 부터 준비되고 있었어.
(동베를린 사람들은) 서베를린 사람에게 그렇게 감사함을
느끼지 않아. 자, 한국에도 이런 패러다임이 가능할까? 너무
먼 얘긴가? 아니면 이것도 너무 유럽적인 이야기인가?

A 너무 유럽 중심적인데.

E 음…

N 그래, 왜냐하면…

A 너무 유럽 중심적이야… 정말로.

<div align="center">3.</div>

A *(독일어로 말하며)*재미있네.

E 그래서 나는 이렇게…*(전화벨 소리가 울린다)*…오 마이 갓,
지금 말고. *(웃는다)*

N …애들일 수 있잖아…

N 아니야…아…전화 좀 받아도 될까?

N 그럼, 그럼!

E 아…나 Y에게 니 성을 알려줘야하는데, 걔가 벨 눌러야 하니까.

N 음…

A 맞아…

E …뭐였더라…?

N Mi.

E Mi…Mir…좋아.

A 근데 내가 내려갈게. 왜냐면...

E 그래…

N 그래…너 …니가 가야지…

A *(이어서 말한다)* 흠. 우리 셋이 다 다른 포지션에 있다는 게
흥미롭네. 3개의 케이스 스터디라 할 수도 있고…아니면
3개의 다른 문화적 백그라운드라고 할 수도 있고. 첫 번째는
우리가 지금 있는 독일. 두 번째는 당연히 한국. 그리고 우리
의 유고슬라비아 경험, 쪼개진 유고슬라비아. 그리고 공동체

패러다임…그리고 함께 하는 것. 이건 적어도 지금은 완전히 다른 것 같아. 독일에서는 90년 대에 벌써 성공 했으니까. '우리는 하나다', '우리는 한 민족이다.'(Wir sind ein Volk)… 라고 말하면서. 한 민족…통일 독일…그리고 너네는 지금 같거나 비슷한 길을 가려고 하지. 뭐냐면, 두 한국으로 나눠진 게 치명적인 오류였고, 동시에 자연스러움에 반하는 일이라는 측면에서도 말이야…근데, 알고 싶은 건, 북한 사람들도 너네랑 같은 생각일까?…민족국가(nation)의 측면에서, 그냥 국가(state)말고…근데, 너는 북한 사람들을 너희…'민족(Volk)' 이라고 생각해?…같은 국적(nationality)? 유고슬라비아의 경우는 완전히 달랐거든. 거기서, 만약 크로아티아 사람에게 '우리는 *(편집자주: 세르비아 사람과)* 하나다, 같은 언어를 쓰고, 같은 국가다.' 이렇게 말하면 엄청난 문제가 될 거야. 왜냐하면 유고슬라비아는 '그렇게' 존재하지 않았거든. 아니면 적어도 지금은, 지금 현재의 국가에서는…일종의 모독 같은 거라서. 특히 세르비아랑 크로아티아는…지난 5-6년 동안…유고슬라비아라고 말하는 것, 세르비아에서 크로아티아를 말하는 것, 크로아티아에서는 그 반대로….이런 건 정말 위험한 일이 되어 버렸어. 만약에 세르비아에서 '나는 크로아티아 사람이다.'라고 말하는 것 정도는 괜찮은데, 근데 '유고슬라비아 사람이다.' 라고 말하는 건 지금 지배적인 민족주의 레토릭에 완전 반하는 말이거든.

E 그래…나는 *(A와 N 모두에게)* 너희한테…아주 중요한 단어를 캐치했는데… *(A에게)*. 너는 공동체 그리고 함께 하는 것에 대해서 얘기 했지…그래서 내가 이 RED PEOPLE에게 제안하고 싶은 건…우리 타이틀에 RED PEOPLE이 있지만…이 사람들은 유토피아적 공동체에서 함께 하고 싶은 문제적인 사람들인 것 뿐 이잖아. (N: 음…)

A 그렇지…

E …파라다이스 같은 공동체…그런데 우리가 그걸 어떻게 만들 수 있을까? 어떻게 이 문제를 헤쳐나가야 할까? 그러니까… 이 주제로 인터뷰도 할 수 있고…그냥 사람들을 만날 수도 있고, 근데, 우리가 만나는 사람들은…비인간적인 단어로 표현하자면 …그냥 우리의 이야기를 하게 만드는 수단이나 도구인건가… 그래서, 우리의 프로세스는…예를 들어, 너희를…문제가 있는 … *(모두 웃는다)* 내 친구들에게 소개하고, 아니면 이런 주제를 이해할 수 있는, 또는 우리와 조화가 될 수 있는…다른 단어를

A	쓰고 싶은데…동화말고…어쨌든…그런 친구들에게 소개하는.
	그렇지, 그런 식으로 할 수 있지…
N	잠깐만… 어떤 단어…? *(E 웃는다)*
E	… 공명… 공명하는 것!
N	아, 공명…
E	응.
A	난…이렇게 생각했는데…전체 책이…이런 질문들에 대한 인터뷰를 통해 만들어지는 거지. '공동체, 함께 하는 것, 문제' …그럼, 어떤 것이, 한 공동체 안에서 한 사람의 포지션을 반영할 수 있을까. 그리고 우리가 독일, 한국 그리고 유고슬라비아라는 테마 안에 집중한다면, 그것에 대해 깊게 생각해보고 목소리를 낼 수 있는 사람을…각 나라에서 2명 정도 찾아서…그들이 사회에 어떻게 통합되었는지 혹은 통합되지 못했는지 얘기 해보면 어떨까? 지금 생각나는 동독 출신 친구가 한 명 있는데. 동독 사람들은 뭘 느꼈을까? 지금 통합되었다고 느낄까? 그들의 과거에 무슨 일이 일어난 걸까? '공산주의의 아틀라스 (Atlas of Communism)'라는 멋진 공연이 있었는데, 아마 고리키 극장에서 본 거 같아…거기서 동독 사람 하나가 동독은 서독에 식민지화 됐다고 느꼈단 얘기를 했어, 그리고 이런 얘기도 했는데…뭐였더라?…내적인 식민화 메커니즘 (Internal colonisation mechanisms)…너네도 이렇게 얘기 할 수 있지…일종의 고발처럼, '유고슬라비아는 사실 큰 세르비아 프로젝트였다.' 라고. 세르비아 사람들은 다른 민족 그룹을 식민화했어…지금은…모독이라고 할 수 있는 말이 되었지만. 그럼에도 불구하고, 이런 시각에서 볼 수도 있는 거지. 그리고 이어서 추론해보면, '한국에는 어떤 시나리오가 있을까? 누가 지배자가 되고, 누가 식민화 당할까? 남한이 DMZ를 해체하고 …북한을 지배하려 한다고 말할 수 있을까. 자기 삶의 방식이 나 이데올로기를 포기한다는 측면에서? *(N에게)* 어떤 걸까…?
N	아니, 아니…*(웃는다)* …아, 너 말 다 끝날 때까지 기다릴게…
A	근데, 내가 이런 생각을 하게 된 입장이 되어버렸는데, 이거는 정말 피해자를 분명하게 만드는 건가…뻘갱이(red people)의 피해자화 된 포지션은…자본주의 패러다임에 대항하는 이데올로기인건가. 근데 한편으로는…여기서 발터 벤야민이 생각 나. 왜냐면 벤야민이 이렇게 썼거든…그것이 유토피아 정치학의 미션이라고. 이 대목에서 우리는 지워져 왔던 사람들의 포지션에서 역사를 다시 생각해봐야 해. 고통

받아왔고, 패배한 사람들. 그리고 발터 벤야민의 관점에서
그 사람들은 지배계급의 대척점에 있는 사람들이야. 그건…
노동자들…아니면…좌파…인텔리겐치아(inteligencia)지.
넓은 의미에서.

4.

E 는 젠가 게임에 관한 비디오를 보여준다. 모두 함께 비디오를 본다.

N 음…*(비디오에서 게임의 룰을 한국어로 설명하는 소리가 들린다)*
E 이건…
N 음…
E 안정적인…
N …건축물.
E …그런 거고. 다 만들고 나서 블록을 하나씩 밖으로 빼는 거야.
 그러다가 누가 이걸 무너뜨리면, 무너뜨린 사람이 지는 거지.
 이건…의미는 좀 달라서, 우리가 생각해보기는 해야 돼.
N 음… 약간…아주 다르진 않고…이거 정말…
E 그래서 사람들이… 나는 게임같은 걸 생각 해봤는데…
 사람들이… 참여를 할 수 있게 말이야. 게임은 참여하기가
 좋잖아. 모든 한국 사람들이 이 게임을 알아…*(비디오 소리가
 커진다).* 난 이게 좋더라고!*(웃는다)* 사람들이, 예를 들어,
N 그래서, 무너지면…어떻게 되는 거야…
E 폭삭…*(웃는다)*
N …벽이 폭삭 무너지면? 그럼 나머지 책들은 어떻게 되는 걸까?
E *(웃는다)* 모르겠네…예를 들어서, 이렇게…*(비디오 속의
 사람들이 웃는 소리. E도 웃는다.)* *(부엌으로 가는 A 에게)*
 넌 이 게임 알아?
A 아니.
E 자, 사람들이 블록을 하나씩 순서대로 빼. 그러면 이 나무
 블록이 갑자기 넘어지는 순간이 오는 거지. 그 사람이…
 오…*(비디오의 상황을 설명하며)*…이 여자가 진거야.
N 내 생각은…이게 좋긴한데…무너진 책들이 공간에 남는 게
 …막 흩어져서…그럼 아무도 가져가려고 하지 않을 것 같아…
 그리고…책을 공짜로 가져가게 한다는 생각은…우리의 반대편
 사람들이 하는 방식이잖아…우리도 뭘 주는 거지…리서치를
 한다는…측면에서. 우리는 이걸 경험했고, 그래서 문제가 될

수는 있는데. 너희도 같은 걸 겪지 않도록 대비한다는 차원에서 말을 퍼뜨리는 거지. 나는 가끔 이런 방식으로 우리의 작업을 생각하고 있어. 무엇을 주는 것…아니 나누는 것…주는 게 아니라, 나누는 것…왜냐하면, 보통, 사람들은 지식에 접근하질 않거든. 이야기하는 학문이라고 할 수 있지. 학자들은 시간이 있어. 노동자들은 없지. 우리의 지식들은 특권층 사람을 위한 것만은 아니고, 다가오는 모든 사람들에게 나누어질 수 있는 거야. 누가 올지 아무도 모르잖아. 예를 들어 학교 다닐 때 공산주의에 대해 배운 사람이 올지…반공을 배운 사람이 올지 …그것에 문제를 가졌던 사람들이 올 수 있고…우리 책을 갖게 되는 거지. 난 여기에서 책을 읽고…사람들은 서로 그것에 대해서 얘기하고, 그런 일들이 생겨날 수 있지 않을까…

A 유토피아를 위한 매뉴얼… *(웃는다)*

E *(웃으며)*…유토피아를 위한 매뉴얼…

N 유토피아를 위한 매뉴얼…왜냐하면 지금은 공산주의로 돌아가기 좋은 타이밍은 아니니까…아니면 공산주의는 파시즘과의 전쟁에서 그 목적을 달성했지. 하지만 지금은 아마, 더 나은 버전으로 가고 있는 때가 아닐까…공산주의 2.0 같은.

E 웃는다.

N …그런 거 있잖아…

A 계발되는 것!

N 새롭게, 계발된 버전! 업그레이드!

E, 웃는다.

N 우리는 다른 사람이기 때문에…이 아이디어가…완전 다른 방식으로…파란을 일으키는 그런 컨셉의 아이디어는 될 수 없을 거야. 같은 컨텍스트도 아니고, 같은 구조도 아니고, 같은 정신적, 정서적 환경을 갖고 있는 것도 아니고, 같은 경제적 패러다임을 갖고 있는 것도 아니니까. 그리고 그냥 그걸 바라본다면…어떤 유토피아 같은 제안이 될지…누가 알아 …내 안의 생각을 외쳐보는 거지…

A는 깊고 큰 숨을 내쉰다.

N …벽돌이라는 측면에서는…*(날카롭게 내쉬며)* 아마도 이렇게
할 필요는 없을지 몰라…이런…L…*(손가락으로 L 모양을 하며)* …왼쪽의 L… 미친(Loony)의 L…좌파의 L … 정신 나간
(lunatic) L…갑자기 왼쪽으로 …착착 가는 것처럼! *(손가락으로 보여주면서 날카롭게 왼쪽으로 돌아 앉는다.)* 이건 그냥
하나의 반듯한 벽이 될 수 있어, 사람들이 와서 하나씩 가져
갈 수 있게…

A 나도… 반듯한 하나의 벽이 훨씬 좋은 것 같아…

5.

E 그래…그렇게 됐어…모든 것이. 남한이 북한에 대한 정보를
일본과 주고 받는 것을 그만 두기로 했어. 지소미아를 연장
하지 않기로 했어.

A 아… 뭘…

N 새롭게하는 거…

A 갱신...

E 갱신, 맞아. 그리고 이게 지금 한국에서 일본과의 가장 큰
이슈야. 지금 미국이 남한에게 지소미아를 다시 연장하라고
압박을 넣고 있는데. (A: 아….)왜 그런지 모르겠네. 왜 미국
하고 일본이 서로를 서포트 해주고 있는지 이해가 안 돼

A가 히죽히죽 웃는다.

N 내 생각엔, 그건 순전히 신자유주의적인 생각에서 그래.
자본을 위해서. 자본으로 식민지를 만드는 것이고, 자본주의
악당들이지…이게 그들이 하는 거야.

E 이런 한국의 운명을 생각하면 좀 슬프다…한국…두 한국 말이야.

(...)

N … 이런 이야기도 넣어볼 수 있겠다…아니면…
(남은 아이스크림을 치우려한다.)

A 난 사실 더 먹고 싶은데.

N 물?

E 모르겠어… 아니, 난 안 먹을래.

N 나도.*(남은 음식을 냉장고에 정리한다.)* A! 너 이것 좀…도와

	줄…고마워, 자기. (*E 웃는다*)
E	이건 정말…
N	그래 이거 정말 어렵지…
E	응.
N	정말 걱정되는 상황이네. 쉽지 않아, 가망도 없고…
A	근데…(*A가 식탁쪽으로 온다, 바닥의 삐걱 소리가 A의 목소리를 방해한다.*) 유고슬라비아 상황은 가망이 있었나? 영국은? 그냥 그 말에 반대한다기 보다는…
N	두 한국 사이가…정말 애매모호하다고 들었는데, 나는 좋은 편이라 생각했거든. 사람들이 합치는 것을 원한다고 생각했어. 가족과 떨어진 사람도 있고…펜스나 장벽에 의해서 갈라져서 서로 다른 쪽에서 서로 자라왔잖아. 그래서 그렇게 생각했어. 물론 이데올로기가 작동하기 때문에 역사는 언제나 반복되고, 구조도 항상 반복되지. 사람들이 반복되지는 않지만, 이데올로기는 반복되지. 그래서 이 부분이 이야기하기 좋은 포인트가 될 수 있을 거 같아. 이데올로기들. 당연히 우리가 피할 수 없는 것이고. 하지만 우린 정말 그걸 주의해야 해…
A	… 어떻게 개괄할지에 대해서.
N	그래. 그리고 이데올로기와 그 작용을 어떻게 눈에 보이게 만들지에 대해서. 그리고 그건…인터뷰 전략으로…나쁘지는 않은 거 같아.
	(...)
A	약간 다른 얘기를 하자면. 내가 칼스루에 교수랑 얘기 했는데. 너네 이 영화 알아? 찾아볼게. 어떤 영화냐면…유고슬라비아 감독 두산 마카베예프(Dusan Makavejev)영화인데. 레닌 기념비가 어떻게 해체되는지를 담은 유일한 사람이래. 1991년 베를린에서. 장벽이 무너지고 나서 말이야. 그 교수는 동독 출신인데. 우리는 이 모든 기억의 정치와 전체적 전이…전환에 대해서 이야기했어. 아직도 분명하지 않고, 아직도 독일에서 잘 소화되지 않은 그 이야기 말이야. 어떻게 보면 모두…
N	그건 모두 사실에 바탕을 두고 있는데…이제는 그냥 장벽이지 갑자기 아무것도…
A	그냥 장벽이고, 장벽은 무너졌고, 우리는 하나가 됐지.
N	그게 다야. (*입에 무언가 가득 담긴 채 말을 한다.*) 왜냐하면, (*현실에서는*) 그건 사람들에 관한 것만이 아니라…부딪히는…

	이데올로기에 관한 거거든…
A	*(계속해서)*…소유권들, 문제들…
N	맞아…독일에서 아직도 부딪히고 있는 것들이지, 사람들은 합쳐졌는데. 아니…영토는 합쳐졌는데, 사람들은 낮게 평가 됐지…저쪽 출신 사람들…
A	… 동독…
N	동쪽. 왜냐하면 …
A	… 지금도 낮게 평가 돼.
N	왜냐하면 타자이기 때문에. 다른 정신적 환경에서 자라왔고. 다른 문화적 환경에서…
A	여전히 그래. 수입을 보면…같은 직업인데 드레스덴과 슈투트가르트를 비교해 보면. 슈투트가르트에서 훨씬, 훨씬, 훨씬 더 많은 돈을 벌 수 있어.
N	그거 일종의, 합법적인 계급 차별이네…안 그래?
A	그렇지, 맞아…
E	맞아, 맞아…
N	… 법에 의해 합법화 된. 권력의 이데올로기에 의해서 정당화 된.
A	정당화 된 불평등.
N	국가가 불평등을 조장해. 창피한 줄도 모르고 아직까지… 놀랍지 않지. 한국에서도 이렇게 될지…잘은 모르겠어…너무 먼 얘기 같기도 하고…너무 먼.
A	…
N	…그래 조금…먼 …맞는 지점이야. 목표로 삼기 올바른 지점 이기도 해…
A	우리한테도 맞는 거 같아. 이런 질문들이. 왜냐하면 우리가 전시를 하는 컨텍스트에서 '도래할 공동체' 에 대한 질문을 해볼 수 있잖아…우린 이런 질문들을 제기해 볼 수 있어. 우리가 '하나의' 한국에 대해서 두 한국 사이에 함께 할 수 있는 합의된 무언가가 있을까. 다가올 통일 한국을 위해서 말이야… 그게 뭘까? 미래에 관한 그런 그림은 픽션이나 판타지일까?
N	그래 이건…
A	추측이지, 어느 정도는.
N	이건 정말 좋은 포인트다. 이건 우리에게 이전의 경험을 이야기하기 위한 문을 열어주는 것 같아.
A	유고슬라비아에서 일어난 일, 독일에서 일어난일 , 그리고 한국에서 일어날 수 있는, 일어나길 기대하는 일이 무엇일까.

Un/bricking the wall, kids playing kit, 2019.

1.

Er 동독에서는 그걸 가리키는 특별한 단어가 있어⋯베싸비써
 (Besserwisser)라고. 그러니까⋯

A ⋯ 더 잘 아는 사람이라는 뜻이지⋯

Er ⋯ 항상. 우리는 그걸 베싸비써(Besserwisser)라고 해. 근데
 그건⋯

A 그거 보통 서독 사람들을 두고 하는 말이지⋯

Er 그걸 우리 ⋯ 동독 사람들은 90년대에 '베싸베씨
 (Besserwessi)'라고 말했어⋯

E 아⋯ 맨스플레인(mansplain)같은 말이구나.

Er 우리가 아무것도 모르니까 모든 걸 다 설명한다는 말이야.

E 더 잘 아는 서독 사람(Besserwessi)⋯

Er 우리가 좀 바꾸긴 했지만⋯동독 사람들이 베싸비써를
 베싸베씨로 바꿨지⋯

A 나이스⋯

N 우리 독일어 선생님은 동독 사람데, 항상 이렇게 가르쳐.
 '이게 문법적으로 맞는 말이에요⋯하지만 이걸 동독 사람들은
 이렇게 말하죠.' 라고. 말하자면 우린 두 언어를 배우는 거야.
 (모두 웃는다). 시간을 말할 때⋯동서독이 차이가 있거든,
 지금 어느 때보다 그 차이가 존재하고 있다. 대부분의 차이는
 동독 사람들에게 불리한 식으로 사용 되는 것 같아.

Er 서독 사람들은 12시 15분을 '12시에서 15분이 지났다'라고
 말하고⋯동독에서는 '1시에서 45분 전이다.' 라고 하지.

U 근데 사실, 너한테 그런 말 많이 들은 거 같아⋯저 여자는
 '동독 사람이라 이해를 못한 거 같아. 저 남자는 서독 사람이라

잘 모르는 것 같아'···

A 그렇구나, 어떻게···

U 독일에는 정말 다양한 방언들이 있잖아. 근데 요즘에 얼마나 많은 사람들이 동독과 서독을 나누고 있을까.

E 넌 어떻게 생각해···동독 사람들과 서독 사람을 구분이 되나? 사람과 관계를 맺을 때···

U 니 말은···

E 내 말은···

U ··· 언어로?

E ···언어로···

Er *(U에게)* 언어로 구분이 되냐고···?

U ··· 그니까···*(더 설명해주려 한다)*···음···

Er은 무언가 중얼거린다.

A 근데 너네 세대에서는 어때? 누군가 동독 출신인지, 서독 출신인지가 중요한가?

Er 몇 년 전까지만해도, 그런 게 윗 세대들한테는 중요한 문제였던 것 같은데···그 세대에서는 확실히 동서독의 구분이 있었으니까. 많은 동독 사람들이 서독으로 갔는데, 아직까지 서독사람들의 50%는 동독에 전혀 가보질 않았데. 그 사람들은 '왜 우리가 아무 데나 가?' 이렇게 생각하는 거지(N: 맞아, 맞아!) 근데 나는···나 같은 젊은 세대는 다르지. 예를 들어, '난 동독을 본 적도 없어. 난 그냥 독일 사람이야.' 라는 거지.

A 나는 독일 사람이다···그래, 그래, 그래.

Er 나는 독일 사람이다. 그게 다야.

A 점점 더 그렇게 느끼게 되는 구나···

Er 사람들은 자기들이 나누어버리지. 동독이냐 서독이냐로. 왜냐하면 동독사람들은 AFD(역주: 독일 극우 정당)에 투표를 하는 이상한 사람들이라 생각하거든···

A 아직 결론이 난 건 아니지···난 그게 문제가 되고 있다고 생각해 ···*(식기 소리가 난다. N과 U가 접시들을 옮겨서 디저트를 놓을 자리를 마련한다.)* 정확히는 AFD 때문에, 지난 번 작센 주 선거에서 AFD가 전보다 3배나 넘는 득표율을 기록했잖아. 브란덴부르크 주에서도 같은 일이 일어났고, 아직 주도 세력은 아니지만, 지난 선거에 비해 2배나 높은 득표율을 기록했지. 근데···너의 할아버지, 할머니가 들려준 얘기를 했잖아···기억에

대해서…그 분들은 그 때가 좋았다고 하셔?

뒤에서 불분명한 대화소리가 들린다.

Er 통일 되었을 때 말이야…?

A 응, 응, 응… 동독 사람이셨잖아…일종의 트라우마를 경험
 하셨던 걸까?

Er 우리 부모님은 자신들을… 벤데게비너(*Wendegewinner*,
 역주: 변화를 통해 이득을 본 사람)라고 생각해.

A 아… 벤데게비너

Er 부모님은… 우리 가족한테 이익이 많이 있었다고 생각해.
 더 좋은 직업을 얻었고, 수입도 좋아졌고. '통일은 우리 가족
 한테는 좋았다.' 라고 말해두자.

A 아하, 오케이. 그럼 이전 시절을 그리워 하시기도 해?

Er 부모님은…조금…왜냐하면 서쪽 사람들의 태도나 행동을
 싫어하실 때가 있거든(모두: 음….)친밀함을 그리워 하셔…

A 친밀함…

Er 사회주의 사회의 친밀함. 사람들이 이웃 간 더 친절하고, 더
 잘 돕고….아니 도움이 필요한 모두를 잘 도왔는데. 근데 지금은
 도움이 필요해도 본척만척 하는 세상에서 살고 있지. 사람들은
 아무도 돕고 싶어하지 않잖아. 그냥 자기 일이 제일 중요하지.

2.

Y 언젠가…

E가 웃는다.

N 니가 물어봤잖아…우리가 그런 목소리를 어떻게 대표한다고
 생각할 수 있을까? 라디오 드라마를 생각했던 때로 돌아가보면
 …우리는 목소리 이데올로기를 어떻게 생각하지? 나한테 그건,
 '우리가 추구하는 거야.' (*박수소리가 들린다.*) 우리는 정치하는
 사람도 아니고…그렇다고 어떤 특정 개인 한 명이라고도 할
 수 없지. 그리고 유명인들은 그렇게 자신을 만들거나 자신의
 의견을 만들기도 해. 특히 연예인들이 많이 쓰는 방법인데,
 자기가 대표하고 있는 것을 생각하는 게 아니고, 그…자기
 생각을 말할 때 생각이 있다고 느끼잖아. 자기가 위치해 있는

맥락과 이미 만들어진 담론에 대해서 고민하는 사람은 거의 없지. 사람들은 일반적으로 이데올로기가 자기한테 어떻게 작동하고 있는지는 고민하지 않잖아. 이데올로기에 대해서 생각하고 쓰는 사람들조차도. 그 사람들은 자기가 이데올로기에 영향을 받지 않는다고 생각해. 지금, 우리도 마찬가지야!

Y 내가 왜 갑자기 그런 말을 했냐면…니가 어떤 사람을 대표하느냐 그렇지 않느냐의 문제라기 보다는…관객의 입장에서 어떤 프레임을 이해하는 데에 그 부분이 중요하니까…왜냐면…

N 그래, 그래, 그래… 당연하지!

Y … 이 사람은 이런 데에 관심이 있구나 하고 생각할 수 있고. 예를 들어 왜 식민화의 문제라고 생각할까? 유명인으로서 너에 관한 문제가 아니라…(*웃는다*)

N (*웃는다*) 아니, 이건 유명인으로서 나에 관한 일도 아니고, 유명인으로서 인터뷰 한 누군가에 대한 말이었어…이 '유명인화' 되는 패러다임은 요즘 예술에서 일반적이잖아. 이건 니가 말한 건 아니었어.

Y 음.

N 니가 말한 게 아니야. 아니, 아니, 아니! 넌 완전 다른 말을 했지.

Y 아, 오케이.

N 여기서 주제를 다루는 방식은 이런 거야…스펙타클을 만드는 거. '장벽이 이렇게 무너진다…' 아티스트가 대표하는 이데올로기에 따라, 우리는 벽을 세우는 스펙타클, 그리고 벽이 해체되는 스펙타클이 있는 거지. 내 생각에 이 스펙터클은 정말 문제야. 전략 정치, 미디어 정치에 관한 문제지. 니가 이데올로기에 대해서 물어봤잖아. 그게 바로 우리가 작업하는 내용이야. 어떤 생각들의 기원. 그리고 어떤 정치적 순간에, 이 생각들을 활성화 시킬 때, 어떤 결과들이 나올까? 어떤 정치적인 결과가? 사람들에게는 하나가 되는 게 좋지. 계속 나누어져 있었으니까, 가족들도 나누어졌고…계속 반복하게 되는데…결국 우리가 그것에 대해서 어떻게 느끼는가에 대한 거야. 우리의 걱정, 두려움, 불안, 경험, 이런 것들이 어떻게 우리의 일상 현실에 반영 될 것인가, 우리는 그것을 어떻게 계속 할 수 있을까? 우리는 계속 할 수 있기나 한 걸까? 우리는 우리의 가장 깊은, 이 아직 오지 않은, 존속 되지 않은 공동체에 대한 모순적인 감정을 표현할 수(아니면 억누를 수) 있을까?
(Y: 음…) 우리는 아직 심각한 분리를 겪고 있어. 그래서 감정이 우리를 한 방향으로 이끌고 가지. 사회 규범, 문화, 계급, 가족의

요구가 우리를 다른 방향으로 분리시키지. 그건 인간에게
치명적인 것이라고 생각해. 이런 분열은 모든 것을 파괴할 거야.
그리고 우린 모두 미쳐버리겠지. 그리고 난 이게 '자본주의
노동'이라고 생각해.

Y 왜 그게 자본주의에 관한 거야?

N 왜냐하면 그게 최종적으로 컨트롤 하거든…인간이 고립되도록
…그리고 인간의 욕망을 관리하고, 인간의 기쁨을 지휘하지.
그러니까 넌 니가 말해왔던 '것'을 해야만 해. 왜냐하면 그게
합리적으로 선언된거니까. '상식'이지. "야, 합리적으로 생각해",
라고 종종 서로에게 강요하잖아. 그렇게 말할 때 너무 싫어.

Y 다른 사회주의 국가랑은 다른가?

N 2019년의 사회주의적 환경에서 어떻게 보일지는 모르겠어…
왜냐면 이제 없잖아 (웃음)

Y 내 말은, 어떤 차이가 있을 수 있냐는 거지?

N 내가 묻고 싶은 것이기도 해…내가 사회주의를 택하는 건,
거기에는 내가 스스로 다룰 수 있는 문제들이 있기 때문이지.
만약에 내가 뭘 선택해야 한다면, 나는 선택하지 않을 거야.
(Y: 응, 그래, 그래…) 근데…유고슬라비아가 만든 문제들을
처리하는 걸 선택하게 되면…자본주의 (아니면 미국)가 만든
문제들. 예를 들어, 만약 내가 썩은 자본주의에서 살고 있다면.
난 유럽 버전의 썩은 자본주의에서 지금 살고 있지. 그리고
난 이게 싫어…왜냐하면 사람들이 망가졌거든. 내가 어렸을
때보다 더 많이 망가졌어.

Y 아니면 90년대나 2000년대 보다 더 심한가? 이게 일반적인
자본주의가 아니라 신자유주의라고 할 수 있을까?

N 정확히 그거야…

Y 난 사람들을 특정 방향으로 끌고 가는 것과 비슷하다고 생각해…

N …그렇지…

Y 그래, 그래…

N … 강제로…억지로! (Y 웃는다…) 변화가 실제로 강요되었지.
적어도 경제 체제가 자본주의로 전환되는 것에 투표한 사람,
그런 식으로 될 거란 걸 인식한 사람은 내가 아는 한 없어.
온 나라가 코끼리를 컵에 밀어 넣는 것 같은 변화를 강요당했지.
준비도 안 되어 있었고, 능력도 없었어. 구 유고슬라비아 공화국은
상당한 발전상의 차이를 보였기 때문에, 이런 드라마틱한
변화에 관여할 능력이 전혀 없었어. 그래서 난 이 프로젝트에서
…A와 나는, 실패한 변화 과정에 대한 쓰라리고 냉정한 경험에

	대해서 이야기하고 있는 거야. 사람들 사이에서 엄청 큰 문제를 발견하는 건 아니지만… '이념의 노동'이라고 생각해. 사람들 뿐만 아니라 그 관계들, 사회적 인프라와 안보가 담보 되었고, 그게 손상 되었지. 내 생각에 우리가 주목하는 곳은 (통일의) 영향으로 발생할 이런 정치적, 경제적 파괴야.
Y	탈북민을 인터뷰하지는 않았어?
N	했지…
E	하려고 했지…
N	하려고… 했는데…
Y	이제 이 프로젝트에서 E의 포지션이 궁금해지네…
E	아…근데 나 가야해.
N	가야한데.
Y	오 안돼…
E	아…정말 미안. 근데 우리…나중에 얘기할 수 있을 거야. *(모두 웃는다)* 난 정말…
N	… 아름다워.
E	(모두 웃는다) 난 정말 아름답지. 니 질문들이 마구 입력되었어. 그래서 머릿 속에 생각이 너무 많네.

(…)

A	미안, 나 이 대화를 켐니츠와 같이 할래. *(역주: 켐니츠는 독일 작센 주의 도시, 최근 극우주의자들의 시위로 유명해 졌으나 과거에는 칼 마르크스 시로 불리기도 하였다)*
E	(웃으며) … 켐니츠랑…
A	걔네 융통성있거든…

3.

"북한의 역사는 공식적으로는 *1948년 북한의 설립으로 시작된다. 1945년 제2차 세계 대전에서 일본이 패배하면서, 한국은 일본의 식민지에서 벗어나지만, 이어서 38선을 따라 구소련의 영향력 아래에 있는 북쪽과 미국의 영향력 아래에 있는 남쪽으로 나뉜다. 소련과 미국은 한국의 공동 관리권 도입에 동의 할 수 없었다. 이로 인해 남과 북에 별도의 정부가 설립되었고, 이 두 정부는 한국 전체를 통치하는 데에 대한 정당성을 각각 주장했다. 이러한 결정을 할 때 미국이나 소련은 한국 국민의 의견을 듣지 않았다.*

설립

1945년 9월 6일 서울에 미국이 상륙하기 전에 남쪽과 북쪽의 의회는 김일성을 대통령으로 선출하여 대한민국을 선포했지만 미국은 그 의회를 인정하지 않았다. 무엇보다도 미국이 통일을 승인하지 않았기 때문에, 협상이 실패한다.

1948년 8월 15일 미국의 비호 아래 남쪽에서는 대한민국을 선포하고, 이승만이 대통령으로서 선서를 했다. 이에 따라 1948년 9월 9일, 북쪽 의회는 국호를 '조선민주주의인민공화국'으로 바꾸고, 김일성을 주석으로 선언한다.

한국 전쟁 (1945-1953)

이러한 상황으로 인해 1950년 6월 25일, 국경에서 계속 되었던 사건들이 전쟁으로 발전하여 긴장이 고조되었다. 북한군은 성공적으로 진격하여 서울로 들어와 반도 남쪽으로 이동하였고, 국민들은 저항하지 않았기 때문에 한국이 스스로 무너질 것이라고 생각했다. 그 때 미국이 개입하기로 결정한다. 더글러스 맥아더 장군이 이끄는 미군은 1950년 9월 15일 인천에 상륙했다. 북한군은 38 선으로 후퇴했고, 북한으로 향하는 미국의 갑작스런 공격으로 평양까지 후퇴하게 되었다. 당시 새로 형성된 중화 인민 공화국 정부는 KGB를 통해 미군이 북한군 붕괴 후 국경을 넘어 중국을 점령하고, 제국을 되찾아 대만으로 도망 간 장제스를 잡으려 함을 알게 된다. 이를 막기 위해 중국은 북한으로 군대를 보냈다. 혹독한 겨울은 미국의 침략을 늦추었고, 봄이 오자 저항이 강화되기 시작한다. 이에 미국은 함흥항으로 퇴각하였다. 병사들이 후퇴하고 있는지 맥아더 장군에게 물었을 때, "아니다, 우리는 전진하고 있다. 반대 방향으로!" 라고 성내며 소리쳤다. 한국인들은 점점 더 전쟁에 연루되기 시작했고, 중국의 지원과 소련의 무기는 승리를 보장하는 듯 했다. 1953년 7월 27일 판문점에서 미국과 조선 민주주의 인민 공화국 간 휴전 협정이 체결된다. (법적으로 말하면 북한과 미국은 여전히 전쟁 중이다.) 비무장 지대가 있는 38 선에 경계선이 만들어졌고, 중화 인민군은 북한에서 매우 빨리 철수했지만 미군은 현재 남쪽에 남아 있다.

조선민주주의인민공화국

1948년부터 김일성은 북한의 총리였으며 최고 지도자라는 타이틀과는 거리가 멀다. 1972년이 되어서야 주석으로 취임했고, 1994년, 죽을 때까지 유지했다. 평화로운 정치 분위기로 인해 북한은 전쟁에서 빠르게 회복되고 있었다. 1960년대에는 경공업뿐만 아니라 중공업이 빠르게 성장했다. 또한, 북한은 미군에 대항하는 조치를 취했다. 그래서 1968년 미국 스파이 선박 푸에블로 (Pueblo)를 잡았고, 1969 년에는 정찰기가 격추되었고, 1979년에 박정희가 사망했다.

1970년대는 세상을 여는 시대로 기록되었지만, 큰 규모는 아니었다. 평화통일 협상이 1972년에 시작되었지만, 1973년에 끝났다. 구 유고 슬라비아 공화국 대통령인 Josip Broz Tito는 1977년 8월 24일에서 30일까지 조선 민주주의 인민 공화국을 방문했다.

1991년 9월, 조선 민주주의 인민 공화국과 대한민국은 유엔에 가입했다. 소련의 붕괴는 북한에 큰 문제를 일으켰다. 우선 미국의 공격 위험이 증가하고 가뭄, 식량부족 및 기근과 동시에 서방 국가의 강력한 경제 봉쇄 아래 경제가 무너지기 시작했다. 무엇보다 CIA는 1993년 북한이 핵무기를 생산하고 있다고 발표했다. 오늘날까지 승자를 알 수 없는 고양이와 쥐게임이 지속되고 있다. 온오프라인으로 협상은 계속되고 있고, 세계는 수십 년 동안 지속된 한반도의 위기가 어떻게 결말을 맺을지 면밀히 지켜보고 있다."

출처: 북한의 역사 (세르비아어), 위키백과
https://sr.wikipedia.org/sr-el/%D0%98%D1%81%D1%82%D0%BE%D1%8
0%D0%B8%D1%98%D0%B0_%D0%A1%D0%B5%D0%B2%D0%B5%D
1%80%D0%BD%D0%B5_%D0%9A%D0%BE%D1%80%D0%B5%D1%98
%D0%B5,
마지막 방문: 2019년 9월 12일, 22시 13분

Brick wall, childrens playing kit, 2019.

4장.
나는 내 이야기가 예술에
사용되는 걸 원치 않아.

N 장벽의 전략을 이해해보려고 노력했는데. 하나는 장벽을 세울 때, 다른 하나는 장벽이 해체될 때…(손으로 단어를 더 설명하면서)…근데 통일이 되었을 때 사람들의 입장에서 감정, 정치, 이데올로기, 모든 것들을 이해해보려고 했는데…무슨 일이 일어날까?

A 만약 일어난다면. 아니 그게 일어났을 때.

N 많은 사람들이 이런 일이 일어나고 있다는 것을 너무 써먹고 있어. 우리도 마찬가지고, 확실히. 우리는 각기 다른 세 가지 입장이 있지만, 뭘 대표하지는 않아. 이게 지금 중요한 점이야. 아무도 대표하지 않는 것, 특히 국가의 입장을 대변하지 않는 것. 우리 중 아무도 그렇게 하진 않지 (A: 그치…) 어느 쪽도 아니야 …우리는 이것을 국가를 대변하는 것보다 한 차원 더 높이려고 하잖아. 실제 지식의 차원으로 공유하려는…

A 인류학적인 문제지…

N …인류학적, 사회적, 정치적 문제이지. 그리고 이걸 사고로 이해하는 것…사고의 과정으로서. 정치적 전략으로서 우리 모두를 설득 시키는 거지. 그런 관점에서 여기 참여하는 모든 사람들의 지정학적 관심이 무엇인지 이해하려고 노력하고 있어. 왜냐하면 이 모든 것이 독일 장벽이 무너지는 30주년이 되는 해에 이루어지고 있으니까. 이 작업에시 우리의 포지션은 구 유고슬라비아의 경험을 점유하고 있는 사람으로서이지.

A 이미 경험한 사람으로서…

N …베를린 장벽의 붕괴 결과...

Y 그거 알아? … 나는 내가 너한테 뭔 말을 했는지가 기억 안 나…
 (웃는다)

E도 웃는다.

N	나도 정확히는 기억 안 나. *(웃음).* 우리가 다시 얘기 할 수 있을 거라고 생각하고 있어. *(모두 웃는다.)*
Y	아니… 왜냐하면 너한테 했던 중요한 얘기가 생각이 안 나거든. 내가 뭐라고 말했어? *(모두 웃는다.)*
N	아주 좋았던 것은 기억해.
Y	그게…3월 이었나, 맞지?
N	3월이었지. 심지어 우리가 아직…
A	3월이었다고?!
N	응…
Y	그치.
A	6개월 전에…?
Y	반 년 전에…
N	그게…내 생일 바로 전 날인가 그랬어…
Y	아…
A	아, 그랬어?! 야하!
N	3월 7일인가 8일인가…
E	아니. 8일. 3월 8일
A	그게 어떻게… *(모두 웃는다)* 6개월이나…! *(모두 웃는다)*
N	그런 의미에서, 우리가 아무 것도 다시 얘기할 필요는 없어. 왜냐하면, 어쨌든 이건 다른 작업이니까. 근데 너에게 이걸 공유하고 싶었어, 비판적으로 장벽 해체를 본다는 의미에서…
Y	그게…그…통일…?
N	응.
Y	*(혼잣말처럼)* 한국의…
N	응. 그러니까, 우리는…베를린 한국 문화원 전시에서 라디오 드라마가 선정이 안 되었다는 걸 알고 나서. 몇 개월 후에 한국의 큐레이터에게 초대 받았어. 서울, 세종 문화회관…

E가 한국어로 설명한다.

Y	음, 음, 음!
N	그래… 이 추모…음…E가 더 잘 설명할 수 있을 것 같아… 우리가 이해하기로는 한국에서 이게 엄청 큰 일이었고, 그 활동가를…
E	김근태…

N	… 민주주의를 위해 싸웠던. *(E 는 한국어로 더 자세히 설명한다)* E가 C를 알게 됐고. 아! 큐레이터…
Y	지금 한국에 계시지.
N	그래서 훨씬 쉬워졌어. *(모두 웃는다)*
Y	여기 안 계시구나…
E	응.
Y	근데 그 분이 큐레이터 였어…?
E	북한 미술 전문가셔.
Y	아…나 이거 먹어도 돼?
N	…그럼! 되고 말고.
Y	어쨌든 이거나 먹어야 겠다! *(웃는다)*
N	그럼! 묻지 말고… *(웃는다)*
Y	그럼, 먹어야지…
N	그리고…
Y	… 그럼 전시는 언제…
E	12월에.
Y	응, 그치. 12월에. 거기서 너네 작업을 발표하려고 하는구나? 근데…
N	책을 만들거야.
Y	아, 그래.
N	그렇게 결정을 했는데…큐레이터는…사실 처음에 우린 라디오 드라마로 초대를 받았는데, 라디오 드라마의 목소리로 하려고 했던 P를 인터뷰 하지 못했어. 그래서 이렇게 결정을 했지… P가 되게 중요한 말을 했는데…
A	아마 그 문장이 첫 문장이 될 수 있지 않을까? 책을 딱 열면 문장이 하나 있는 거지. '나는 내 이야기가 예술에 사용되는 걸 원치 않아.' *(E 웃는다.)*
N	그렇지!
Y	그 문장은 사용해도 돼?
N	…P가 동의한다면. 어쨌든 챕터 하나의 제목은 될 거 같아. 이 작업에 대한 짧은 소개를 하자면. 우리가 이 작업이 좀 추상적이라는 걸 깨달았을 때, 이런 형태로 그리고 이런 주제로 말이야. 그럼 이 추상을 보여주는 건 어떨까? 하고 얘기가 나왔어. 그래서 우리가 직면한 문제를 시각화 하기로 했지. 왜냐면, 더 넓은 차원에서 어떤 한국 사람들 (남과 북 모두)은 이 책의 개괄적인 문제들과 연관이 있을 거라 확신했거든. 그리고 우리가 '유고슬라비아의 경험'이라는 위치에서 말하는 게 가치 있을 거

라고 생각했어. '보세요. 여기 우리는 독일 통일 이후에 변화가
일어난 곳에서 살았고, 그렇게 유고슬라비아는 해체되었어요.
그래서 유고슬라비아는 파괴 되었어요.' 그게 한국에서 똑같이
일어날 거라는 게 아니라. 그런 일이 일어났다는 거지. 그게
역사의 일부가 되었고. 우리는 이게 중요하고 관련 있는 거라고
생각했기 때문에 이 경험을 끌어오려고 하는 거야. 인터뷰를
하고 사람들에게 들려주기 위해, 우리가 중요 하다고 느끼는
것을 위한 적당한 장소를 찾으려고 해.

자, 여기 문제들의 집합이 있어. 많은 문제들이 있고, 권력의
입장에서 해결책을 찾으려는 것은 아니야. 아니. 우리가 원하는
건, 다른 측면에서 이런 문제에 접근할 책을 만들어내는 거야.
이 책은. 그 자체를 위한 거야. 이 책이 벽돌이 되어서 장벽을
만들거야. *(작업에 대한 스케치를 보여주기 위해 일어나려 한다).*

Y	그래서, 나한테는, 인터뷰를…
N	여기에…드로잉 한 게 있어. 오 미안, 니 말을 끊었네.
Y	그래서, 최대한 많은 사람을 인터뷰하는 거야? 아니면…
N	그냥 몇 명만…
Y	…아 몇 명만 하는 구나?
N	많이는 아니고.
Y	음, 음, 음.
N	그렇게 많지는 않고. 우리가 생각한 사람들 몇 명이 있었는데 …뭐라고 할 수 있을까?…우리가 생각한 거라는 건…
Y	… 필수적인, 아니면 중요한, 아니면 관련 있는…?
A	응, 말할 것이 있는…
N	… 반영할 수 있는…
A	…경험했던 것들을.
N	아, 그리고 너 남자친구가 유고슬라비아 사람이라고 들었어… (Y: *(웃으며)* 응 …) …완전 직접적으로 주제에 관련이 있네. *(E 웃는다)* 왜냐하면, 만약에, 너희 둘한테도 이게 대화의 주제가 되나…특히 넌 정치학을 공부하잖아.
Y	이게, 책으로 만들어진 장벽이야?
N	응.
Y	… 여러 가지 책인가?
N	아니, 아니, 아니. 우리 책으로 만든 거야.(Y: 아, 오케이…)
A	우리 책은, 일종의…
N	…벽돌 같은 거지…있잖아. 우리는 인터랙티브한 걸 하고 싶었는데…공간에 어떤 형태를 만들어서… 이 아래에 하얀

좌대가 있는 건, 이 많은 책을 인쇄할 만한 돈이 충분하지
않아서, 원래는 책만으로 장벽을 만들고 싶었거든.

Y 아 다 지원받는 거 아니야? *(웃는다)*

N 아니.

Y 근데, 큐레이터도…? 아무 것도?

A 지원 받기는 하지, 충분하지 않아서 그렇지.

N 그러니까, 우리가 800…

E 유로를 받지.

N 우리는 책을 만드는 데 그걸 쓸 거고. 우리는 못 가(웃는다).
 아무도.

Y 아, 진짜? 비행기표 사는 거 그런 걸 다 알아서 해야하는구나.

N … 우리는 돈이 없어, 그래서…안 돼. *(웃는다)*

Y 그래서, 거기 안 갈거야?

N 안 가. *(모두 웃는다.)*

Y 뭐?! E, 너도 안 가…?

E 안 갈 것 같아… *(웃는다)*

Y 그냥 너희 작업을 거기에 보내고, 그리고…

N 그렇지.

Y … 다른 사람들이 작품을 설치하고?

N 응.

A 거기서 책을 인쇄할거고 설치도 할거야.

Y 와!

N 그래서, 다 준비해야만 해 …

Y …여기서!

N 음.

E 사실, 표를 봤는데…직전에 도착하는 걸로…근데 한 600유로
 선이더라.

Y 괜찮네.

N 그렇지, 괜찮지. 근데 우리 셋 다 가기엔…

E 애들 데리고! *(웃는다)*

Y *(A에게)* 너도 팀이야…?

N 당연하지.

A 나는 중성이야. *(모두 웃는다)*

Y …뭐랄까? 넌…연극적으로 만드는 데에 책임을 맡으면 어때?

A 웃는다.

Y	*(웃으며)* 모르겠다…그냥 역할을 하나 만들어봐. *(N 웃는다.)*
A	역할 만들기.
Y	그래…
N	우리는 사람들이 벽을 무너뜨리도록 할거고, 그렇게 해서 문제의 책을 갖게 되는 거지.
A	매뉴얼을.
N	이걸 말해주고 싶었어. 어떤 면에선 힘든데, 필요한 일이거든. 도전이긴 하지만 중요하기도 하고. 아트씬에서 이런 문제에 대해서 얘기하지, 질문하는 것에 대해 속임수를 쓰는 방식이 아니라. *(웃음)*…과정을 진행하는 동안 문제가 만들어진 감추어진 도전이었지. 또 독일에서의 디아스포라로서의 삶 *(E에게)* 한국 사람들에 대해서 많이 얘기해줬잖아…니가 독일로 이사온다고 슈퍼 상위층이 된다고 생각하는 사람들 *(아침을 먹는 달가닥 소리가 배경으로 들려온다.)*
E	응…
N	니가 삶에서 고군분투하고 있고, 벌거벗은 존재로 살아가고 있음에도 말이야. 그래서 아무 것도 없는 상태에서도 아트웍을 하고 싶었고, 눈에 보이는 것으로 만들고 싶었어. 우리는 아무 것도 없어. 그리고 우린 가장 낮은 수준으로 생각을 맞춰야만 했어. 우리 큐레이터는 우리의 아이디어를 좋아했지만, 그리고 그것에 대해 너무 고맙지만 말이야. 진실은 우리가 노동자 계급으로 일하고 있다는 거야. 우리는 예술할 돈을 마련하기 위해서 다른 곳에서 일하고 있어. 나는 잔인하고 냉정한 시스템 안에서 주체가 되기 위해, 정치적 입장을 분명히 하려는 노동자 계급 이민자들의 분투를 보여주고 싶었고, 이 냉소주의가 보였으면 좋겠어.
Y	이게 사실 두 가지 관점이잖아, 그치? 하나는 한국의 통일에 관한 관점이고, 다른 하나는 유고슬라비아…통일되지는 않은 …그러니까 분단된.
N	…벽이 무너지는 행위와도 관련이 있지. 여기에는 많은 관점들이 있어. 지금 나한테는 계급 이슈가 되어버린 동독과 서독의 관계. 노동의 값어치가 내려갔어…2등 시민인 동독사람들은 더 낮은 댓가를 받지. 그건 교육에도 반영이 될 거고. 집도…
Y	그치, 월세가.
N	많은 결과들이 발생하지…
Y	이제 알았다. 근데 몇 명정도 인터뷰 할 거야?
E	6명이나 7명…

Y	우리 이야기로 어떻게 기여할 수 있을까?
A	경험들…
E	그리고 우리와 함께하는 이 대화들. 이게 텍스트가 될 거야.
N	자, 이걸 어떻게 할거냐?
Y	대화를 녹음하고…
N	… 그리고 나서 대본을 만드는 거지…
A	그리고 자를 거고. 드라마의 구조와 닮아 있다고 할 수 있겠다.
N	연극처럼. 이름은 없고 뭘 드러 낼 만한 개인적인 것도 없어.
Y	내 이름 써도 돼…
N	나도. 근데 어떤 사람은 불편할 수도 있으니까…P나…어떤 이유에서든…이상하지. 그냥 우리랑 있어서 그런 건가. 아니면 예술이라서, 아마도…?
Y	그러니까 누가 원하면, 이름을 바꾸거나 가명을 쓸 준비를 하는 거구나…
E	그걸 고려해야지…
N	아직 초기단계이고…마지막엔 어떻게 될지 모르겠는데, 나한테 제일 중요한 건 여기에 기여한 사람들이야…그 기여가 눈에 보이고, 인정 받고, 칭찬 받아야지. 우리가 실제 한국 사람들과 얘기하지 않고 이 주제를 다루면 안 되지. 우리는 누구일까? 그건 식민지화의 일종이야. 그니까, 우리는 벽이 무너져서 망했어.

모두 웃는다…

A	우리는 비슷한 문제들을 발견했어.
N	이 벽의 '붕괴'가 아시아에서도 일어나고, 유럽에서도 일어났을 때, 다 같은 거라고 대부분은 틀린 말을 했지.*(박수소리가 뒤따른다.)*
A	그것은 또 정체성 정치를 해체하려는 시도와 관련이 있어. 그런 의미에서 유고슬라비아 모델은 정체성 정치가 계급 정치를 이긴 좋은 예이지. 사람들이 공통적으로 가지고 있었던 건 계급 정체성이고, 다당제 체제가 생겨난 이후, 90년대부터 갑자기 노동자가 아니라 특정 국가의 구성원으로 다루어졌어.
N	민족성…
A	민족성이 계급 이슈를 덮어버렸지.
N	이제, 가장 중요한 건…말 끊어서 미안…가장 중요한 건 자기의 아이덴티티를 표현하는 거야. 지금 좌와 우 사이의 전쟁터가 되어 버린 정체성을. 왜냐하면 정체성은 사회에서 자기의 위치 뿐만 아니라 자기의 내면과도 관계가 있으니까 *(웃음)* 만약에

내면에 있는 것을 포기한다면, 그러니까 '우리의 개별성을 취소하는' 방식으로 포기한다면, 자본주의를 이 다음의 적당한 도전으로 향하게 하겠지. 그건 우리 내면의 존재를 식민지로 만드는 거고.

E 좋네.

N *(웃음)* 고마워.

E 왜냐하면…이건…내

N … 느낌…?

E … 느낌이기도 하고.

N 나 오늘 아침에 오드리 로드(Audrie Lourde)의 멋진 문장을 읽었는데. "그래, 자유. 중요하지. 제일 중요한 거지. 정치적 자유를 얻어내는 것도 중요해. 그러면 모든 것의 바깥에 있게 되지. 사회의 밖, 모든 것의 바깥에. 굶주림. 그건 무슨 종류의 자유지?"

A 배고픈 자유지. *(웃는다)*

N 실제로 넌 사회에서 이런 정치적인 주체화를 얻어 낼 수 있어. 반드시 그런 결론은 아니지만, 자본주의에서는 '같지 않으면' 아웃이지. 나한테 그건 절망적이야. 왜냐하면 내가 흑백의 이분법적인 논리로 생각해본 적이 없다는 걸 알게 되었거든. 하지만 이게 시스템이 작동하는 방식이야. 그리고 또 이 이분법 이라는 측면에서, 우리가 나누어졌다는 것은 틀린 거고, 우리가 합쳐졌다는 것이 맞는 건 아닐까 생각하게 돼. 우리 책이 사람들을 생각하도록 하면 좋겠어. 아, 이건 이렇고, 이게 유럽사람들이 분단이라는 개념으로 다시 우리를 식민화 할려고 하는 거고. 왜 우리가 그런 것들을 비교하냐면.

Y 그게 너희 작업의, 말하자면, 메시지 같은 거구나.

N 아니, 그 중 하나인 거지.

Y 그게 나한테는 가장 매력적이고 흥미로운 부분인 것 같아. 나는 너희가 어떤 맥락에서 작품을 디자인했는지 이해할 것 같아. 많은 문제들이 있잖아. 외국인이고 이주 여성이고, 한국, 세르비아, 크로아티아 사람이니까. 우리는 이런 문제에 정말 익숙하지. 정치적 의미에서 뿐만 아니라 이런 흑백논리가 분명하니까, 전달하려고 하는 것을 좀 좁히면 어떨까… 항상 너네가 이쪽인지 저쪽인지를 표현해야 할 때가 있잖아. *(E와 N 함께: 음…!)* 그 사이에는 정말 아무 것도 없지. 거기에 대해 할 말 많아. 녹색당이나 노동당 같은 리버럴한 곳에서도 내가 다른 의견이 있다고 해도 주요 의제를 항상 갖고 가야 하잖아. 그래서 어떻게

표현할 수가 없어, 그건 정말 공격이거든. 그래서 나는 사람들 앞에서 내 진짜 의견을 표현할 때 아주 신중한 편이야. 너희 작업은 이런 게 될 수 있겠다. '세 명의 아티스트가 베를린에서 우연히 만났다. 그들은 일종의 공통점을 찾았다, 공통의 문제, 공통의 시각을. 이들은 개인의 이야기를 책에 담아 이 벽을 부수려 한다. 그리고 설치의 목적은 우리의 관계와 우리의 정치 안에 존재하는 벽을 부수기 위해서이다.'

N 여기서 벽이 무너졌을 때를 이야기하는 것도 가치가 있을 거야. 이 벽은 자본주의에서 온 파시즘으로부터 사람들을 보호했잖아. 이 파시즘의 벽이 무너지면서 모든 곳으로 퍼져나갔지. 동독 사람들은 일곱 가지 색깔의 M&M 초콜릿을 가지지 못했다고 절망했어. 유고슬라비아에는 90년대 초에 밀카 초콜릿이 들어 와서, 나도 그게 있다는 걸 알았어. 근데 그 밀카에 대해서 우리가 지불한 가격은 얼마였을까?

전에 유럽문화재단이 이런 질문을 했어, '왜 갑자기 우파 정치가 커졌을까요?' 그 사람들 아주 중요한 걸 잊어버린 거 같은데, 두 '전체주의'를 동일시 한 것. 그들은 공산주의가 파시즘과 같은 거라고 얘기하는데, 그것 때문에 거리나 의회에 우파들이 생겨난 거라고. 그게 공공 장소를 포퓰리즘 으로 가득 찬 데모나 하게 만든 거지.

(…)

아이의 목소리가 뒤의 방에서 들려온다. 80년대 독일 밴드의 "마지막 카운트다운(It's a final countdown)노래가 흘러 나온다. 모두 웃음을 터뜨린다.

N 여기서부터 시작하고 싶었어. 베를린 장벽. 베를린 장벽이 무너진 걸 기념하는 행사가 11월에 있어. 그리고 한국 문화원에서 베를린 장벽 붕괴와 DMZ붕괴에 대한 이야기를 하는 행사를 하는 걸로 알고 있어.

U는 Er에게 DMZ가 무엇이고 어디에 있는지 설명한다.

N 우리는 DMZ를 가고 싶었어. 아마 문화원에서는 우리가 거기 가려는 돈을 주진 않을 같아서. '좀 얌전한 아이디어를 만들어 보자. 근데 이 안에서 말이야.' 라고 얘기 나눴고, 그렇게 처음에

	라디오 드라마로 변신한 거지. 그래서 P를 인터뷰 하고 싶었어. 이렇게 아이디어를 얻게 되었지.
E	*(U에게, 한국어로 설명한다.)* P가 누군지 알아?
N	우리는 P가 이야기를 풀어 놓을 수 있는 공간을 제공할 수 있다고 생각했는데, 그 때…*(웃는다)*…우리가 P에게 갔을 때, 마음을 바꾼 것 같았어. 어떤 식으로든.
U E	P가 마음을 바꾼 거야?
E	응, 응.
N	음…내가 너무 직접이었던 것일 수도 있고…영어가 문제였을 수도 있고. E가 오기 전에 내가 먼저 도착했는데, 아이랑 같이 갔었거든. *(웃음)* 근데 P가 굉장히 혼란스러워 보이더라고. 나는 왜 왔는지를 얘기했고, 그 때 알았지…P는 나를 그냥 손님으로 생각했구나. 그래서 커피를 주었어. *(E가 무언가를 한국어로 말하고, U는 웃는다.)* 그러고 나서 점점 내가 누군지 알게 된 거야. 왜냐하면 나에 대해서 E와 얘기했던 것들이 생각난 것 같았거든. 그렇게 천천히 다가 갔는데. 우리의 이야기는 대부분 P의 아이들 이야기에 집중되었어. 왜냐하면, 그게 더 쉬웠으니까. 나는 아마도 내가 대화를 하는 데에 좋은 해법은 아닐 수 있겠다는 생각을 했었던 것 같아.

근데 P에게 가서 이야기를 나누었던 건 사실 인터뷰는 아니었어. E가 P에게 이 예술 프로젝트를 통해 자기 이야기를 들려줄 기회를 가지면 어떻냐고 했을 때, P는 두 가지 흥미로운 이야기를 했어. '나는 내 이야기가 예술에 사용되기를 원하지 않는다. 그리고 C가 얼마나 마음에 들지 않는지를 얘기 했지.' *(E에게)*혹시 내가 잘못 해석하고 있다면 고쳐줘…(E: 응.) C가 북한 사람들을 대하는 방식이 마음에 들지 않는다고 했어. (모두:흠…) 그리고 나한테 그건…레드 카드 같은 거였어! 뭐가 잘못됐구나…그게 나한테는 어떤 계기였는데. 우리의 작업도 이것에 관한 거야.

벽이 붕괴되는 상황이 같은지를 도덕화 하고 이론화하는 게 아니라, 설사 우리가 그걸 반영할지라도. 21세기에 통일이라는 주제를 다룰 때, 무엇이 문제인지를 이야기 해야한다고 생각했어. 우리의 문제는 우리가 모르는 사람과는 얘기할 수 없었다는 거야. 그래서 사실, 이런 문제를 더 잘 이야기 하기 위해서, 우정을 사용했어. 우리에겐 친구들만 있으니까.

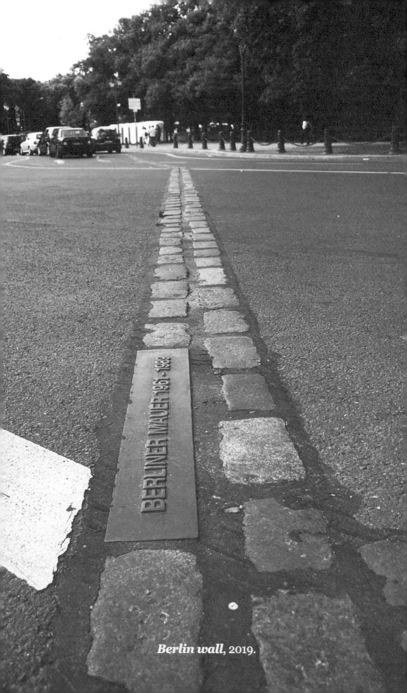

Berlin wall, 2019.

5장.
오 안돼, 이제
동독사람들이 올거고,
무언가를 원하게 될거야.

모두 웃는다.

M 괜찮아…남북한에 관해서 내가 아는 건 그저 관광객 입장에서야.
그리고 뉴스를 통해서 아는 것 뿐이지. 거기엔 이상한 양극성이
있어. 정치적 군사적 측면에서 말이야. 동독 시절에 여기도
그랬는데, 그렇게 심하지는 않았어. 왜냐하면 동독이 서독하고
너무 가까웠거든, 그래서 부정적인 면들은 보여주지 않아도
됐었지. 베를린은 특히 그런 면에서, 부드러운 공산주의였다고
할 수 있어. 근데 한국의 현실에 대해서 모르는 내가 무슨 말을
할 수 있을까? 넌 상상할 수 있어? 북쪽은 배고파 하고 있고,
음식 부족에 시달리고, 남쪽은 넘치지. 그럼 경제적인 관점에서,
평등을 이루려면 엄청 많은 돈이 들어 갈 거야. 더 많은 돈을
벌거고, 더 좋은 사업이 이루어지겠지. 똑같은 일이 독일에서
일어났으니까. 서독은 동독에서 아주 잘 팔릴 수 있다는 걸
깨달았어. 안 그러면, 모든 것들이 그렇게 쉽게 팔리지는 않았겠지.
많은 사람들이 부자가 되었어. 다른 한쪽에서는 그 사람들을
동등한 레벨로 끌어올리기 위해서 많은 돈이 들었어. 사람들은
세상의 일원이 되기 위해서 무엇을 해야했을까. 경제적으로
빈약했던 사람들은 눈을 크게 뜨고 바라보았지. 부유했던 사람
들이 부정적인 측면들을 그렇게 잘 돌보지 않았다는 사실이
드러났어. 문제는 지금 시간이 너무 많이 지다는 거지. 동독
은 여전히 행복하지 않아. 내가 오페라에서 일하고 있을 때,
장벽이 무너졌었어. 나는 그렇게 말했지. '오케이, 집으로
가야겠다.' 며칠 지나고 나서, 서독으로 여행하는 것이 자연
스러워졌어. 우리는 서독에 친구들이 있었는데, 드디어 그
친구들을 방문할 때가 온거야. 우리가 가는 걸 친구들이 받아

줄 거라고 생각했고, 우리는 그걸 그냥 둘 수 없었지. 그래서 트라반트 *(역주: 동독 자동차)* 에 탔어. 애 셋이랑, 와이프랑, 동생이랑. 정말 빡빡했고, 그렇게 타는 거 불법이었는데. 괜찮았어. 도시가 거의 축제 분위기 였으니까. 그래서 차를 타고 포츠다머 광장으로 갔지. 교통 법규를 안 지켜도 돼서 좋더라고. 우리는 동서남북 방향을 기준 삼아 대충 찾아갔어. 그 때는 네비게이션이 없었으니까. 나는 거리 표지판들을 보면서 그냥 운전을 했어. 동독에는 그런 표지판들이 없었거든. 주소를 몇 번이나 놓쳤는데, 그러다가 막 인도도 올라가고 그랬어. 아마 사람들이 그렇게 생각했겠지. "저 동독에서 온 멍청이는 자기가 뭘 찾고 있는지도 모르네."

또 꼭 말하고 싶은 건. 동독 사람들이 갑자기 돈을 받게 된 거. 안 그러면 엄청난 긴장이 있었겠지. 이쪽엔 아무 것도 없는데, 저쪽에는 많은 것들이 제공 되고 있고, 이쪽에서는 부족해서 없는 좋은 걸 팔고 있으니까. 그래서 정치인들은, "좋아, 그럼 사람들에게 처음엔 돈이 있어야겠군." 하고 생각한 거야. 소위 환영자금 같은 거였어. 한 사람당 100마르크 씩. 애들은 얼마 받았는지 정확히 기억은 안 나는데, 애들도 받았어! 근데 난 그렇게 좋진 않았어. 지금 생각해보면, 그 때 동독사람들이 바로 뭘 사러 가지 않았으면 좋았겠구나 싶어. 왜냐하면 분명히 그건 미래가 아니었거든. 그 100마르크는.

A 그거 좀 굴욕적이다.

M 응, 사실 그래. 근데 그 때는, 그게 스무스하게 잘 이루어졌어. 물 흐르는 것처럼. 그걸 보면, 경계가 무너지는 광경, 다른 시스템, 나누어진 나라, 다른 풍경 안에서 생기는 모든 격동을 무시하고, 그냥 사람을 볼 수 있어. 순수한 사람을 말야.

A 아무 것도 묻지 않는 사람…

M 응, 근데 또 한 인간이 어떻게 정치에 참여하는가 하는 질문이 생겨. 참여하지 않으면 불편하면 안 되잖아. 우리 가족은 교회에 다녔는데, 교회는 교회가 속한 국가에 대한 책임을 갖거든. 우리에게는 평화가 있었어. 근데, 어떤 직업들은 당원이 되지 않으면 못하는 것들이 있었지. 예술의 입장에서 회색빛 현실과 지루한 정치는 이점이 많이 있었어. 정치는 지루했고, 경제도 지루했지. 그래서 그 당시에 우리는 유고슬라비아의 상황이 더 발전 되어 있다는 인상을 갖고 있었어. 근데 다른 동유럽에 비해서 굉장히 서구화 되었다는 이야기도 들었어. 우리는 외국 여행 허가를 얻기가 힘들었어. 우리는 정말 동쪽에 있었지.

회색 빛깔 집에, 회색 빛 가게에. 모든 것이 지루했어. 그런데
그게 예술에는 기회가 된 거야. 만약에 뭘 만들면, 더 눈에 띄게
되거든. 지금은 뭘 만들어도, 도시에 그런 것들이 차고 넘치기
때문에, 사람들이 뭘 해야겠다는 동기부여를 받기가 힘들잖아.
고요했어. 아주 단순한 침묵을 찾으려고 하는 어린아이처럼…

E 통일이 되고 나서 너희 오케스트라에는 동서독 사람들이 다
오게 되었어?

M 응, 공개 공모를 통해서. 근데 장벽이 무너지기 전에도 우리
에게는 특별한 역할이 있었어. 전쟁이 끝나고 다 폐허가 되었고,
장벽이 세워졌지. 근데 예술감독이 서독에 살고 있는 동료들을
지켜낼 수 있었어. 그래서 서독 동료들도 같이 일을 했어, 그래도
살기는 서독에 살았지

A 그럼 월급은 어떻게 받았어?

M 일부는 서독 측에서 받고, 일부는 동독 측에서 받았어. 그 동료들은
악보를 싸게 살 수 있었지. 동쪽에 좋은 출판사가 있었거든.
대신 동료들은 우리한테 서독 물건들을 갖다줄 수 있었고.

A 아, 서쪽의 초콜릿.

E 근데, 관객은 동독 사람만 있었던 거지?

M 아니, 아니, 왜냐하면 서베를린 사람들도 동쪽에 올 수 있었거든.

A 아 서베를린 사람은 동베를린으로 여행할 수 있었는데,
그 반대가 안 됐던 거구나.

M 한국 처럼 완전히 나누어지지는 않았거든.

U 멋지다. 동독에서 온 악보, 서독에서 온 초콜릿

모두 웃는다.

A 오페라는 어땠어? 통일 전과 후에 오페라가 어땠는지 기억나?
너 거기서 얼마나 일한거지?

M 1983년부터. 학생 때부터 일한 걸로 치면, 거의 70년대 말부터.
근데 그 질문 답하기 어렵다. 그래도 동독이 좋았고, 서독은
암울했다고 말하긴 싫어. 한번은 내 동료가 나를 비판한 적이
있는데, 내가 우리 공연에 대해서 아주 멋졌다고 얘기하지
않았다고 말이야. 신입 동료 였고, 공연에 대해 신나했지. 우린
중립적인 편이야. 실수를 보여주지 않지. 마치, '우리가 약한
걸 보여주지마.' 하는 것 처럼. 문제 없어. 그게 서쪽 시스템이야.
근데 동료에 대해서 물어봤잖아. 모두 아파, 정신적 문제가
있어. 일종의 요양소 같은 곳이지. 밖에서 보기에는 그냥

오케스트라야. 우리는 아름다운 음악을 만들지. 하지만 안에서 일어나는 일은 끔찍해. 우리 모두에겐 자기의 시대가 있어. 결국 모두가 같은 문제를 겪고 있다는 걸 알면 좋은 것 같아. 이제 국가의 분단에 대해서 생각해 볼 순간이야. 무슨 말이냐고? 독일을 생각해본다면, 많은 것이 변했어. 나는 서베를린에 대해서도 생각하고 있는데, 서베를린은 미국의 지원을 받았지. 그래서 특별한 지위를 가졌던 거야. 그리고, 꼭 꿈처럼 보이고 싶어 했지. '자본주의가 답이다!' 하고 말이야. 갑자기 적이 사라졌고, 모든 것이 퍼져나갔지. 모두들 좌절했어. 서독에 있던 사람들도.

오케스트라 같은 작은 우주에서는 무슨 일이 일어나는지를 볼 수 있지. 거기에도 경계가 있어. 인공적인 경계, 관악기랄지, 금관 악기랄지 하는 악기 그룹의 경계 말이야. 오케스트라와 합창단 사이의 경계는 아주 분명하지는 않지만, 그것도 나누어진 것이라고 할 수 있지. 젊은 사람들과 늙은 사람들 사이에도 무언의 경계가 있지.

오케스트라의 지원 과정에 대해서 얘기해 줄게. 젊은 사람들이 와서 자기의 연주 테크닉을 보여줄 때, 엄청 스트레스를 받아. 자리에 비해 지원자가 많으면 문제가 되잖아. 이건 몇 시간해도 모자랄 이야기인데, 인터뷰니까 짧게 할게. 나는 요즘 수습기간인 동료하고 함께 하고 있는데, 그 수습 연주자의 미래를 결정할 방에 내가 들어가서 말했어. 이런 수습 기간은 좋지 않은 것 같다고 근데 아무도 수습 기간이라는 것을 없애려고 하지 않더라.

E 니가 처음 일했을 때는 어땠는데?
M 나는 그런 거 없었어. 동독에는 수습기간이라는 건 없었어.
E 그럼 사람을 어떻게 뽑아?
M 이런 식인데, 3단계의 과정을 거치고 그걸 통과하면, 그냥 영구 계약을 맺는 거야.

A는 자기의 귀를 의심한다!

A … 바로 종신 계약을 맺는다고!?
M 응, 이런 건데. 사람들은 서로를 통해서 배우고, 서로를 통해서 발전한다는 거지.
A 좋은 사회주의가 너의 마음에서 들려오고 있네.
M 정치적인 방식으로 말한 건 아니고, 아니 정치적이지. 이건 돈에 관한 거니까. 이런 의미에서 돈은 신이 아니야. 정치인

들은 자기 주머니에서 돈을 주는 것처럼 행동하지만, 사실
그렇지 않잖아.

A 그래… 그건 권력의 포지션이지….

M 그래서 처음엔 자신을 하찮게 만들어야만 하지...

E 그렇지, 그렇지.

M 처음에는 좀 작아져야만 해…가난한 나라에서 강했던 사람들이
있었어. 그 사람들은 부족했기 때문에 힘을 가질 수 있었어.
그래서 서쪽에서 온 사람들에게 난 묻곤 했지. '어떻게 그런
럭셔리한 음악을 만들 수 있지?' 물론, 더 좋은 바이올린을 살
돈이 있었긴 해. 근데. 우리가 서독의 작은 마을로 여행을 갔을
때, 난 조금 이상하다 생각했어. 도로도 잘 포장 되어 있었고,
지구가 둥글다는 사실도 알게 됐지. 완벽히 잘 만들어진 도시
였어. 그리고 호텔에 가는 길에 퇴근하는 한 여자를 봤어. 근데
좀 불쌍해보였어. 레고랜드 같다는 생각이 들었거든. 모든 것이
잘 되어 있었어. 그럼 난 거기서 뭘 할 수 있을까? 하고 생각
했지. 장벽이 무너지고, 환영자금을 받았을 때, 동독 남자들은
다 차를 갖고 싶어 했어. 그러면서 어떤 쪽은 더 우월해지고,
다른 쪽은 약해지는 거지. 그래서 질문이 생겼어. 아직도
만족스럽지 않아? 내적인 부분에 있어서는 여전히 만족스럽지가
않아. 당시에 좀 나이 많은 친척이 한 분 있었는데, 그 분이
항상 얘기 했었어. '이 환영자금은 정말 잘못된 결정이었어.'
보이는 삶은 잘 적응이 되어갔어. 돈 쓰는 것을 잘 따라했거든.
아직도 기억나는 게, 서베를린에 있는 친구들 집에 갔을 때,
그 친구들은 선생님이었는데. 그런 생각을 하고 있는 거야.
'오 안돼, 이제 동독사람들이 올거고, 무언가를 원하게 될 거야.'
근데 마지막에는 그 친구들도 혼란스러워했었어. 왜냐하면
우리가 아무 것도 요구하지 않았고, 대신에 그 친구들이 우리
집에 더 자주 놀러 오게 되었거든. 그리고 명확해진 거지.
자기들이 좀 나쁜 생각을 가지고 있었구나 하고 말이야. 서쪽
친구들은 이제 동독사람들이랑 해야할 게 뭔지를 알게 된거야.
나도 좀 순진했던 거 같아. 내 친구들은 우리가 서쪽 사람들
처럼 행동하지 않을 때, 물었었지. '너 지금 돈 잘 버는데 왜
새 세탁기 안 사?'

E 통일 되기 전이랑 후랑 월급 받는 시스템이 어떻게 달랐던 거야?

M 일단 화폐 가치가 좀 바뀌었어. 우리는 동독 화폐를 포기했는데,
'1서독 마르크 = 2동독 마르크' 가 됐지. 그래서…지금 더 잘은
생각이 안나. 아무튼 이렇게 바뀐 시스템 때문에 그냥 서독

마르크(DM)가 되었지. 동독 마르크는 사라졌어. 그렇게 되서 서독 쪽 통화로 월급을 받게 되고, 그래서 처음에는 더 낮았고, 점점 '맞춰졌지.'

A 그럼 서독하고 비교해봤을 때, 너는 덜 받았던 거야?

M 응, 근데 지금은 똑같이 받아. 차이가 그렇게 크지는 않지만.

E 한국에 대해서 더 물어봐도 될까? 넌 처음에 어떻게 한국에 대해서 관심을 갖게 됐어? 처음에 한국을 어떻게 경험하게 됐어?

M 사람들을 통해서. 통일 후에 생긴 일인데, 오케스트라에서 처음 한국 음악가를 만났어. 한국에서 지원하는 사람들이 있었고, 그렇게 만났어. 언어가 흥미롭다고 생각했고, 그래서 배우기 시작했지…조금. 그러고 5년 있다가, 처음으로 한국을 여행 했는데, 말을 하나도 못 알아 들을까봐 걱정했어. 그 때는 내 친구가 옆에 있어서 다행이었지만.

E 어디서 한국어를 배웠어? 주민문화센터(Volkshochschule)?

M 응, 처음엔. 그리고 나서 한국에서 배웠어. 그 때 청소년 오케스트라에서 일하던 친구가 있었거든. 그 친구가 나한테 와서 학생들을 위해 레슨을 해줄 수 있는지 물어봤어. 재밌을 거 같아서 하겠다고 했고. 난 처음에 그게 개인 교습 같은 거라고 생각했는데, 그래서 내가 한국어를 잘 못해도 할 수 있지 않을까 했거든. 근데 그 남한에 어디였더라. 왜 그 도시 이름이 생각 안 나지?

U 진주!

M 맞아! 진주. 거길 갔어. 그 작은 도시에 버스를 타고 도착했는데, 여자 직원이 한 명 있었어. 그 때까지 개인 교습하는 거라고 생각하고 있었지. 그리고 그 여자 직원이 우리를 엄청난 한국 식사에 초대를 했고, 약간 내가 중요한 교수라도 되는 것처럼 말이야. 거기서 그 주의 프로그램을 받았는데, 20명의 아이들과 또 다른 한 그룹의 20명의 아이들이 있었어. 그 애들을 나 혼자 이끌고 리허설을 해야한다고 생각했어. 공포였지.

모두 웃는다.

나중에 내 친구도 왔고, 같이 했어. 아이들이 너무 괜찮았어. 나는 교수도 지휘자도 아니었지만 말이야. 그렇게 한국에 세 번을 더 갔고, 그 다음에 친구 만나러 한번 갔어. 마지막에 갔을 때 DMZ에 갔는데, 그 전에는 난 그렇게 관심이 없었거든. 독일이 분단 되어 있을 때, 그 경계가 어떻게 생겼는지 나는

알잖아. 근데 한국의 경계는 더 심하더라고. 지금은 거길 관광객으로 가고싶은 마음은 전혀 없어. 근데 나랑 언어 교환 하는 친구는 나한테 거길 보여주고 싶어하더라. 거기서 땅굴도 봤는데 흥미로웠어. 연극같은 느낌이 들었어. 한쪽은 농담도 절대 하면 안 될 것 같은 엄격한 분위기 였고, 다른 한쪽에서는 사람들이 막 사진을 찍고. 뭔가 비논리적인거야. 땅굴에 들어 가니까 그 땅굴을 팠을 사람들에 대한 동정심도 생기고. 나 처럼 동독에 살았던 사람의 관점에서 봤을 때, 북한에서의 생활은 아마 더 힘들거라는 생각이 들더라고. 굶주림 같은 것을 겪고 있다면, 더 이해하기 쉽지 않을 거. 그럼 그냥 같은 생활인데, 다른 백그라운드가 있는 일 같은 건 아닌 거잖아.

A 5~6개의 물건만 선택할 수 있는 곳이라면…

M 살아 남느냐, 그렇지 못하느냐의 선택만 있을 때…같은 일이 유고슬라비아 전쟁에서도 일어났잖아. 내가 진짜 경험한 일은 아니니까 얘기를 할 수는 없겠지만. 그 때 너는 몇 살이었어?

A 열 두살. 기억이 나. 나는 전쟁이 일어났던 도시에서 살았거든.

M 어느 도시지?

A 오시예크(Osijek). 시내에서 20km 정도 떨어진 곳에 부코바르 (Vukovar)란 곳이 있는데, 전쟁에서 완전히 폐허가 돼 버렸지.

M 이건 이제 다른 이야기다.

A …그 경험…을 말하는 건 쉽지 않아…그런 경험을 했건 하지 않았건…강제수용소에서 살아 돌아온 사람이 이야기 하는 거랑 비슷한 거 같아.

M 그 사람들은 잘 얘기 안하잖아. 왜냐하면 같은 경험을 한 사람을 찾기가 힘드니까.

A 흥미로운 건 두 독일의 완전한 통일이 복잡한 모든 상황을 반영하지는 못했다는 거지. 특히 동독의 입장에서는. 동독이 서독에 식민화 된 느낌이랄까.

M 맞아, 그렇게 얘기할 수도 있을 거 같아. 근데 그 일은 기꺼이 일어났지, 동독이 '날 식민화 해!'라고 소리 쳤던 것처럼. 나는 일반적으로 말하는 게 어려워. 독일인과 한국인은 실제 존재 하는 게 아니잖아. 그냥 사람이 존재하지, 개인 한 사람 한 사람이. 오케스트라도 마찬가지인데, 권력을 위한 욕망이 있는 다섯 사람만 있어도, 그 사람들이 모든 걸 망쳐버려. 동독 사람 중에서 완전 자본주의자가 되어버린 사람들이 있잖아. 근데 그 사람들은 늘 그래왔던 거야. 오케스트라에 되게 올곧은 동료 한 명이 있는데, 그 친구는 동독의 소울을 가진 서독 친구야. 서독에서는

아이들이 '돈이 존재 한다'는 백그라운드를 갖고 자라났잖아. 동독에서는 그렇지 않아. 돈은 그냥 의미만 존재할 뿐이고, 그것 자체에는 가치가 없거든. 내가 그 때 당시 매달 1000 동독 마르크를 벌었는데, 충분했어. 음식도 싸고, 집세도 쌌으니까. 근데 바지가 너무 낡아서 새 바지를 사야 한다 하면, 미리 계획을 했었어야 했지. 돈에 그렇게 편하진 않았어. 개인적으로 뭔 갈 해서 돈을 더 벌 수는 없었으니까.

A 개인 소유권 같은 건 있었어?

M 집 한 채는 소유할 수는 있었는데, 그게 다야.

A 지금이랑은 다르네, 요새는 한 사람이 열 채, 스무 채도 갖고 있잖아…

M 다르지, 그것이 정치나 국가와 연결되어 있지 않으면, 사람들이 소득이 더 있었겠지. 근데 일반화 하기는 힘든 거 같아. 그런 면에서 어떤 국가들의 통일은 나한테 너무 추상적이야. 분단을 없앨 수는 있지만, 결론적으로 질적인 측면에서 일어난 것들이 그 통일의 과정에서 관련된 사안마다, 사람마다 너무 다르니까. 작은 그룹 별로 생각해 볼 수는 있겠나. 뭔가 더 나아졌나 그렇지 못한가. 근데, 벌써 정당문제부터, 어려워지잖아. 나는 정당의 당원에 쉽게 가입하거나 하는 사람은 아니거든, 교회 공동체도 그렇고. 그렇다고 내가 무신론자는 아니지만, 어쨌든 그런 그룹에서는 편하지가 못한 것 같아. 어떤 면에서는 사람들이 이런 개인적인 행동을 안하는 게 감사하기도 해. 나 한국에선 그런 걸 느꼈는데, 사람들이 크게 항의하는 것 없이 그냥 간단히 자기 할 일을 하는 거야. 다수에 개인을 동일시 한다고 할까. 그 청소년 오케스트라랑 기차를 탔는데. 애들이 되게 참을성 있게 앉아 있더라고…여기서는 상상하기 힘들지. 내가 앉아서 쭉 봤는데, 한 애는 가만히 앉아서 자기 차례를 기다리더라고, 지루해보이지도 않고 말이야. 만약 독일 사람이었다면 엄청 짜증냈을 거야. 그런 감정인거지. '나, 나, 오직 나.'…난 이런 게 없을 때가 좋아.

E *(U에게)* 너는 정당활동이 어때? 어떻게 동기부여를 받는지 궁금하네.

U 내가 뭘 꼭 하고 싶어서 하는 건 아니고…

M 너는 너 자신을 그렇게 많이 강조하진 않잖아…

U 나는 누군가가 필요하지…

M 너는 사회로 뛰어들 누군가가 필요하지. 기쁜 측면이 있는 거 같아. 집에 앉아서 "내가 했고", "내가 만들었고", 그런 걸

생각하면서, "근데 아무도 나를 이해하지 못하고", "제대로 들어주는 사람이 없고." 이러고 있으면 너무 외롭고 쓸쓸하잖아.

U 가치있는 일을 현실로 실현시키는 감각을 가진 사람을 좋아해.

M 넌 사람에 대해 관심이 많구나. U가 녹색당에 관심이 많다고 들었어. 그래서 당원이고 아주 열심히 한다고. 민주주의 선거 과정 안에서, 왜 무효표를 던지는 사람들이 있을까에 대해서 관심 있다고 했지. '예, 아니오'로 얘기할 수 있는 사안이 아니기 때문에? 그냥 게을러서 인가? 아니면 무관심인가?

A 투표를 해야한다고 느낄까? 아니면 투표를 통해서 뭔가 바꿀 수 없다고 느끼는 걸까…?

M 점점 정치정당에 관해서는 어려워지는 것 같아. 내가 사는 브란덴부르크 주에 이번에 선거가 있었는데. 포스터에서 이상한 얼굴들을 봤어. 엄청 나이스 해보이는 얼굴의 FDP당 후보랄지, 근데 난 거기 투표할 수 없었지. 난 좌파당에 투표 했어. 좌파당이 큰 기회를 가진 것처럼 보이진 않지만, 난 정치는 정의와 평등을 위해 존재한다고 생각하거든.

A 좌파들이 자신들의 가치를 강화하기 위한 힘을 충분히 갖고 있지 못한 것 좀 이상한 거 같아.

M 자본주의 시스템에 대항하는 건 그래도 잘 하고 있지.

A 사람들이 아직 안전하다고 생각하나 봐.

M 난…대다수의 사람들이 자기의 편안한 상태를 위협당하는 걸 두려워하는 것 같아. 변화를 방해하는 건 이기주의라고 생각해. 동독 사람들이 자기들의 공동체성을 그리워한다고 말할 때, 이웃들에게 더 열려 있었던 거 말이야. 그런 노스텔지어가 영향을 미치지. 만약에 내가 친구 집 고치는 걸 좀 도와준다고 할 때, 그 친구가 나한테 돈을 주거나 아니면 내 집 수리를 똑같이 도와주거나 하는 게 좀 이상하다고 생각했어. 아니면 친구 집에 가기 전에 전화하는 것도. 동독에서는 완전히 달랐거든.

A 나도 유고슬라비아에서 비슷한 걸 경험했는데.

M 거기선 어땠어? 세르비아가 크로아티아보다 경제적으로 좀 더 힘이 세지 않았나?

A 아니, 유고슬라비아로서는 한 경제체제였지. 근데, 크로아티아가 좀 더 유리한 입장이었어. 관광업이랑 아드리아해 덕분에. 또 크로아티아는 몇 세기동안 합스부르크 왕가의 일원이기도 했고. 그에 비해서 세르비아의 대부분은 5세기 동안 오스만 제국의 일부였고, 그래서 불평등을 내포한 경제적, 문화적, 종교적 차이가 있었던 거야.

M	누군가가 경제적으로 더 셌나?
A	응, 슬로베니아랑 크로아티아가 셌지. 두 나라는 주요 가톨릭 국이기도 했고. 그래서 구 합스부르크 왕가의 나라들이 한 쪽에, 그리고 다른 한 쪽은 구 오스만 제국의 나라였던 거야. 또 가톨릭과 그리스 정교의 충돌도 있었고. 이런 것들이 긴장의 주요한 요인이었지.
M	그런 것들이 선입견을 많이 가져다 줬을 거 같아.
A	당연하지. 게다가, 수도가 베오그라드였는데, 슬로베니아 사람들과 크로아티아 사람들은 만족할 수 없었어. 그 사람들이 만든 게 다 베오그라드로 가니까. 거기에 문제와 갈등이 더 해진거야. 결국 문제들의 팔림프세스트 *(역주: 사본에 기록되어 있던 원 문자 등을 갈아내거나 씻어 지운 후에, 다른 내용을 그 위에 덮어 기록한 양피지 사본)*가 된거지. 동유럽에서 사회주의가 무너지고 반대 되는 것들이 균형을 잃어 버린거야.
M	그래, 같이 붙잡아야 할 무언가를 잃어버렸겠지. 무언가 뒤얽힌 형태가 되었고, 모든 것이 무너졌지.
A	그리고 유고슬라비아에서는 종교적 차이 뿐만 아니라, 세계 2차 대전의 나쁜 기억에서 생겨났던 민족 정체성에 대한 의문들이 있었던 것 같아. 그래서 50년은 이런 복잡한 문제들을 풀기에 충분한 시간이 아니었던 거지. 형제애와 통일이라는 이데올로기적 언어가 티토(Tito) 생전에는 먹혔는데, 티토가 죽고 나서는 모든 것이 사라졌어.
E	너는 너의 정체성이 뭐라고 생각해? 한번도 안 물어 봤네…
A	나는 항상 내가 유고슬라비아 사람이라고 말해. 그렇게 말하는 게 좀 급진적인 표현이긴 하지만. 특히 유고슬라비아가 더 이상 존재하지 않는 지금의 맥락에서는 말이야. 그래서 그렇게 말하면, 새로 형성된 민족 이데올로기에 명확하게 반대하고, 분할에 대해서도 명확히 반대하는 입장인거지.
M	그걸 반대하는 것에 대해 넌 뭘 할 수 있어?
A	아무 것도 할 수 없지.
M	오케스트라라는 소우주에서 보면, 자기 주장을 가질 수 있어. 근데 변화가 필요할 때, 모든 사람이 거기에 동의를 하지. 그런데 이렇게 말하는 사람도 있잖아. *'좋긴 하지. 그런데…'* 법을 통해서 만들어지고 체계화되어야 할 국가들 간의 관계를 살펴보면 문제는 더욱 명확해져. 민주주의는 좋아, 그런데 가끔 나쁜 결과를 가지고 오기도 하지. 아내는 가끔 나한테 '당신의 그 미친 그룹 밖에 나와서 보고 결정해요.'라고 말을 해. 합리적

인 결정을 할 수 있는 이성적인 사람이 있어야 해. 지휘자가 있으면 어떤 걸 멈추게 할 수 있어서 일이 진행되게는 할 수 있지. 나쁜 민주주의에 맞서 사용할 수 있는 브레이크 같은 것이 필요해. 하지만 그 브레이크가 잘못 사용되지 않도록 누가 보증할 수 있을까? 문제가 많은 국가에 어떻게 적용할 수 있을까? 그런 점에서 질문이 생겨. 너희는 왜 통일을 원해?

A 그런 점에서 내가 가진 질문어, 누군가 '나는 독일인이다.' 또는 '크로아티아인이다.' 라고 말할 때, 그건 어떤 의미일까…?

M 맞아, 그건…

A 우리가 할 수 있는 것은 우리 안의 역동성을 발견하고, 그게 어떤 기능을 하고, 못하는 건 뭔지를 보는 것이라고 네가 말했잖아. 그건 좋은 포인트인 거 같아…

A 오케스트라에 몇 명이나 있어?

M 백 명정도.

E 백 명?!

M 응, 20여 개의 다른 나라에서 온 사람들이지.

A … 가끔 긴장해야겠다?

M 응, 근데 그럴 이유는 없어. 사람들은 교육수준도 높고, 민주주의 원칙에 대해서도 알고 있지, 그래서 질서가 있을 것이라는 환상이 있어. 하지만 거기 사람들은 어떤지 알아? 예를 들어, 오케스트라 입단 지원자의 연주를 듣고 온 동료가 나한테 이렇게 말하더라고. '이번엔 한국인 지원자가 없네?' 그리고 어떨 때는…정말 꿈같이 아름답게 첼로 연주를 했던 한국인 첼리스트가 있었는데. 그 사람을 보고 내 동료가 이렇게 말을 했지. '우리 이러다가 오케스트라에 죄다 한국사람만 남겠다, 그럼 넌 우리한테 넌 한국어 통역해줘야해.' 그게 뭔 말이야? 정말…그런 걸 유머라고 하는 걸까…?! 그냥 나쁜 사람이야, 그 사람들은 이미 오케스트라에 '다른 사람' 들이 너무 많다고 생각하는 거지.

A 오케스트라에 백인이 더 많아야한다…이렇게 생각하는 건가?

M 그 보다도, 그 사람들은 이렇게 생각해야지? 왜 그럴까? 왜 저 친구들이 우리보다 더 연주를 잘할까? 그렇다면, 거기 가서 더 나은 음악가에게 배우고 와야지. 그 단계를 진행해야지. '그들이 오는 것을 막아야해.' 라고 말하는 것보다 그렇게 하는 게 올바른 행동인거지. 그 사람들을 못 오게 한다는 건 그건 존재하지 않는 것에 대한 두려움을 표현하는 거거든. 정말 슬픈 일이지. 정신이 상실되었어. 어쩌면 희망을 잃어서는 안

되지만, 근데…'다음 세대는 더 낫겠지. 세대의 문제이기도 하니까. 나는 40대를 지나왔고, 40대 중반이 가장 불안한 시기인 것 같아. 나에게는 가장 힘든 시기 였지. 그 때는 바보 같은 자의식이 있어서. '우리는 우리다. 나는 이런 직업을 갖고 있다. 이제 40대 중반, 내 시간이다.' 그래서 이렇게 말을 하지. '이제 권력의 위치에 있는 내 차례이다! 이전의 나는 너무 어렸고, 곧 난 너무 늙을거니까. 지금이 파워를 가질 시간이다.' 하지만, 젊은 세대가 훨씬 더 즐겁잖아.

Mr. Park's problem No.2, x-ray photo, 2018.

6장.
그 사람들 완전
평범한 사람이더라고.

1.

E 이 작품 알아?
A 아, 응, 응, 응… 새로운 거지…응.
E 응, 근데 난 이게 별 의미가 없는 것 같아. 다른 오브제랑
 있으면 의미가 생기기는 하지…어떤 의미냐면...
N 무슨 말인지 알겠다.
E …감정. 그러니까 난 좀 더 감각적인 방법을 쓰고 싶어…
 아니면 감정이 들어가게. 예를 들어 음식 냄새를 맡으면 어떤
 느낌이 생기잖아…(미소를 짓는다)
N 노래 어때?
E *(미소를 지으며)* 응…
N 노래! 아까 그 노래말야…
E 아 응, 그 노래…!

 (...)

A 아하…오케이, 오케이… 여기 있다!
E 응.

 (...)

N 그 때 그 사람은 노래를 불렀어
E 그 때…
N 고문을 당했을 때…
A "창피하게 무릎을 꿇고 사는 대신, 차라리 당당하게 서서 죽겠다."

(갑작스러운 고요. 키보드에 타이핑하는 소리만 바깥 도시의 소리에 맞춰 베이스가 되어 준다. 모두가 갑자기 자기 안으로 빠져 들어간 듯, 분위기가 뭔가 뜨겁고 무겁다. 더운 여름 날 공기처럼.)

2.

A 혹시 어디서 들을 수 있어? 아니면…

E 내가 찾아줄게…

A 그니까…어떤 느낌인지 좀 보려고… 난 그… 그 노래가 좋더라. 네가 했던…작품에서 배우가 부른 노래 있잖아… 참…

N 아름다웠어.

E 음…

A 그러니까 그… 우리 작품 있는 곳으로 사람들이 들어오면 장벽이 있고, 노래가 나오는 거지.

E+N 음!

A 왜냐하면, 내가 뭘 들었냐면…내가 지난 주 'Tanz im August' *(역주: 베를린에서 8월에 열리는 무용 축제)* 에서 한 무용수와 얘길 했는데, 그 사람 작품에서 그게 나오더라고. 뭐라고 하지? 엄청 큰 카세트 플레이어? 알지?그 80년대 그 오래된 모델…

N *Zvučnik?*

A … 응. 카세트 플레이어…

E+N 아아아아! 응, 응, 응…

A 작품에서 그 무용수가 이런 말을 했어. 'DMZ에서 남한은 소리를 내보내는 커다란 벽을 쌓았어. 대형 스피커로 만든 벽 …소리를 내보낼 수 있도록.

E 남한, 북한! 둘 다 그렇게 하고 있어!

A 아, 그럼 싸우고 있구나…

E 북한도 계속 소리를 보내고, 남한도 계속 소리를 보내지…

A 그럼 소리로 싸우는 건가?

E 응!

N 그거… 음악 같네!

E 벽이 있지…

N 둘이 대화를 하고 있었다고 생각 해… *(웃음)*

E *(웃음)* 대화는 아니고, 둘 다 자기 주장만 하는 거지.

A 소리로 싸우는 거!

E …예를 들어…

A 소리 주장…

N	··· 주장 ··· 음악 같은 소리! 음악 전쟁! 음악을 써서 하는 전쟁!
A	소리 경쟁!
E	그냥 ··· 목소리인데··· 예를 들어, 남한에서는 북한에 "남한으로 와라, 여기 자유가 있다! 여기서 부자로 살 수 있다···블라, 블라, 블라" 그리고 북한에서는 자기 체제 선전을 하는 거고··· *(웃음)*
A	오 세상에···

A는 인터넷에서 무언가를 찾으면서 중얼거린다. N이 날카롭고 크게 숨을 내쉰다. E는 한국어로 말하며, 검색하기 위해 키보드를 두드린다.

| E | 자··· (노트북을 A와 N쪽으로 돌리는 소리)···자막은 없는데, 그냥 한번 느껴봐 ··· |

독일어로 인터넷 광고 소리나오고, 한국어로 여자 목소리로 스피커 장벽에서 소리가 들려온다.

N	아···!
E	이거 엄청 보수적인 TV쇼인데··· *(한국 TV 쇼의 소리가 배경으로 들려온다.)* ···20 km나 되는데··· *(통역해준다.)* "여러분은 여기 남한의 소리를 들을 수 있습니다···"뉴스 같은 게 나오네 ···남한에 대한 아주 긍정적인 뉴스, 그리고...
N	이거···관타나모 같네···
E	관타나모?
N	관타나모는 미국에 있는 감옥인데···사람들한테 소리로 고문을 하지.
A	*Vidi kako to izgleda!* 이거 봐! 대박이다!
E	이게 DMZ야. 그···
A	근데, 뒤에 소리는 잘 안들리네?
E	··· 북한에서 오는 소리? *(인터넷에서 나오는 노래가 뭔지 귀 기울여 듣는다. N은 혼자 중얼거린다.) (웃으며)* 아··· 보자··· *(남한 쪽 진행자가 계속 말하고 있고, 어떤 소리인지 식별할 수 있다.)* 이거, 북한에서는 라디오에서 나오는 소리네···
A	아···
E	···어떤 한 사람이 얘기를 하는 건 아니고···이 위쪽을 통해서···
A	아, 아, 아···
E	그래서 만약에 우리가 라디오 채널을 만들면···우린 그냥··· 그걸 들을 수 있겠다··· 차 안에서···

A	…주파수를 통해서 하는 거구나…
E	응… 이쪽이 북한이야…남한과 같아 보이지… 여기는 남한이고

N이 부엌으로 간다.

E	그리고 영화도 있는데…아주 유명한 영화야…그 영화가 이런 상황을 담고 있지…남한 병사와 북한 병사가…이런 소리들을 만들고…근데 나중에 우정도 생기고. 북한 병사가 남한에 넘어와서…이건 픽션이긴 한데…이런…문화적 배경에서 나온 거야.

(…)

A	음…근데 난 이게 너무 좋다…꼭 안해도 되지만… *(E는 웃고, A는 작게 중얼거린다)* 아, 그니까…난 여기 방송에서 말하는 사람이 마음에 든다고.
N	정말 파워풀해 보인다…위협적이기도 하고…
A	너무 좋은데… 음악을 틀어서 뭔가 전복 시켜볼 수는 없을까, 아니면 연주…
N	… 안 될 거 같아…너무 거창해 …
A	… 아니면 미니멀 테크노를 틀던지…

E 웃는다.

A	생각해봐. 엄청 큰 벽에서 소리가 나오는 거야… *(휘파람으로 인터내셔널가를 부른다)*

E 웃는다.

N	상상이 된다…
A	모두 엄청 혼란스러워하겠지… *(웃음)*

3.

E는 한국어로 무언가를 적고 있다. 감탄으로 채워진 잠깐의 고요한 침묵. 글씨를 쓰는 과정이 이어진다. 노력이 웃음으로 변한다. E는 글자 하나 하나를 설명한다.

E	모든 … (A: 아하) … 것들이. (A: 아하) 나누어졌다. (A:아하)

E　　모든 … (A: 아하) … 것들이. (A: 아하) 나누어졌다. (A:아하)

N　　'나누어졌다.'가 가운데 오는구나. 이게 포인트네. '나누어졌다'
　　　가 '모든-것'을 나누고 있어. 진짜 나누고 있네.

E　　모든 것이 나누어졌다. 이렇게…

N　　완벽해…!

A　　근데 그러면…그럼 사실 이렇게 되어야 하는 거 아닌가
　　　(한국어를 보여주면서) 모든 -나누어진- 것들…? 그래도 '모든
　　　것이 나누어졌다'라고 알 수 있잖아…이걸 가지고 놀아보자.
　　　한국어로 어떻게 발음해?

E　　아… mo… mo… mode… mode… moden… Moden.
　　　Na… nu… O, o, o… djin. Ko, kot, kot, kot, kot…tl. *(웃음)*
　　　(모두, 큰소리로 반복한다): Modn - Nanu-Odjin…

A　　O-djin…

N　　U 이름이네…?

E　　맞아, 맞아… 딱 그거야! 그래… *(웃으며)* U의 이름이랑 같아.
　　　(U의 이름을 적어 보여준다.) 사실은…

N　　우와… *(E는 웃는다)* …*(N은 E의 말을 따라한다)* 'Nanu-
　　　Odjin-Gotl…

A　　Gotl…

모두 Go-tl을 올바르게 반복하기 위해 여러 번 반복한다.

E　　Modn - Nanu - Odjin - Gotl …

N　　Gotl..

A가 웃는다.

N　　완벽해!

A　　완벽!

N　　되게 콧소리가 난다…

E　　… 이걸 책에 이렇게 넣는 거지 …빨갱이(Red People)에
　　　대해서 이야기했던 모든 주제는, 사실 빨강이라는 건 가르겠다는
　　　생각이잖아…그래서 가족도 나누어지고…계급도 나누어지고
　　　…*(웃음)*

E 그리고 마지막 장은… 첫 장과 같은 제목으로…하지만 다른 사람이 되는거지. 프라하 갔을 때…너무 재밌었는데…거기서 북한 사람을 실제로 처음 만났어 *(웃음)*.

A 와!

E 20명 정도가 왔고. 8가지 분야의 학자들이 왔는데. 정치, 사회, 언어. 예술 등 등. 나는 예술 파트에 있었고. 북한 음악학자를 만났어. 그리고 그냥 평범하게 만나지더라고. 그 순간 북한에 대한 내 선입견이 깨지는 거야. 그 사람들 완전 평범한 사람들이더라고. *(웃음)* 나는 북한 사람이 도깨비라고 배웠거든…

N 그 챕터를 만들까 -그 사람들 완전 평범한 사람들이더라고?

E 근데 이게 어쩌면…한국사람들이 사람을 어떻게 바라보느냐 하는 문제인 거 같아. 예를 들어, 우리엄마나 오빠랑 영상 통화 같은 거 하면, 바로 이렇게 말하거든. "야, 너 살찐 거 같다! 너 왜 화장 안했어?"

U 근데 사실…

E 한국 사람들한테 외적인 아름다움이 되게 중요하거든.

U 근데 어쨌든, 내가 말하고 싶은 건 태도가 완전히 다르다는 거야. 예를 들어, 유럽 사람들이 아시아 여성에 대해 어떻게 생각하는가…

A 생각해보자…

U …아시아 여자에 대해서 생각해봐, 그리고 어떤 식으로 아시아 사람을 바라보고 있는가…

A 이거 진짜 흥미롭다…

U …백인 남성. 그…그 사람들은 다른 태도를 가지고 있는 것 같아

A 내가 요새 내 친구들한테 계속 이런 질문을 하는데… '남한과 북한의 긴장관계를 어떻게 봐?'

N *(Er에게)* U가 너를 위해 커피를 부탁했어 *(웃는다)*

Er 아, 그래, 그래, 그래… 정말 고마워.

U … 남한과 북한의 긴장이라…

A 너희는 두 한국이 통일할 가능성이 있다고 생각해…아니면 없다고 생각해? *(E 웃는다)*

U 근데 나는 먼저…

A	내가 처음부터 이걸 이렇게 직접적으로 묻는 이유는, 나는 컨텍스트를 충분히 알지는 못해서, 그게 미묘한 가운데에서도 분명하게 가능한 일인지, 아니면 더 섬세한 방법으로 진행 되어야 하는 건지.
U	… 중요한 건…난 북한에 대해서는 잘 모른다는 거야.
A	아아…재밌네.
U	모르지…몰라.
A	그래도, 그냥 일반적으로…뭐라고 말할 수 있을 거 같아…
U	난 특별한…두려움은 없어.
A	어떤 두려움도…
U	어떤 두려움도…
A	공산주의에 대한 두려움.
U	아…(A가 웃는다.)
E	공산주의에 대한 두려움, 아니면 통일에 대한 두려움?
U	통일에 대해서도, 사회주의에 대해서도, 북한에 대해서도… 두렵지 않아.
E	음, 음, 음…
U	근데 잘 모르는 사람들은, 두려움을 갖고 있지, 그래서 걱정을 만들어 내는 거야…
A	…그리고 스테레오 타입과 클리셰들을 만들어 내지.
U	음…그래서 내가 어떤 예상도 하지 않는 거고, 북한이나 사회주의에 대한 어떤 클리셰도 가지려고 하지 않는 거야. 왜냐면 나는 내가 잘 모른다는 사실을 알거든. 그래서 두려움이 없는 거고.
A	니가 한국과 북한이 접촉하는 게 아무 것도 아니라고 말했을 때, 되게 흥미로웠거든. 사람들은 완전히 고립되어 있고, 서로 분리되어 있잖아. 그리고 난 이게 얼마나 복잡하고 섬세한 문제인지 이제야 알았거든. 그리고 어떻게 한국이 여전히 냉전 메커니즘 안에서 희생되고 있는지, 그 지정학적 위치를 방해 받는 형식으로 말이야. 우리 최근에 영화 봤잖아…
N	… 국정원 나오고…김근태가 나오는..
U	음…
A	고문당하고 등등…
N	어떻게 구타를 당했는지…(E는 U에게 그 영화의 한국 제목을 알려준다.)
A	미국 정치가 반공 히스테리를…어떻게 한국으로 들여왔는지 처음 알게 됐어. (E: 응, 응, 응… N: 그래, 바로 그거야.)

그리고 실제로 이 공산주의 담론은 남한이 스스로 만들어낸 것이 아니라 식민주의적 반공 담론의 도구에 속했기 때문에 시작된 거라는 것도. 이런 식인거지.

Time in the divided space, 2019

7장.
두 개의 조국

K	접시 줄까?
A	괜찮아!, 응, 이상하다. 기계가 *(편집자 주: 녹음기)* 있으니까… 모든 게 좀… 유니폼을 입은 거 같네
K , Eu	같이 - 응!
A	… 그리고 이 전체 내용은…. 우선 우리가 무엇을 하고 있는지 설명해 주면 니가 이해하기 좋을 거 같아서. 먼저 설명하고 나서 얘기를 시작하자. 우리는 라디오 드라마를 만들려고 했었어. 오디오-아트웍 같은 거였고, 남북한과 동서독의 복잡한 관계를 다루려고 했지. 동시에, 유고슬라비아와의 차이점과 유사점을 알아보고 비교하고 싶기도 했고. 이민자 입장에서 우리가 흥미롭다고 생각하는 건, 그러니까 독일로 이민한 사람의 입장에서… '독일은 도대체 무엇을 겪었을까? 무엇을 느끼고 있을까? 완전한 통일(통합)이 있을 수 있을까? 독일의 시스템에서 사람들은 어떻게 받아들여지고 있나? 아니면 거절을 당하고 있는가, 왜 그런가?' 하는 문제였어. 이 프로젝트의 제목은 Red People 이고, 우리가 관심있는 건. 이렇게 표현하고 싶어. '빨간 이념'이야. 공산주의는 사회적인 격차를 없애고, 사회를 더 잘 만들려고 하는 시도야. 그리고 이게 약간 빨강의 위험 이라는 생각을 한 거지. 독일에서 사회주의의 기억은 거의 억압 당하고 있잖아. 유고슬라비아에서는 사회주의의 과거에 대한 절대적인 검열에 직면해 있고, 한반도에선 이념적인 적대감이 지속되고 있지. 북한은 공산주의 국가이고, 모두 북한을 악마화 하고 있어. 동시에, N과 나는 한국에서 사람들이 사회주의를 다르게 생각하고 있다고 느꼈어. 넌 어떻게 생각해? 사회주의에 대해서 공감해?
K	솔직히 말해서 공감해 *(웃는다)* 하지만 난 대다수의 한국인들을

대표하지 않아. 우리 아빠는 독일에서 사회철학을 전공했어.
80년대에 한국에서 대학생이었고 독재에 반대하는 학생 운동을
하기도 했지. 사회주의에 관심이 있었고, 그 관심 때문에 독일에
오게 된 것도 있어. 칼 막스(Karl Marx)를 공부하기 위해서
말이야. 그렇게 위르겐 하버마스(Jürgen Habermas)와 함께
공부했지. 아빠는 자기 이념을 숨김없이 드러내는 편이라 그게
우리를 양육하는 데에도 영향을 미쳤어. 우리한테 그걸 가르친 건
아닌데, 아빠가 그렇게 살아갔으니까, 일종의 롤모델이 되어
준 거지. 자유시장경제체제나 자본주의의에 대해서는…난 조심
해야 한다고 생각해. 시스템이 원래는 약한 사람들을 보호 해야
하는데, 자본주의에서는 그런 게 없고 인식되지도 않고 있잖아.
난 이론적인 바탕이 없어서, 학문적 담론 안에서 확인 할 수는
없지만, 그렇기 때문에 사회주의에 공감하는 편이야. 많은
한국인들이 나에게 동의하지는 않을 거야.

E 맞는 말인 것 같아. 5월 민주화 운동을 대한 연극을 같이
 만들었을 때. K가 노래를 부르는 장면도 있지. 거기에 K 아빠에
 대한 얘기도 나왔어. 근데 어렸을 때 집에서 그런 노래를
 들었대. 운동권 노래들. 신기하더라고. 어렸을 때, 보통 노래,
 그러니까 대중가요를 안 들었고, 데모할 때 들을 수 있는
 노래를 들은 거잖아 좌파적 입장이라고 할 수 있지.

K 아빠 친구들도 대부분 독일에서 정치학이나 철학을 전공한
 사람들이라 아빠랑 의견이 비슷했거든. 그래서 한국으로 다시
 돌아왔을 때, 그 때서야 이게 일반적인게 아니구나 하는 걸
 알게 된거지.

A 오히려 예외라는 걸 알게 된 거야?

K 응.

A 좋다, 전쟁의 한 가운데에 있었다는 말이네.
 넌 여기서 자랐어? 독일에서?

K 응, 여기서 태어났고 10살까지 독일에서 살았어. 그 후에 가족이
 한국으로 돌아갔고, 24살 때 나만 다시 독일로 돌아왔고
 그 때부터 여기서 공부했고, 살고 있어.

A 그럼 너한테는 조국이 두 개 있는 거네. '소속된다' 라는 말을
 이런 맥락에서 써도 된다면 말이지. 어떻게 보면, 넌 여기서
 태어났고 내가 봤을 때 넌 여길 너의 모국으로 여기는 것 같아.
 모국이라는 이상한 단어가 뭘 의미하든. 근데 모국이라는 말은
 우파 이데올로기랑 관련있는 말이잖아. 내가 가끔은 누군가
 이 용어를 되 찾아서 다시 '긍정적인' 의미를 부여해주면 좋겠단

생각을 해. 이 투쟁이 가진 또 하나의 문제의식은, '모국에 대해서 우파의 입장 뿐만 아니라 보수나 전통의 입장으로' 생각해 보는 거지. 너는 한국하고는 어떻게 관계맺고 있어?

A는 처음에 관계(Verhältnis)대신에 실수로 운명(Verhängnis)라고 말했고, 덕분에 다 웃었다.

A 통일에 대해 어떻게 생각해?

K 지금이야말로 현실적이지 않다고 생각해. 북한과 남한은 어떻게 하면 통일할 수 있을지 잘 모르겠어… 통일하면 좋을까? 경제적 관점에서…

A … 통일할 수 있을까?

K 음. 우리에게는 특별한 이해가 없어. 지금 북한에서 진짜로 발생하는 일에 대해 알 수가 없지. 북한은 경제적으로 어떨까? 그건 이미 동독과 서독 사이의 큰 문제였잖아. 그 격차…음… 가난한 사람과 부자 사이의 격차. 그리고 이건 독일에서 지역 문제가 됐지. 독일의 새로운 주들이 된 동독지역은 서독보다 못 살았기 때문에 큰 문제였어. 그게 많은 갈등의 원인이었기도 하고. 우린 아직도 연대자금을 지불하고 있잖아. 이런 비슷한 일이 한국에서 일어날 수도 있지. 북한은 남한과 비교하자면 낙후된 나라고 북한의 지역들도 그렇게 괜찮진 않잖아. 동독과 서독의 차이보다 심할지도 몰라.

E 통일 될 때 독일에 있었어? 기억나?

K 응. 기억나지… 우리 아빠가 너무 행복해서 잘 기억이 나.

A 벽이 무너진 순간…너무나도 상징적인 사건이었으니까…

K 우린 베를린에 살다가 1989년에 브레멘으로 이사했는데, 그 때 벽이 무너졌어. 기억나. 아빠가 행복해 하더라고. 우리 아빠랑 아빠 주변의 한국 학생이 다 행복해했지. 한국에서도 비슷한 일이 일어나면 좋겠다 하고 원했던 거 같아. 뭘 원했냐면, 여기서 뭔가가 일어났으니까, 이제는 한국의 통일을 위한 과정이 일어나겠구나 하고. 그 후로 30년이 됐는데, 우린 아직도 기다리고 있어.

A 방금 한 말을 제대로 이해했다면, 독일 통일 덕분에 한국도 같은 과정을 시작할 희망이 있었단 말이야?

K 응, 독일을 롤모델로 여겼어.

모두 다 웃는다. 뒤에서 놀고 있는 아기가 큰 소리로 떠든다.

A 흥미로운 이야기네. 2년 후에 유고슬라비아는 하나의 나라였는데, 전쟁으로 갈라졌잖아. 이건 분단 과정의 일부였거든.

K 사람들이 원했던 게 아니었어?

A 그걸 어떤 입장에서 분석하고 이해하려고 하는지 따라서 다르게 말할 수 있겠지. 사실을 보면 그래. 유고슬라비아는 인구가 2천2백만이나 되던 나라였는데, 이제는 슬로베니아, 크로아티아, 세르비아, 보스니아, 헤르체고비나, 몬테네그로, 코소보, 마케도니아로 분리됐어. 경제적인 측면에서 보면 시장이 하나만 있었는데, 이제 경계가 생기고 서로 미워하는 사람들이 생겼지. 유럽 연합의 입장에서는 경계가 생긴 게 좀 사실이 어리석은 일이야. 왜냐하면 경계라는 건 자유 여행만 의미하는 게 아니라 문화가 만들어 지고 서로 교환 되는 것을 의미하기도 하니까. 상황이 얼마나 나쁜지 상상이 돼? 돌아보면, 전쟁이 30년 전에 끝났는데 갈등은 아직 해결되지 못했어. 더 나은 미래에 대한 생각이 아예 없는 건 아닐까.

K 다른 사람들도 그렇게 생각해?

A 내가 이렇게 설명하는 방식은 소수의 입장인 것 같아. 니가 너에 대해서 말했던 거랑 비슷하게. 이제 유고슬라비아 이후는, 국가라는 개념으로 도취되어서 살아가는 시기인 거지. 난 독일 철학자 헬무트 플레스너(Helmut Plessner)의 뒤늦은 국가 (Die verspätete Nation)에 나오는 이 문장을 많이 사용해. 플레스너는 그게 파시즘과 나치즘의 원인이라고 말하거든. 그 사람은 이렇게 주장하는데, 프랑스, 영국이랑 비교해봤을 때, 독일이랑 이탈리아는 통일된 국가가 되기엔 너무 늦었단 거지. 거기다가 독일과 이탈리아는 다른 식민지 제국들 처럼 세계 식민지 분단에 많이 참여를 안했으니까, 뒤늦은 독립체로 생각해 볼 수 있다는 거고. 1871년이 되어서야 독일은 하나의 통일된 나라를 만들었어. 유고슬라비아 모델에서 이 뒤늦은 국가라는 이론을 적용해보면, 그 해체 과정을 이해할 수 있어. 80년대 말에, 크로아티아와 슬로베니아가 자기들만의 나라를 가져야 한다는 이야기가 공공의 영역에서 퍼지기 시작했지. 자기들이 가진 자치국가, '한 국가=하나의 영토' 라는 생각을 실험해 볼 때였어. 진짜 바보같지! 왜냐면 요즘 이 새로운 '독립' 국가들은 유고슬라비아 안에서 있을 때보다 훨씬 더 역할을 못 해내고 있으니까.

잠시 말을 멈추고 바나나 케이크 한 조각을 먹는다.

84

A	한국 사람들은 어떻게 생각해? 남북이 한 나라라고 생각하나? 아니면 한 나라가 아니라고 생각해?
K	꼭 바이에른 주 사람들 처럼, 자기들만의 고유한 나라라고 생각을 해. 좀 다른 종류의 자부심인데. 난 항상 남한 사람들이 좀 차별적이라고 생각했어. 학교 다닐 때 그런 말 많이 들었거든. '우리는 순수 한국인이다.' 그리고 항상 경계선을 그리지. 한국 교육을 난 그렇게 이해했어. 통일이 되었다고 남한 사람들이 북한 사람들을 따뜻하게 환영할 거라고 생각하지 않거든. 그렇게 쉬운 일이 아니잖아. 독일에서는 차별이나 인종차별에 대해서 많이 얘기 하잖아. 근데 내가 난민 친구들을 만나면, 그 친구들이 그렇게 말해. '비난 받아야 할 사람들은 다른 사람들이야, 우리가 아니라고.'
A	그렇지. 우린 *(편집자 주: 언제나)* 좋은 사람들이지.
K	항상 그 경계에 관한 문제인 것 같아. 이런 생각 없이 통일을 하면, 문제가 많을 거라고 생각해. 엄청난 갈등이 있을 거야. 사회적 갈등들이.
A	당연하지, 상상이 돼.
K	근데 그게 항상 그래. 한국에 중국 노동자들이나 조선족들이 일하러 오면, 항상 노동조건이 더 나쁘지. 더 나쁜 취급을 받아. 진짜 그런 점에서 회의적이지. 그냥 남한 사람들이 북한 사람들한테 열려 있는 마음을 갖는다는 게 상상이 안 돼.
E	내 생각에 보통 남한 사람들은 북한 사람들을 실제 존재한다고 생각하지 않는 거 같애. 약간 유령 처럼 생각하지. 북한이라는 나라가 있다는 생각도 별로 안하는 것 같고. 그냥 좀 이상하다고 생각하는 거지. 남한 사람들은 '한국' 이라고 할 때, 그냥 남한 이라고 생각하는 거 같아.
A	이해 된다. 한국은 항상, 남한 뿐이라는 거지.
K	완전히 숨겨져 있는 거지.
A	한국에서는 그런 대화를 전혀 안하나?
K	통일에 대해서?
A	우리가 우리를 어떻게 보고 있는지를 반영한다는 차원에서 생각해봤는데. 이 문제에 대한 어떤 담론들이 있어? 그리고 북한에서 무슨 일이 일어나고 있는지에 관한 거랄지? 문화적, 이론적 논쟁들이 거기 있는지?
K	*(E에게)* 아마 니가 더 잘 알 것 같다. 그런 포럼 같은 거에 참여했잖아. 근데 상아탑에서 하는 이야기 같아. 그런 얘기 하는 학자들이나 아티스트들이 있지. 근데 나는 아티스트들을

그렇게 많이 알지는 못하고. 그냥 한국 밖에 있는 아티스트들이 훨씬 이 주제에 대해서 많이 다루고 있다는 인상은 있어. 한국에서는 별로 얘기 되지 않는 주제인 것 같아.

E 한국 밖에 사는 아티스트들이 이 주제에 더 관심을 갖고 있다는 건 느꼈어. 그냥 이 주제가 핫 하니까. 많은 외국 사람들이 여기에 관심이 많거든. 근데 남한은 아니고 북한에 관심이 많은 거지. 많은 사람들이 이미 평양도 알고, 김정은도 알고 있어. 근데 남한 대통령은 누군지 몰라.

A 한국 사회에 침묵이 있다는 게 흥미롭네. 우리도 과거의 고통스러운 사건에 대해서는 이야기 하지 않아. 나에게는 그게 약간 불길한 조짐이야. 예를 들어, 우리가 독일 통일에 관해서 이야기 할 때, 난 어떤 식으로든 서독이 동독을 식민화 한 거란 말을 듣진 않았거든. 물론, 식민지를 다른 나라에서 만든 건 아니라는, 그런 차이는 있지. 이건 오히려 '이데올로기적 식민화' 인 것 같아. 그리고 경제적 측면에서도. 동독 사람들은 '구'나 '그 외' 사람들이라는 느낌을 받고 있어. 내가 이렇게 말하는 것과 비슷하지. '저는 '구' 유고슬라비아 사람입니다.' 내가 어디 출신인지 써야할 때, 난 항상 '유고슬라비아'라고 쓰거든. 칼 막스 시 *(역주: 구 동독지역의 도시로 현재 이름은 켐니츠 이다.)*에서 태어난 사람도 비슷하겠지. 그 사람은 뭐라고 쓸까. 그 사람은 켐니츠에서 태어난 건가? 동독에서 태어난 건가? 아니면?

E K는 켐니츠에서 2년 간 일했었는데.

K 응, 나 켐니츠 극장에서 2년 동안 일했어.

A는 몹시 놀란다.

A 정말? 이거 정말 이상한 팔림프세스트네. *(역주: 다시 쓰고 지우고 그 위에 다시 쓴 고대 문서).* 켐니츠에 가면 한 쪽은 무시당하고 있는 사회주의 건축물이 있고, 다른 한쪽은 쇼핑몰 같은 자본주의적 공간이 있어. 그 역설이 공간적으로 놓여 있는 거지.

E 우리의 주제는 빨갱이(Red people), 그리고 모든 나누어진 것들에 대한 거야. 그래서 우리는 이 세상에서 나누어진 게 뭘까를 계속 질문하고 있어.

A 응. 우리는 이 나누어짐을 어떻게 반영할 수 있을까? 원인이 뭐고, 어떻게 극복할 수 있을까? 질문하는 중이야.

K 나한테는 좀 어려운 것 같아. 왜냐면 나누어진 것은 중요하거든.

젊은 사람들이 경계를 그리는 이유는 자기 스스로를 정의 내리기 위해서야. 난 유고슬라비아에 대해서는 전혀 모르지만, 나한테는 너무 로맨틱한 것 같아. 좋고. 작은 나라들은 자기들의 독립을 얻은 거잖아. 너무 순진하지. 똑같은 게 남북한에서도 일어나고 있어. 예전에 전쟁이 끝났고. 지금은 두 나라야. 독일이랑 오스트리아처럼. 그래서 그냥 북한과 남한으로 평화롭게 남을 수도 있는 거지. 전쟁 없이 말이야. 서로 소통 하면서. 공식적인 경계선과 분단이 더 만들어지는 거지.

A 내가 잘 이해한 건가? 먼저, 둘은 그냥 나누어져 있어야 하고, 그리고 나서는 같이 있을 수 있고, 함께 살 수 있다는 거지? 그리고 전쟁은 끝내는 거고. 분단을 받아들이면, 회복과 치유의 첫 걸음이 될 수 있다는 거네.

K 아마도. 한반도 분단이 너무 오래 지속 되었기 때문에, 그래서… 난 언제나 통일에 찬성하는 입장이었어. 정말 어려운 관계잖아. 30년 동안 같이 못 보고 산 동생이 있는 것처럼. 그러니까 지금은 같이 살아야지. 같은 언어를 말하고, 비슷하게 생겼고. 같은 부모님이 있으니까. 근데 사실, 공통점은 하나도 없어. 그래서 남한 사람들 중에 '난 통일에 대해서 관심 없어, 왜 그 귀찮은 걸 해야해?'라고 말하는 사람들이 이해가 되기도 해. 그래서 어려운 문제라고 생각하는 거야. 통일이. 왜냐면, 서로를 대하는 방법을 찾는 것이 반드시 서로 통합한다는 말은 아니니까.

A 좋은 말이다!

K 그래서 유고슬라비아처럼 좀 다르게 보이는 상황을 듣는 것도 흥미로웠어…

A 유고슬라비아에서 어려운 점은 분단이 폭력적이었고, 엄청난 트라우마를 가져다주었다는 거지. 한국도 그런 점에서 비슷 하잖아. 나에게 늘 질문이 생기는 건, '서로 분리되는 데에 다른 방법을 찾을 수는 없나?' 사회주의가 붕괴되고 나서 두 나라가 된 체코슬로바키아처럼. 전쟁없이 말이야.

K 거기는 분단이 되어서 행복한가?

A 그래 보이지… 적어도 '다시 한 나라가 되자.' 이런 얘긴 못 들어 본 것 같아. 우린 제목으로 두 가지 좋은 표현이 있는데, 하나는 Red People, 다른 하나는 Red Ideology. 난 켐니츠 에서 아주 멋진 칼 막스의 흉상을 봤어. 그리고 그 아래 이렇게 적혀 있지. '전 세계 노동자들이여, 단결하라!' 멋진 생각이지. 다른 면에서 보면, 이 '나누어진 모든 것(Everything Divided)'

이라는 생각은 그 반대의 과정을 생각하고 있지. 이 역설을 어떻게 생각할 수 있을까?

K 무슨 의미야?

A 나에게 좌파는 부정의와 계급적 적에 대항하는 민중의 단결이라는 생각에 기반하고 있거든. 근데 다른 면에서 보면, 너는 '우리', '우리 나라' 그리고 명확한 경계선으로 그어진 국경이라는 개념을 가지고 있잖아.

K 아하, 어떤 사람이 '이건 우리 나라고, 저건 너희 나라야' 라고 말하면, 함께 할 수 없고, 나누어 져야 한다는 건가…?

A 존 레논 노래에 이런 게 있잖아. '나라가 없다고 생각해 보세요. (imagine there are no countries).' 난 항상 국경을 이해하는 데에 문제가 있었어. 지금까지도, 난 국경의 존재에 대한 좋은 주장을 못 찾았어. 내 아들이 말을 하기 시작했을 때, 아이가 소유의 개념을 발견하는 것과 말의 시작이 같이 가는 거라는 걸 알게 되었어. 그래서 소유권의 문제가 언어와 어떻게 연결이 되어 있는지를 보면 재밌지. 그리고 경계를 그리는 것도.

E 경계에 대한 이야기이기도 해.

A 그렇지…

K 놀이터에서도… 많이 듣잖아. '이거 내꺼야! 내꺼…!'

A 넌 지금은 어떤 작업 하고 있어?

K 나는 엄마야. (모두 웃는다.) 그게 엄청난 예술이지.

A DNA 조각품…

K 지금은 하는 거 없고. 나는 배우야.

A 연기를 배우는 건 어땠어? 어디서 공부했어?

K 여기서 공부했어. 에른스트 부쉬 학교에서. 여기서나 한국에서 연기 배우는 건 좋은 경험이었어. 나는 움직이는 걸 배웠고, 생각하는 걸 배웠지. 큰 그림에서 생각하는 걸.

A 그리고 그게 스스로를 작가의 관점에서 이해하게 된 이유인 거구나. 독일에서 자랐기 때문에 가능한 일이라는 생각이 들어. 배우가 감독의 도구가 아니라는 생각.

K 여기선 다르지. 감독은 자기도 이해 못한 걸 하도록 요구할 때가 있어. 아이를 낳은 이후에, 내가 작가로서 이 입장을 실험해보는 데 관심있다는 걸 알게 됐어. 내가 어떤 역할을 연기하든 내 자신이 거기에 들어 있으니까.

A 그렇지, 얼만큼은 픽션이고, 얼만큼은 자전적인건지.

K 아니면, 완전히 자기 자신으로 하기도 하고.

A 그리고 이런 관점에서만 본다면…

K 그렇지! 그건 바뀌지 않는 거니까.

A 자기가 누구인지 모르고서는, 좋은 공연을 할 수 없는 것 같아. 모노드라마 같은 거라고 할 수 있지. 이 이야기는 하버마스에 대한 것이기도 하고 너의 자전적인 이야기에서 온 것이기도 하지. 배우들은 자기의 이야기를 없애서는 안 돼…

K 그럼, 안 되지.

A 아직 질문이 남았는데, 관객이 지루해하지 않게, 예를 들어 케이크 먹는 연기를 어떻게 할 수 있을까? 앞에 100명, 200명의 사람들이 앉아 있는데, 그 사람들에게 의미 있는 진짜 경험을 하도록 연기한다는 건 어떤 걸까?

K 정말 어려운 질문이다…

A 왜 예술작업은 다른 것들보다 더 성공적일까?

K 얼마 전에 친구한테 갔는데. 친구가 다른 여성들하고 모성애에 관한 퍼포먼스를 만들었더라고. 그 때 질문이 들었는데. '왜 남자들은 이런 주제에 관심을 갖지 않지?' 그건 모성애에 대해서 이야기 할 기회가 많지 않아서지…많은 여성들이 엄마임에도 불구하고 말이야…

A 이건 되게 시급하게 다뤄야 할 주제라고 생각하는데. 특히 너와 같은 경우에는 말이야. E에게도, 그리고 내 아내에게도. 너희 셋은 모두 너희를 다르게 만드는 이민자라는 백그라운드를 가지고 있잖아. 그래서 덧붙이자면, 너네는 다 엄마들이고, 세 가지의 타자성이 여기에 있지.

E 우린 벌써 제목은 정했는데. 다른 여자(The Other Woman). 무슨 의미냐면…N은 독일 여자를 위해서 일을 했었어. 독일에서 그런 광고를 했거든. '독일 여자들은 일하기 위해서 보이지 않는 다른 여성의 손이 필요하다.' 결국 그 다른 여성은 동유럽 여성인 거고. 우리가 모든 것이 나누어졌다(Everything Divided) 작품 얘길 하다 보면 결국 다른 여자(The Other woman) 작품 얘기로 끝이 나더라고.

K 지금 존재하는 아주 중요한 주제지.

A 여성으로 존재하는 건 쉬운 일은 아닌 것 같아. 노동자이자, 엄마이잖아. 내 아들이 태어났을 때 그걸 인식하기 시작했어. 내 인생에 가장 밀도 있는 순간이었지. 그리고 깨달았어. 남자로서 난 보고만 있었어. 내가 참여할 수가 없었어. 몸으로 해주는 것에 말이야. 남자는 그래서 눈 밖에는 없는 거야. 두 개로 나누어져 있는 거지. 남자들은 머리에만 있어. 여자 들은 몸에 있고. 근데 그게 맞나? 아니면 내가 또 남자 입장

에서만 말도 안 되게 얘기하는 건가?

남자인 아이를 보면서 답을 받고 싶어하지만, 아이는 대답하지 않는다.

K 맞아.

A 남자들한테 물어보면 재밌겠다. 우리가 어떻게 더 가까워
 질 수 있을까. 그리고 어떻게 모성애의 경험을 나눌 수 있을까?
 그게 가능하기는 한 걸까? 이 '나누어진 상태'를 유지 하지 않고
 말이야. 남성이 절대로 엄마가 될 수 없다는 사실을 생각해
 본다면 어떨까?

K 얘기해본다는 거야?

A 응. 엄마만 엄마가 될 수 있다는 사실을

E 나누어진 것들에 대해서 생각하면 해 볼만한 주제들이 정말
 많다. 남성/여성.

A 이 얘기 우리 한번 했었잖아. 그리고 지금 인터뷰 하고 있는
 사람들의 파트너들이 다 동쪽 출신이란 걸 발견했지.

모두 웃는다!

E 우린 이런 공통점을 공유하고 있는 몇몇 커플들을 알게 됐는데,
 사회주의 백그라운드를 가진 파트너들이 있는 사람들 말이야.
 그래서 그렇게 질문했지, 왜 한국 여자들이 동독 남자들을
 만나게 되는 걸까?

K 재밌네!

E 이 세 경우가 어떤 가설을 세우기에 충분하지 않지만.
 그냥 상상해본거지.

모두 웃는다. 아기가 노는 소리가 들려온다.

K 전시가 언제야?

E 12월 18에 시작해. 시간이 많이 없지.

A 이 책을 설치하고 싶은 건데.

K 내가 E하고 한 공연에서 부른 노래는 '님을 위한 행진곡' 이야.

E 이 노래를 홍콩에서 부른 버전을 봤어. 사람들이 중국어로
 노래 하더라고.

A 아마, 이 노래를 적어볼 수 있을 거 같아.

E 독일어로?

A 아니, 영어를 생각했는데. 번역된 게 있을까?

K 나 너네 프로젝트 너무 좋고 생각해. 그래서 지금 질문이 드는 건. 남한과 북한을 어떻게 더 연결시킬 수 있을까 하는 거지. 그리고 이 빨갱이라는 것의 정의도. 이거 중요한 거야?

A 뭐에 대한 정의 말이야?

K 빨갱이. 누구를 얘기한다고 느껴질까? 나도 거기에 포함되나? 아닌가? 이런 질문이 생기네. 그 의미가 무엇일까? 동생하고 오늘 얘기했는데, 동생이 우린 사회주의를 원하는거지, 공산주의를 원하는 게 아니라고 하더라고. 그래서 의문이 들었지. 흐음?

A 재밌다!

K 근데 그게 어떻게 다를까? 정치적 측면에서…

A 지금까지 사회주의는 계급의 차이를 없애는 정치적, 이념적 시스템으로는 결코 실현되지 않았다고 말할 수 있지. 오늘날 그렇듯이 그 생각은 유토피아 같아. 계급 투쟁은 아직 끝나지 않았잖아.

K 그리고 거기에 우리가 다시 있지. 경계와 계층의 문제에 직면해 있고. 계급 투쟁은 중요해. 산업 노동 세계의 원동력이니까.

A 문제는 노동의 나눔(분업)이지. 모두가 지적 노동에 접근 할 수 있는 것은 아니니까. 모든 사람들이 수공업자가 되길 원하는 것도 아니잖아. 이 사람들을 어떻게 평등하게 만들 수 있을까? 하지만 적어도 이것이 문제라는 결론에 도달하면, 그게 해결의 시작이 될 수 있어. 안타깝지만 지금은 자본주의 담론이 지배적이잖아. 그리고 사회주의와 공산주의 사상은 향수나 망령으로 존재하니까. 유령…문제는 어떻게 사회를 리모델링 할 수 있는가 하는 거야. 얼마 전에 있었던 브란덴부르크와 작센 주 선거에서 보면 좌파당은 갈수록 적은 표를 얻고 있어. 나 스스로 제기하는 문제는 세상을 더 나은 방향으로 움직이기 위해 예술가로서 무엇을 해야 하는가야. 좌파의 역할은 무엇이고 어떻게 해야할까? 더 많은 관객에게 어떻게 다가갈까? 우린 포퓰리즘 담론이 우파 정치에 의해 도구화되는 시대에 살고 있으니까. 난 포퓰리즘을 되찾고, 그걸 박탈당한 대중들에게 사회주의 사상을 전파하는 도구로 바꾸는게 시급한 일이라고 생각해. 우리 좌파/빨갱이들은 항상 너무 많이 이론화 시킨다는 위험성이 있지. 마르크스 또는 헤겔의 이론에 누가 실제로 관심이 있을까? 부르주아지의 특권 계층 밖에는… 마르크스와 헤겔을 읽지 않는 사람들과 대화하는 방법은 무엇일까? 그리고 사회주의가 유일한 해결책이라고 확신할 수 있는 방법은?

K	포퓰리즘 전략의 문제점은 항상 적을 외부에 둔다는 거지. 좌파들은 나치를 적이라고 생각하고. 그런 점에서 좌파는 타인을 받아들이려고 더 열심히 노력하고 있고, 그래서 나한테는 어떻게 더 대중적인 방식으로 행동할 수 있는가 하는 질문이 생겨.
E	최근에 한 컨퍼런스에 갔는데 누군가가 사회주의와 공산주의의 차이에 대해 질문했지. 거기서의 답은 공산주의가 실패했고, 사회주의는 여전히 북한에 살아 있다는 것이었어. 러시아나 동유럽에서는 실패했지만.
K	실패! 독일에서도!

모두 정말 크게 웃는다.

A	실패한 공산주의.
K	토마토 더 먹을래?
A	아니, 괜찮아. 근데 물 좀 줄래. 넌 한국에 얼마나 자주 가?
K	얼마 전에 갔다 왔어. 넌 가본 적 있어? 전시 때문에 갈 건가?
A	아니, 한번도 가본 적 없어. 만약 펀딩을 받으면, 언젠간 갈 수 있겠지. 가야지.
K	가보고 싶어?
A	완전! 아마 전에 가본적이 있을지도. 내 전생에 말이야. 근데 인정이 안 되네, 되나?
K	기억이 없으면, 안 되는 거지.
E	근데 얘는 한 달에 3번은 타이 파크에 간데.
K	그게 뭔 데?
E	아 몰라? 프로이센 파크?
A	어쨌든, 거기는 진짜 한국음식은 없고, 거의 태국 음식만 있어.
K	태국 커뮤니티 같은 건가?
A	응.
E	그냥 공원인데, 주말마다 거기서 아시아 사람들이 음식을 팔아.
K	스트리트 푸드 같은 건가?
E	응
A	한번 가 봐.
K	그래야겠다. 가보고 싶네. 다음엔 너네집 근처에서 만나야겠다.
A	그러자!
E	나 너한테 N 도 정말 소개해주고 싶어. 내 베프야, 넌 내 한국 베프고..

녹음기를 바라본다.

A 이제 그만 끌까?

K 그래. 한번 생각해보자. 저거 없이 또 무슨 얘기 할 수 있을지…

모두 웃는다.

Rijeka sewer, frottage on music paper, 2016.

Preface

Red people is a spatial installation made as a result of a collaborative research process between Eunseo Yi – South Korean theatre director, Andrej Mircev – Yugoslavia-born dramaturge coming from Croatia and Nikoleta Markovic – Yugoslavia-born artist coming from Serbia.

This artwork is especially conceived for the VIII Memorial exhibition of the democracy activist Kim Geun-Tae, titled *Community to Come*. It consists of 2000 copies of the book **Everything Divided** made by authors and grounded in their interviews with friends. The book is a docu-fiction drama based on true stories and life experiences. The installation is thought of as an intervention in the exhibiting space. It prevents the audience to enter the exhibition space in their *natural, expected way* by building the wall of books across one of the main gallery passages. The walls of the passage are both covered with the *Timeline* poster-like depiction of events that occurred in the world (with the focus on West and East Germany, North and South Korea, and Yugoslavia) during the three weeks of horrendous tortures endured by Kim Geun-Tae in September 1985.

The aim of this un-bricking of the passage is to provoke the audience to respond to the obstruction in the space by grabbing the books, dismantling the wall and freeing their route. This interactive act of taking the (free hard copy of) **Everything Divided** serves to re-enact and spatialize paradoxes invested in the theme of the book. The book itself stands

as an attempt to address all the complexity of the sometimes blundering parallel between strategies of ideological demarcation such as the one of the Berlin Wall and DMZ, as well as their political implications which are ideologically modeling everyday life of real people. It is exactly at this point that the artwork started unraveling.

An additional layer of reading comes with the dissembling of the wall of books which is simultaneously connecting yet separating the passage walls and two sides of the *Timeline*. When the majority of the books are taken and the way is cleared, the audience is literally passing through the time zone established by the *Timeline*. This transition of the observer – from participation in the undoing of the wall, passing through it and being inside the time-tunnel – directs the audience towards (re)reading of contemporary events by literally walking through scattered historical facts and events of the world in one share of time (the 1980s). We have started with the question: what connects the fall of the Berlin Wall, the reunification of two Koreas and the dismemberment of Yugoslavia? Is it the feeling of togetherness and commonality that is past to some, future to another and questionable present to all three? Gathered historical data, aligned in the form of the day-to-day timetable of occurrences around the Globe, reveal and make visible the ideological agendas operating in the background of this historical continuity. What are those? How did they affect us and what would that mean in terms of the politics of our work?

The data collected mostly from the Internet and online available official reports served to depict a mainstream version of what is most successfully reflecting the *zeitgeist* of the 1980s. As it appeared, the conditions around the world pointed to notable and violent political shifts in the African continent and the Middle East. What was less noticeable, yet obvious enough to find their way into the pop-culture, were the Cold war plots. They were mostly concerning spy games - books and Hollywood movies on exposing USSR spies or

their fleeing to the West - in an attempt to promote capitalist ideology. What was noticeable in them was strong anti-communist atmosphere and clear agenda of discrediting communism and socialism as a competitive political, social and economic order. The main impression is that this particular reading of historical narrative could expose the reason for the police brutality which Mr. Kim Geun-Tae has been subjected to. It became obvious that anti-communist rhetoric has been imported and in many different contexts used as an excuse for exclusion, division, excessive aggression and violence, segregation, marginalization and ultimately rejection and isolation.

Nowadays, Europe is facing numerous violent acts of right-wing populism, economic crises which have further induced migrations, recession, gentrification, joblessness, and poverty. In this sense, the question is inevitable: which ideology(ies) are these strategies belonging to? And, in terms of ideological streams that authors have tried to (re)trace and unpack, what is their relation to the 2005 (2009) act of legalization of the equating of Communism with Fascism?

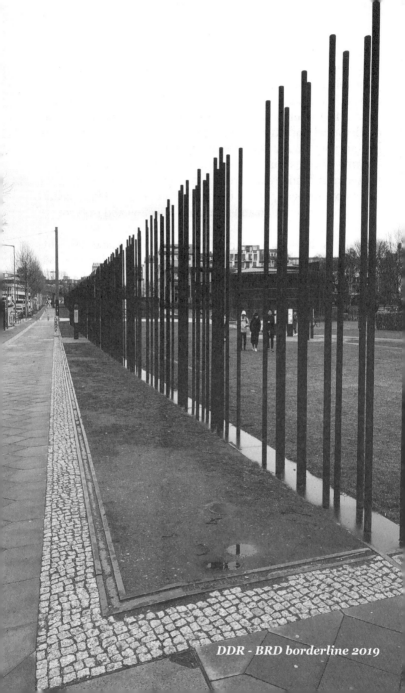

DDR - BRD borderline 2019

Prologue

N I should mention something... (*while approaching to the table*). We are recording.

Y Now?!

E Ya.

N We started recording previously. But ...

Y Is it like a...

N Why are we recording?

Y Candid camera?

Everyone is laughing.

N Why... why do we record?

A Everything you say will... can and will be used against you... (*Everyone is laughing*)

N So, I just wanted to tell you... If you agree. If you don't, we shall switch it off.

Y It's fine. Now I am very aware of that.

Everyone is laughing.

N Why do we do that? It's not for... It's easier for us to remember what we said and if a good idea comes up, so that we don't skip it.

Y It's not for your piece of art? (*Indistinctive murmuring of all participants.*) It's going to be a part of that? Not the work?

N Not everything. Nothing that you do not authorize
first... will not go into the... It is just for us not to slip
our minds. And it can be destroyed if you want it...
(*Y smiling* ...) No, I have people... So. We wanted
to – just a short excursion into our process. We
wanted to have an interview with Mrs. P. And she
was explicit that she doesn't want it. This is how we
came to the form of the book. We had something
else in mind. You remember, I was telling you about
the DM Zone and the *frottage*... (Y: Yea, yea...) This
is how we started. And then the radio-drama, and
then it went into the sculpture and t-n-n-n-n-n...
But now we ended up with the book because we had
many experiences of people... For example, she said:
I don't want this... May I share this? (*addressing to
E*) May I share her sentence?

E A... ya, ya.

N So, she said she doesn't want her story to be used by
art. I mean... One can understand it in many ways,
but for me it was an appealing critic of art – I am
very critical of art too – though it's probably coming
from a different position. So, I wanted to under-
stand what is her position. I went to talk to her,
but she didn't... she did not... respond. Something
happened there which was a bit off and then she just
stepped back. And then I realised, maybe... Maybe
the theme that we are working on, is not so comfort-
able for sharing like this, you know? Western people
are feeling 'comfortable' with this embarrassing... I
don't, but... But this somehow become a... a...
I don't know... a pattern - the ruder you are, the
more a... sort of a... symbolic power you gain in the
public space.

Y What's the topic of your work? I... forgot.

Everyone is laughing.

N	A, you forgot it...
E	A, a... (*smiling*).
Y	... the experience of this divided countries...
N	It's reunification.
A	And all the troubles with it.

Smiling.

Hungary - Croatia borderline, 2019.

Chapter 1:

I was born in non-existing country

A Yea, it's good, it's semi-professional. So... but this will not be part of the book, a? Or, shall we...

N Whatever we decide... we can also make it a bit *komisch*... from time to time... (E: Mhm...) With big quotes... (E: Ja, ja...) ... some kind of a... juicy joke or something... (*E is smiling*...) Whatever we decided to do. But I am talking no more. I am speaking too much... again.

Short silence. Just E smiling.

A Just, like, pause... All the time. (*E is smiling*...) You know, in Beckett... he has this beautiful... when the character says nothing, you really fell... (E: Aha...) ... silence in between answers... That's so Asia... or it is just my fantasy about Asia...? (*E smiling*...) ... Silence, well thought, articulated... ... (*E smiling*...) ... No conflicts, everything is peaceful... Against, you know, this western...

N We break the silence! (*shouting one of the trademark paroles from the demonstration against racist TV commercial made by* Hornbach *and* Heimat *re-stereotyping an image of Asian women in western society. E is recognizing and smiling*...)

E It... it's your, your fantasy, I think... (*smiling*)

A	Is it a colonial phantasy?
N	Ya.
E	Ya, ya...
A	Oh, ok. Ya. Because... You know, what I've been struggling with, is, I actually came to realize I don't know nothing about your culture. And that was the moment when I thought - it is interesting that we are making a work... (*E is laughing* ...) ... a sort of... We want to question all this political, ideological issues... And I... At one point... I thought like... how are we going to do that...? I don't know anything about your culture at all... And, even I don't know much or enough... (N: Enough...) ... of this culture where I am living now... Not to mention, also, that I somehow have a feeling that I should also know more about my own culture, whatever my own culture is. That faced me with this... figure of the unknown.
N	Other...? Or...?
A	Other! Yea, yea, yea... But you know... it... But in the way that this other is also within me. That there is also Other in Me... that needs to be colonized... or is in danger of being colonised by this Other... This SuperEgo who wants to... who pretends to know everything, who is in charge of knowledge... Who is in charge of any kind of authority... Because... I remember asking your friends about Wong Kar Wai... I thought he was Korean director... and then I took a look and... and I said, no, he's a Chinese. (*E smiling*...) It was so stupid of me to make this mistake... (E: Ja, ja...) You know like... And for us, I mean, for... from the position of the white male... I had always trouble... really confessing it now, but for years I couldn't ... everyone from the Asian continent looked the same... (E: Ja...) I couldn't make a distinction. Now, I think, I got to the point where I could... but is

that already a sort of... racist view? I am just articulating what... what... you know... all the... all the stereotypes and all the ...

N The most known one. I mean, it goes also for the term African-American... Zizek says: don't say African-American, it's already racists...

A Yea, yea, yea...

N He claims that it's "less insulting" to say *black* then...

A ... then African-American.

N Well he... I got the point there and I think... I am on that line also, but just for the record, 'cause we are recording this and we will be having this as... as a huge part of our work... I think what is important are the positions within this artwork. And this is why, I think, that the position of an experience of Yugoslavia is something that could actually offer a... us... the *white* ones... the "ones that don't know"...

A ... a de-colonial position.

N *Ne. Ne.* What I meant was to offer a position to understand. (A: Aha.) Because, as you said, we don't know. On the other hand, we are having this experience of Yugoslavia... (and the Third way).

A ... in between...

N ... and the experience of non-ethnic state... which ... came...

A ... after.

N ... after.

A And maybe... not from this position of identity politics...

N Not taking that position. This is why it's important for me to say, sort of un- ... When you need to underline...? When you have to underline something...? A sentence, a row...? ... (E: Mhm...) That it is not about identity and it's not only about race but it's also about ... (*the sound of clearing the throat*) ... about not knowing. Because we are only dealing with presumptions. Like, what is Asian...? And this

is what we had... when we were preparing Asian demonstrations against Hornbach. So... when you go to support... then you have to understand how are you contributing to the support - from which position, what am I there for, I mean? People are completely aware... *stark*... strong, and really, articulated... What am I doing there if I am not coming as a representative? From which position am I saying something? Only from this self-reflexive auto-criticism. Nothing else.

A And solidarity.

N And! And, yea... *nur*! (*smiling*) *Nur* solidarity!

A ... *nur* solidarity!

N *Nur* solidarity... (*smiling*) Yea... And ... When you go from the position of Yugoslavia, Yugoslavia had this... anti-imperialist, anti-colonial and anti-capitalist politics of Non-Alignment movement... This is something that we've been working with for years now. Right? Back in Croatia and in Serbia, too. And this is from where we could address... something. But not only Korea... but the wall as a strategy and politics of contemporary ideologies which are 'uniting' territory but dividing people. And Korea... a... this big millennial event of uniting Koreas is about uniting people, regardless of territories. (*Smirking on herself about this naive construction.*)

E smiles.

N So, in these terms I think it could be really interesting what is this non-existing country? Is this longing for something that use to exist... (A: ... longing for belonging)... because it could also be read from the realm... of a... historical revisionism. And nostalgia as its main tool. Because they go back... in imperial times... sort of wiping out a huge part of... *uncom-*

fortable part, but still a huge part of history. Because some people have been born in that, those times ... So there we have a danger. But if we are smart we can address it in a way which is neither nostalgic nor denying, but more challenging. We could pose it as a challenge. Like numbers of questions. We could... we can make some propositions like: is this like the situation in Yugoslavia with Kosovo Albanians and Serbians? And in Albania with Macedonia and Kosovo Albanians from Macedonia? And in Greece... Similar things happened in Bosnia... where you have all three... a... how should I say, nationalities mixed... and this is Bosnian, Croatian and Serbian. All mixed up... Then you have in the northern part of Serbia a lot of minorities... Among them German - *Schwäbisch* ... which have been living in Vojvodina... And they have been heavily discriminated after the Second World War, even though they had nothing to do with the war and Nazi Germany. So, that's a very good but big assignment. We should be careful. We should... we definitely have to have this one.

A Then another title – I really like this – We have a problem. (*E is smiling*: ... Huston).

N ... Huston. Huston, we have a problem. (E: Ya ...).

(...)

A I am working till 4 o'clock...
E 4? So, after 4 o'clock ...
A After 4 o'clock is fine. 5...
E 5...
A Yes...
E Then Saturday will be better because of school on Monday...
A Ok, ok...
E Ok. I will send you a message.

A Saturday...

E I should go.

Toothache, x-ray photo, 2019.

Chapter 2:
We have a problem

N and E are leaving to meet Y, and the talk is interrupted shortly. During that time E talks over the phone in Korean with Y. All characters are quiet, only a soft violin music is playing in the background. The guest is talking about dead pigeon she got to see on the way.

Y Hi! How are you? Hey!

A How are you.

Y Good, and you?

A We just have a...

N Please, have a seat. (*More to herself*) I'm just going to move away... May I offer you here, because there you will not be having enough space... (*E offers space next to her – smiling also*) And I will be sitting here (*showing the ball*).

E A, no, it's ok...

N Are you sure?

E I am so small. (*smiling*) Small body, big mind.

N Biggest heart.

E The biggest heart.

N Did you have any breakfast already? (*addressing to Y*)

Y No. No because of this... (*showing the wound from blood testing*).

N Yea... I got really worried. So, do you want some water?

Y	Yes, thank you.
N	And tea or coffee?
Y	Do you have coffee?
N	Yes. Would it be ok for you if it's Turkish coffee?
Y	Yea, sure. It's actually better, perfect!
N	Ok, coming right up!
A	*Turska kafa.*
N	How was it? Did it hurt?
Y	No, it was just a regular blood check up.
N	A, ok.
Y	I need to go there again tomorrow. Wow! This looks really tasty... and creative.
E	... with sesame.
A	And honey as well.
N	I actually wanted to offer you, if you want, muesli to add...? I don't know if you eat muesli...
E	It's enough already.
N	Enough...? Ok... Want some yogurt and honey mix? But then, when you brought that (*showing the soya fruit yogurt*), you actually read my mind. (*E is laughing*)
Y	What happened to the pigeon?
N	I don't know.
Y	It just happened now? Or did you see it in the morning?
N	This morning, he came back and I was like there is...
A	It's a dead pigeon.
Y	Yea, it's dead but it looked like it choked on something. It doesn't look like it's a natural death. Because if a bird dies naturally, it knows that it is going to die... (*the rest start murmuring together*)... Yea, yea... and then it makes kind of a...
E	Aaaaa...
N	Really?
Y	Ye, I've seen many dead birds like a... dying... like really so peaceful. And that one was like ...

112

yea, someone shoot it... (*N sighting heavily*)... or it
ate something wrong. It doesn't look like a natural.
A Maybe it OD-ed, maybe it wasn't ...

Y is smiling.

N *Oh Man!* Oh, come on, show some compassion.
 (*with teasing sound of the voice*)

E smiles.

A I mean I did... I was, you know, shocked... I mean,
 why did a bird die? But eventually...
N E... (*offering something to E*)
E A, thank you.
Y So you got position in Karlsruhe, right? (A: Ya)
 That's far...
A That's far. Ya. But the good thing is that I will be... I
 will... I will be going there every second week, so...
 (Y: Aaaa... ok.) Twice a month for two days. (Y: A ...)
N Which one?
A Karlsruhe.

E smiles.

N That's really ... interesting.
A That's super.

*In the background, the sound of the silverware and plates
dinging against each other.*

N Would you be needing...?
Y No, I have everything. I have a... fork... a...
N Ok, super! Cause there's more here. Yesterday...
 (*A sudden sound of the fork falling on the floor
 interrupts the talk.*)... I wanted to work. And I

prepared everything. I've been working all day and then my bottom started hurting. Ok, you should walk, and then I walked, I returned back and the guys were out and there was a dinner and bed and tn-n-n-n... and I was like, "I need to work"... It was 10 past 8. At half past 8 I was dead already, in bed, sleeping. And I woke up this morning, a bit before 6. A told myself – wow, you idiot. (*Y and E are laughing*) Completely dead. I don't know what is happening, I am so exhausted these days. Maybe the...

Y ... weather?

N Ya... Could it be? Do you feel the same?

E I had a headache... and I slept a lot... last two days before...

N A, so... ok ... nothing is wrong... because I was already thinking ok, so maybe I should schedule to have my blood checked.

Y Not bad. Ye, not a bad idea. I think regular check ups is not a bad idea. But I also felt like, I don't want to do anything this week.

N Exactly, exactly. It's not only me.

E We should eat vitamin D. In winter.

Y ...

N Yea, the say... everyone uses those, so I was like... ok. (*showing the vitamin D pills table*) It didn't help me a lot... I mean for me it's mostly the sun.

E My tooth is moved. Here. *Unter*... Under side. And my husband loses two teeth.

Y Aaaaa...!

A Oh my god!

E ... in two years. We... we suppose that...

Y ... in Germany!

E In Germany! (*Everyone is laughing*)

N You think it's D...? Makes sense... Because the first thing that they told us when we came here was vitamin D, vitamin D, vitamin D ...

Y	You mean the wisdom teeth?
E	(*explains in Korean*)... no, lower.
Y	(*worried*) Hi, aaaay. O my Gosh.
E	I should be careful.
N	There is something that... there is a kind of jelly that you... use to fortify...
A	That's what I have...
N	... to make them stronger...
A	That's why it's so expensive. Because they know... and they calculated it. (*Y is smilling.*)
N	I should think where is... what is the name of the gel. It is for you and your kids.
E	A, fortify.
N	Yea, so extra calcium and extra vitamins... minerals not vitamins.
E	Aaaa... Is it from E...x or...?
N	Yes!
E	We have it.
N	You have it? Great!
Y	It's a toothpaste, isn't it? E...x ...
E	Yes, yes. (*explains in Korean*)
N	It's kind of a gel... So... But not often. They told us - once a week, right?
E	Ye, ye, once a week.
N	It's Fs'... I guess they eat a lot of... What do you need? (*addressing E*)
E	Calling me?
N	What do you need, what do you need? (*smiling*)
E	I need you. (*smiling*)
N	You need me... (*everyone is laughing, the sound of cutlery in the background*) Like a "good housewife I am... instead of having a seat with you."

E is smiling... and they discuss about weather everything is on the table so not to be interrupted later.

N	I should mention something... (*while approaching to the table*)

N	We have a problem! ... This was our idea.
E	Aaaaa, we have a problem. Ok.
N	So we say: This was our idea; it didn't go through. What do you think we should do? This is our idea now and we want to make an interview with you about what art...
E	Mhm...
N	... in this particular sensitive moment.
E	Mhm...
N	(*continuing*) ... because art also has...
A	A, a, a...
N	Art also has this power of appropriation, where it just takes everything for itself. Personally, I don't think artists should give ideas...
A	For free! (*everyone is laughing*)
N	... No, that's not what I meant! Because, this is irregular... irreg... irregulared (?), or unregulated market space. So, capital is always lurking in art for creativity, imagination, vision, dare... so to commodify, sell and earn a profit. And this is why I think that these ideas... utopian ideas, ideas about communities to come, should not be delivered without "caution". But then... how to be cautious? On the other hand, a big part of the value of these ideas is in its sharing and potential for interpellation (E: Mhm...) And this is why I think our book could be ...
A	Well, I think... now, listening to you... I really like this formulation – We have a problem ...
N	Mhm...
A	... And you know, of course, then it also makes this, this possibility to ask the question also internal... like... Do we really understand the position of each other?

N	Exactly!
A	Do I understand my position at all?
E	Mhm...
N	Exactly.
A	Do I then understand also the gender imbalance? Do I understand the cultural differences?
N	Mhm...
A	You know... because... it's probably not the same when I think of the left...
N	Exactly!
A	... and you. (*referring to E*) So that we actually become aware of this whole set of issues which then sound 'sexy' if you say it's a problem...
N	Mhm...
A	It's not a problem maybe... but it's a... it somehow pushes the problem in the front... puts it forward and not... not claiming, you know, as in everything should be smooth, everything should be easy... let's have fun... let's have... By putting out... spelling out all the problems... I think it's also good dramaturgical...
N	Mhm...
A	... moment where you deal with the problem...
E, N	Mhm...
A	... and you also problematize the problem.
E	Mhm...
N	... Yeah, because you actually...
A	Because the problem becomes regulatory principal for the whole... And then you could also say: yea, what is the problem? Which I actually don't know, sort of, where does it come from... the word prob lem... Then at the same time, a wall as a problem!
N	But also walls...
A	... and as potentiality, you know. The problem as a potentiality as well.
N	But also wall, walls as ... as... means of "solving" problems.
A	Mhm.

E	Mhm, mhm.
N	So... and this is the division also between... the ideologies of the DM Zone... So, (*talking and chewing at the same time*), what I understood ... (*the sound of swallowing*)... is the wall dividing ideologies?And now people are going to be unified. So what is happening with ideologies? Because, it is my impression that this is what happened with Berlin wall and this is how Eastern Berliners became second-graded citizens. The ideological paradigm they have been living in till that moment have been superimposed by neo-liberal consumerism. The terrain for this smooth overturn has been prepared for decades. (They have been) Feeling not appreciatted enough by Western Berliners. So, could that be a paradigm in Korea? Or is it too far fetched? Maybe, it's too European, also?
A	Too Europo-centric.
E	Mhm...
N	Yea, because...
A	Too Euro-centric... exactly.

- 3 -

A	*Interresant.* (*Speaking in German.*)
E	And I can so... (*the sound of the phone ringing*)... Oh my God, not now... (*smiling*)
N	... if it's the kids...
E	No... aaa... may I?
N	Sure, sure!
E	Ahhh... I want to give Yu your full name because she should ring a bell ...
N	Mhm...
A	Ja...
E	... so what is the...?
N	*Mi.*

118

E	*Mi... Mi...* Ok.
A	But maybe I could get down because the... the ...
E	Yea...
N	Yea... you should ... you should definitely go...
A	(*... continuing*) Hmh. Well that makes it interesting that we have these three different positions. Three different case-studies... or cultural backgrounds. On one side we have Germany, where we are now. Then we have Korea, of course. (E: Ja.) And then, we have our experience of Yugoslavia and the break up of Yugoslavia. And a completely different, at least in this moment, paradigm of community... and being together. 'Cause, if Germany in the nineties already succeeded, you know, 'we are one', we are one *Volk*'... 'E*in Volk*'! ... Unification of Germany... you are now following the same or similar trajectory, in terms of, you understand that this division between Koreas is a fatal error, so to say. But then at the same time, it is something that is against the nature of... of the people in terms of... But, also for me it would be interesting to hear do you have this idea that North Koreans are the same as you?... In terms of the nation, not as a state... but you know? Do you see them as your... your '*Volk*'... your nationality? Which in case of former Yugoslavia is completely different. There, if you would say to a Croat 'we are the same (as Serbians, ed.rem.) - We speak the same language and we are the same nation - that would be a huge, huge problem. Because Yugoslavs - as such - don't exist. Or at least now, in the present state, that is considered to be... blasphemy. That's you know, in Serbia and Croatia especially... well in the last 5-6 years... it's even more dangerous for you to say that you are Yugoslav then to say you are a Serb. In Croatia. (E: Mhm...) And in Serbia, vice versa: if you say you are Croat - sort of ok, but if you say you are Yugoslav, then you are

119

against this dominant nationalistic rhetoric.

E So... I can get... I can get some important words
 from you... (*referring to A and N together*). So you
 said (*referring to A*): this *community* and *being
 together*... so I can propose a subtitle for RED
 PEOPLE... So, there is a RED PEOPLE in the title,
 and then... a... Problematic people who want to be
 together in a utopian community... (N: Mhm...)

A Ja...

E ... paradise community... But, how can we make that?
 How can we go through these problems? So we can...
 with this subject we can interview... just meet...
 I mean we interview, I think, by ourselves just the
 people who we meet ... is the kind of... very inhuman
 words ... kind of method or tools... to make... to tell
 the story... from us... So the process that I can use...
 I can introduce you to... my friends, who are having
 this problem (*laughing*). Or who can understand
 this theme, or who has a very interesting history that
 we can har monize with ... or... not synchronize... we
 can... I want to use this words... (*showing on thescreen*)...

A Yea, maybe we can...

N Just the sec... the word...? (*E smiling*)

E ... resonate... resonate!

N A, resonate...

E Ja.

A Maybe... I was thinking... the whole book... to make
 it as a collection of interviews on these questions:
 community, being together, a problem... Which
 would, then, reflect the position of a person within one
 community. And then if we stick to these parameters
 that we deal with Germany, Korea and Yugoslavia,
 then we could... again thinking out loud... find two
 persons for each country... that tell the story of their
 integration or disintegration? I am thinking now of
 my German friends who came from DDR. What is

their impression? Do they now feel integrated? What happens to their past? There was this beautiful performance 'Atlas of Communism', which I think you also saw... in Gorki... that they have a feeling that they were colonised by West Germany, so that this piece also talks about this in... how to call them? ... Internal colonisation mechanisms...where you can also say... one of the accusations could be, you know, that 'Yugoslavia was actually a project of Big Serbia'. That Serbs colonised other national groups, which... you know... would be now a blasphemy. But, nevertheless, it could be also seen from this angle. Then in following that way of reasoning:What would be a scenario in Korea? Who would be the coloniser? And who would be colonised? Could you say that South Korea would by dismantling the DMZ... and actually colonise North Korea (in a similar way? - ed. rem.) In terms that they would have to give up on their way of living... of their ideology? What would be... ? (*looking to N*)

N No, no, no... (*smiling*)... I'll wait until you finish...

A But then, this puts me in the position of thinking that this is actually a way of articulating the victim... The victimized position of red people... is ideology against them. That's a paradigm of capitalism. But on the other side... there I would recall for Walter Benjamin. Because he writes... he says that actually, that is the mission of utopian politics. That we have to rethink history from the position of those who have been omitted. Who have been suffering, who have been defeated. And he says, of course from his perspective, that that is exactly the opposite to the ruling class. It's the... well... working class... or leftist *inteligencia*. In the wider sense.

E is playing the video about Jenga game and they are watching the video together.

N Mhm... (*the sound of the video explaining the rules of the game in Korean*).

E So...

N Mhm...

E It's a kind of stable...

N ... building.

E ... building. But they put out one kind of bricks in and then put them out. And when someone breaks the wall, he fails to win. But this means... The meaning is different, so we should think about that.

N Mhm... a bit... but not so much... it is really...

E So people... I was just thinking about games... People who... People can participate in something. It's easy to participate. Every Korean knows this game... (*the sound of the video explaining the game is ascending*). I like this! (*smiling*) So people can try, for example, to...

N So, what happens when you... not ruin, but when they...

E Crash... (*smiling*)

N ... crash the wall? What happens with the rest of the books?

E (*smiling*) I don't know... So we can, for example... (*the sound of people from the video smiling. E is smiling too.*) Do you know this game? (*addressing A who has just entered the kitchen.*)

A No.

E So, people get the bricks out one by one. And then the building suddenly breaks. So when someone... Oh... (*commenting on the development in the video*) ... Oh, and she lost.

N How I think about this... this I actually like but then the rest of the books stay in the space... like scattered

... and nobody will pick them... And the idea is that all the books are gone, for free... Like, opposite of us using people to... so we give something... In terms of... we made a research. And we've experienced this and we think it could be a problem. So, brace yourself and spread the word so to avoid to live through the same experience. This is how I understand our work sometimes. To give something... share, not give, share... because, usually people do not have access to this knowledge. It's academics who are talking. They have the time to talk. Workers don't. And this knowledge could actually be shared in a way which is not reserved for privileged people, but for everyone who comes. Who knows who will come. (...)

If they have a problem with the school... if they are instructed to think about communism in this way or that way... they could have our book. And say - I read it here... Or people could talk to each other, or something like that...

A A manual for utopia... (*smiling*)
E (*smiling*)... Manual for utopia...
N A Manual for Utopia... Because, maybe, it was not a good time for communism back then... Or...
It served its purpose in the battle against fascism. But now, maybe, it's going to... it needs to become a better version... like... Communism 2.0.

E is smiling.

N ... you know like...
A Improved!
N New, improved version! Upgraded!

E is smiling.

N Because we are different people... and that idea... we
 have different experiences. And that idea could a...
 not that idea, that concept could... completely rock the
 ... boat in a different way. Because it's not the same
 context and it's not the same structure and it's not
 the same mental environment and it's not the same
 emotional environment and it's not the same econom-
 ic paradigm. And when glanced there... I mean...
 who knows... It could be any utopian proposition or
 something... this is just me thinking out loud...

A takes a deep, loud breath.

N ... In terms of brick... (*exhaling sharply*) Maybe we
 don't have to do it this way... like... L (*forming an L
 shape with her fingers*) ... L for Left... L for Loony...
 L for... L for L... Leftist... L for... a... Lunatic... for ...
 for... for... suddenly you turn left... like... zak-zak!
 (*demonstrating with hands sudden, sharp turn to
 the left*) It could be just one straight wall where they
 just come and pick...
A I think it's... one straight wall is even better...

- 5 -

E Ye... But these days it is revealed... everything. South
 Korea decided to stop to get more information about
 North Korea from Japan. They stopped to have
 agreement...
A A... to...
N Renew...
A Renew...
E Renew, ya. So it is a big issue now in Korea with Japan.
 Now the US is pressing South Korea to make an
 agreement again with Japan (A: aaaaa...!) I don't
 know why... I don't understand that, but the relation-

ship between Japan and the US, they support each other. (*smiling*)

A is smiling and smirking.

N In my point of view, it's a pure neo-liberal ideology. It's for the capital. Capital is colonising. These capitalist bullies... this is what they do.

E And I am so sad about the destiny of Korea... Koreas ... two Koreas...

 (...)

N ... You can put this also in... otherwise it's going to be... (*handing the rest of the ice-cream cups from the table*)

A I actually want to eat them.

N Water?

E I don't know... I don't want.

N Me neither... (*handing the rest of the food for the refrigerating*) A! Can you just... just... thank you, love. (*E smiles...*)

E So it's really...

N I understand it is really hard...

E Ya.

N It is really worrying situation. It's not an easy one, or promising...

A Well... can we say that Yugoslav situation is promising? That the UK situation is promising...? I mean I am not saying something against that... (*as A is moving toward the table, the sound of the floor squeaking interrupts his voice.*)

N I read, between the two Koreas... it is really ambiguous, but I was on the side of *good*. I thought that joining people together is something that people want. They, they've been separated from their families ...

they have been like growing... on the different side of the fence, of the wall. I thought maybe. Of course history is always repeating itself because ideology is working and it's always repeating the structure. Not the people.
But ideology. Maybe this could be a good point to address. Ideologies. Which of course we can not avoid. But we should be really careful how...

A ... to outline them.

N Yea. And how to make them and their workings visible. And this I think... the strategy of interviews it's not a good... I mean, it's not a bad strategy.

(...)

A I was somehow moved. I went to talk with this professor who invited me to work in Karlsruhe. She asked me at some point – do you know about this film? I was trying to find it. The film is about... it was shot by Yugoslav director Dusan Makavejev. I turned out that he was the only one to film how the Lenin monument was dismantled. Here in Berlin, in 1991. After the wall came down. She comes from East Germany. We had a nice talk in terms of how this whole politics of memory and how this whole transition... *die wende*... is not articulated or is not reflected enough in Germany. Somehow they all...

N They underlie the fact that... it's just the wall and now, suddenly its not...

A It's the wall and the wall went down and we are all together.

N And that's it (*talking with full mouth*). Because, (in reality) it is not only about people it is about ideologies... that collided...

A (*continuing*) ... ownerships, problems...

N Exactly... which collided in Germany, because people

	united... no... *ne*... territory united but the people have been... undervalued... coming from ...
A	... east...
N	East. Because...
A	... they still are.
N	Because of the Other. Another mental environment in which they grew up. A different cultural habitat...
A	And still. If you see the wages... for the same job you would do in Dresden and Stuttgart. You would get much, much, much, much more money in Stuttgart then in Dresden.
N	Which is, actually, legalized class difference... isn't it?
A	Ya, ya...
E	Ya, ya...
N	... legalized by law. Legitimized by ideology of those in power...
A	Legitimized inequality.
N	State encouraged inequality. Shameless but still... not unexpected. I am not sure if this could, would... it could, but if it would happen in Korea... I think it's too far away... it's far away.
A	...
N	... yea a bit... far fetched... but on the right spot. I think, on the right spot aiming for...
A	Maybe that makes sense to us also. This question. Because. The context in which we are exhibiting is asking these questions about community to come. ... We pose this question: Ok, let's say, we agree or there is a consensus in both Koreas that we should do something together for 'a' Korea - united Korea to come... How will it look like? Is it a fiction or a fantasy about how the future will look like?
N	So this is...
A	Speculation, in a way.
N	This is a good point really. It gives us an entrance for addressing previous experiences.

A What happened in Yugoslavia, what happened in
 Germany... (N: Germany...) and what could happen
 in and what we can expect to happen in South Korea.

Divided space - divided time, 2019.

Chapter 3:
Everything we know is wrong

Er We have a special word for this in East Germany... We have a word like *besserwisser*. Someone who...

A ... knows better...

Er ... every time. We just say *besserwisser*. But that's the...

A But that's usually attributed to the West Germans...

Er But we... East Germans said in the nineties '*besserwessi*'...

E Aaaaa... Like mansplain.

Er They explain to us the word because we don't know anything.

E *Besserwessi*...

Er So we changed it a little bit... or, the East Germans changed *besserwisser* to *besserwessi*...

A Nice...

N My teacher is East German and she is always like - Aha, this is grammatically correct, *aber S sagt*... and then she tells us how it is said in East German. So we are practically learning *zwei* languages ... (*girls laughing*). How to tell time... And for me this difference exists, and is now more present than ever, and is used against East Germans most of the times – it exists on the expense of East Germans.

Er Western Germans say 12:15, *Viertel nach Zwölf* ...

for it is *Drei Viertel Eins.*

U But actually, I heard so many times from you... like - she doesn't understand because she is *Ossie* or he doesn't get it because he is *Wessie*...

A Yea, how...

U There are so many dialects in Germany. Now, these days, I don't know how many people divide people to East and West.

E How do you think about that...? Do you think people are divided to Western and Eastern? When they are in a relationship...

U You mean...

E I mean ...

U ... with language?

E ... with language...

Er Divide in language...? (*more addressing to U*)

U ... like... (*trying to additionally explain*) ... Mhm...

Er indistinctive murmuring.

A But how is it for your generation? Does it matter if someone comes from east or west?

Er I think, a few years ago, it was a topic for older generations ... They still saw a division between West and East Germany. A lot of East Germans went to West Germany to look around but till today maybe more than 50% of West Germans never went to East Germany. They think – why would we go anywhere? (N: Exactly, exactly!) And I think my... our, younger generation is different. For example, my generation is like: ok, I never saw anything in GDR. I'm German.

A I am German... ja, ja, ja.

Er I am German. That's it.

A You become more and more aware ...

Er People are dividing themselves. East or West. Be

A	cause East are strange people who vote for AFD …

A Well now that is not the consequence… I think it will become and is becoming an issue… (*the sound of cutlery in the background – N and U are trying to move the surplus plates and make room for dessert.*) Exactly because of AFD, because we see now that the Saxony has voted in a way that AFD has risen almost three times. The same happened in Brandenburg. They are still not the leading power but they doubled since the last elections. But what about… you were telling something about that your grandparents told you stories… memories… How do they see it in terms of … do they see it as a good period or rather…?

Indistinct chattering in the background.

Er You mean the reunification…?

A Je, je, je… and their position coming from the east… Did they experience any sort of traumatic encounters?

Er My parents say that they are… *wendegewinner.*

A Aaaaa… *wendegewinner.*

Er They… they think they have more profit for our family. They got better jobs, better income. Let's say, reunification was good for our family.

A Aha, ok. Are they nostalgic?

Er They … a little bit… because they don't like the attitude or behaviour from people of this western society (Everyone: Mmmmm…) They miss the…

A Intimacy…

Er Intimacy of socialist society. People were more friendly, help more, in neighbourhood or … anyone who needs help. And now they live in a society where people see someone who needs help but look away and don't want to help anyone. You have to look on yourself first.

Y Some day...

E is laughing.

N But you asked me... How did we think that we are
 going to represent those voices? Back in the phase of
 the process when work was still thought of as a radio
 drama... How do we think that we are going to voice
 ideology? And for me that was like – that's what
 we are after. (*followed by the sound of clapping
 hands*) We are not policing people, but also not ...
 like... singling out particular persons. And thus
 making celebrities out of them or their opinions.
 This method is inherited from entertaining
 industry: it's not about what someone thinks he or
 she represents, it's... when people sometimes talk
 they think they own their own thoughts. They rarely
 concern that they are already a part of a context and
 a part of previously established discourse. People
 usually do not take into account how ideology is
 working through them. Even the ones that are
 thinking and writing about ideology. They think
 they are immune to ideology. Even us - now!
Y Well I think, why I mentioned it at a time... it is
 not about you as some kind of representative
 person... But I think it is important as an audience
 to grasp that frame... why is...
N No, no, no... sure!
Y ... that person interested in that. Why is that colonial
 problem? It's not about you as a celebrity...
 (*laughing*)
N (*laughing*) No, this is not about me as celebrity and
 not about you or anyone that has been interviewed
 as a celebrity ... This 'celebrity-sation' is a paradigm

	now common in art. It is not what you said.
Y	Mhm.
N	This is not what you said. No, no, no! You said something completely different.
Y	Aaaaa, ok.
N	But this way of of addressing the subject is like.. sort of a spectacular-ising: ' the wall will go down so...' depending on the ideology that artist is re-presenting, we have either *spectacular-ising* the rising of the wall or *spectacular-ising* the dismantling of the wall. I think this spectacle is actually a problem. It's the problem of the politics of this strategy, of media. You asked me about ideology and this is exactly what the work is about - the origins of certain ideas. And when you activate those ideas, in certain political moment, like this one is, what is an outcome? Political outcome? For the people, it is very nice to unite. They have been divided, families have been divided... I repeat myself now... But in terms of how do we feel about it - what are our worries, fears, anxieties, experiences, how will that reflect on the reality of our daily lives - and how shall we carry on? Shall we be able to carry on? Shall we be able to express (or suppress, for that matter) our deepest, often contradictory, feelings about this community that is yet to come and survive? (Y: Mhm...) We are still doing severe separation. So, feelings draw us in one direction and what we do is... and social norms and cultural, class and family demands separates us in another direction. And I think that is devastating for human beings. It is devastating to live this schism. We are going to go mad, all of us. And I think this is 'the labour of capitalism'.
Y	Why is that about capitalism?
N	Because it is the ultimate control... to isolate a

human being ... and to manage its desires and command its pleasures. And you have to do 'what's been said to you' because that's proclaimed reasonable. A 'common sense'. "Oh, be reasonable", we are often compelled to say to each other. And yet we despise it when it's said to us.

Y Is it different in other socialist countries?

N I don't know how it would look like in the socialist environment in 2019... as we don't have any (*smiling*)

Y I mean, I am asking, can it be any different?

N It's my question too... I opt for socialism because those are a set of problems that I would rather deal with – if I get to choose and I don't get to choose (Y: Ya, ya, ya...) but ... - if I get to choose I would rather deal with problems that Yugoslavia made... then the problems that capitalism (or America) is making. For example, if I would be, like, living in rotten capitalism. And I am living in rotten capitalism. But European version. And I don't like this... because I see and feel people are devastated. More devastated then back when I was a kid.

Y Or, is it more intense then '90s or '00s? Can it be not the general capitalism but the neo-liberalism?

N That's exactly like it.

Y I think that's more like bringing people to the certain direction...

N ... exactly...

Y Yea, yea...

N ... forcing... forcing! (*Y smiling...*) Transition has actually been enforced there. It's not something that they voted for. Or at least I am not acquainted with people that have been aware of it in the way: I'm voting for the shift of economic system (from liberal socialism, ed. rem.) into capitalism. They (the whole country) have been pushed into the transition which

is like pushing an elephant into a cup. Not prepared, not capable and without any capacity to engage in such a dramatic change, as former Yugoslavia republics have had significant developmental differences. So for me, regarding this project... A and me, we are speaking with this bitter but sobering experience of failed transitional project. Which I don't find so much as a problem among people, although that too... but as a 'labour of ideology'. People, as well as their relationships, social infra-structures and social security based on it, are just collateral... Yet, still damaged. I think, what we will be shading a light on, would be these political and economical devastation that we might expect to happen as a resonance of ... (unification, ed. rem.).

Y Is there any North Korean refugees that are being interviewed?

N Yes...

E We tried to...

N We tried to... but...

Y Now I am interested in E's position in the project...

E Aaaaa... but I need to go.

N She needs to go.

Y Oh no...

E Yea... so sorry. But we can talk about that... *später*. (*All are laughing*) I am so...

N ... beautiful!

E I am so beautiful. (Everyone is laughing.) I got a lot of input from your questions. And a lot of ideas in my mind.

(...)

A Sorry I just had this conversation with Chemnitz...

E (*laughing*) ... with Chemnitz...

A They are flexible...

"The history of North Korea formally begins with the establishment of North Korea in 1948. Following the Japanese occupation of Korea, which ended with the defeat of Japan in World War II in 1945, Korea was divided along the 38th parallel into the Soviet Union-influenced northern part and the US-influenced southern part. The Soviets and Americans could not agree on the introduction of joint custody of Korea. This led to the creation of separate governments in the north and south, whereas both claimed legitimacy in governing of the entire Korea. Neither the US nor the USSR consulted the majority of the Korean population when making these decisions.

Establishment

Prior to the American landing on September 6th 1945 in Seoul, the southern provincial assembly as well as the northern one, elected Kim Il Sung as president and proclaimed the Republic of Korea, but the Americans did not recognize that assembly. Among other things, Americans did not approve of unification either, so negotiations failed.

Under the US patronage on August 15th 1948, the Republic of Korea has been proclaimed in the south while Ji Sung-man took an oath as the first South Korea's president. Accordingly, the Northern Provincial Government changed its name and proclaimed the Democratic People's Republic of Korea, on the 9th September 1948, with Kim Il Sung as Prime Minister.

Korean War (1945-1953)

This situation led to the tension that had, on 25th June 1950, advanced the border incident into the war lasting ever since. The North Korean army successfully progresses and quickly enters Seoul and moves toward the south of the peninsula, being aware that the Republic of Korea will collapse on its

own because the population did not resist.

At that moment, the US decides to intervene. The United States Invasion Army, led by General Douglas McCarthur, under the UN cloak, landed in Incheon on September 15ᵗʰ 1950. This further ignited the conflict. The North Korean army started loosing their positions after a sudden attack by Americans who, not only reached the demarcation line of the 38ᵗʰ parallel, but crossed into North Korea heading for Pyongyang. The government of the newly formed People's Republic of China learned via the KGB that after the break-down of the North Korean army, the US military intended to cross the border, occupy China and restore empire or bring back Chan Kai Shek who fled Formosa (present-day Taiwan).

To prevent this, China sent troops to North Korea. The harsh winter slowed down the American invasion, so the resistance began to intensify in the spring. The US military was forced to retreat to the port of Hamhung. It was reported that when a soldier asked him whether they were in fact retreating before the Koreans, General McCarthur shouted angrily: "No, we are making progress. Only in the opposite direction!"

The Koreans became increasingly involved in the fight, and with Chinese support and Soviet weapons, success was guaranteed. On July 27ᵗʰ 1953, in Panmundju, a ceasefire has been signed between the United States of America and the Democratic People's Republic of Korea that is still in effect (legally speaking, North Korea and the US are still at war). The demarcation line was established on the 38ᵗʰ parallel where the Demilitarized Zone was established. The Chinese People's Army withdrew from the DPRK very quickly, while US forces remained in the south to this day.

Democratic People's Republic of (North) Korea

Since 1948, Kim Il Sung has been Prime Minister of the DPRK

and was far from the title of the Supreme Leader. It was not before 1972 that he became president of the state, and that will remain until his death in 1994. Due to the peaceful political climate, North Korea was recovering rapidly from the war. The 1960's saw the fastest growing heavy industry as well as the light industry. In addition, there were actions against US forces, so in 1968 the US spy ship Pueblo *was captured, in 1969 a spy plane was shot down, and in 1979, Park was killed.*

1970's mark the opening to the world, but it was not of a larger scale. The peace and unification negotiations began in 1972 but ended in 1973. Josip Broz Tito, the President of SFRY, visited the then People's Republic of Korea from August 24 - 30, 1977. In 1986 began a program for reuniting families separated by conflict.

In September 1991, the Democratic People's Republic of Korea and the Republic of Korea were admitted to the UN. The collapse of the USSR brought major problems to the DPRK. In the first place the danger of US attacks increased and the economy began to collapse as the country found itself under the strong economic blockade of Western countries which coincided with droughts, shortages and famine. Above all, in 1993 the CIA announced that North Korea was producing atomic weapons. The game of cat and mouse in which the winner is unknown, lasts till today. The on and off negotiations continues while the world is closely monitoring on how this multi-decade crises on Korean peninsula will conclude."

History of North Korea (in Serbian): https://sr.wikipedia.org/sr-el/%D0%98%D1%81%D1%82%D0%BE%D1%80%D0%B8%D1%98%D0%B0_%D0%A1%D0%B5%D0%B2%D0%B5%D1%80%D0%BD%D0%B5_%D0%9A%D0%BE%D1%80%D0%B5%D1%98%D0%B5
last visit: 12.9.2019, 22:13h

Berlin room doorstep, 2019

Chapter 4:
I don't want my story to be used by art

N We are trying to understand the strategies of the wall
 – the one... when you put it and the one when you
 dismantle it... (*explains more in hands then with
 words*) ... But in terms of people, feelings, politics,
 ideologies, everything... We are trying to understand
 what's the... When reunification happens, what will
 happen?

A If it happens. Or when it happens.

N A lot of people are actually exploiting the fact that
 this is happening. Us too, obviously. We have three
 different positions here, but we are not representing.
 Now this is a very important point. Not representing
 anyone, especially not from the national position.
 None of us is. (A: Neither...) Neither of us... we are
 trying to elevate this from national representations
 into the actual intellectuals who are sharing...

A Anthropological problems...

N ... Anthropological, social, political problem and to
 understand this as thinking... as a work of thought.
 As some kind of political strategies which are
 obviously recruiting us all. So, in those terms we are
 trying to understand what is the geo-political interest
 of everyone involved. Because this all happens on the
 30th anniversary of *Mauerfall*. And our position in
 the work can only be the one that occupies experience
 of former Yugoslavia as a position.

A	Someone who already experienced...
N	... the outcome of dismantling of the Berlin wall.
Y	You know... I don't remember what I told you... (*smiling*)

E is smiling.

N	I don't remember precisely also (*smiling*). I was thinking we can recreate it.

Everyone is smiling.

Y	No... because I don't remember saying something important for you. What did I say?

Everyone is smiling.

N	It was very good, this I remember.
Y	You know, it's been like... It was in March, right?
N	It was in March. Even though we don't...
A	It was in March?!
N	Ye...
Y	Yea.
A	Six months ago... ?
Y	Half a year...
N	It's a... it was just a few days before my birthday...
Y	Aaaa...
A	Aaaa, it was then?! Come on!
N	It was 7th or 8th of March...
E	No, 8th... 8th of March.
A	This cannot be... (*everyone is smiling*) Six months...! (*everyone is smiling*)
N	In those terms, we don't need to recreate anything. Because, anyway it's a different work. But we wanted to share this with you in terms of you to critically dismantle our...
Y	So... so... reunification...?
N	Ya.

Y	In Korea... (*more to herself...*)
N	Ya. So, we would... What happened is that we were not accepted with the radio drama for the exhibition in Korean Cultural Centre. Here, in Berlin. But a few months later, we got to be invited by Korean curator, to Seoul, to the Cultural Centre of Seoul...

E explaining in Korean.

Y	M, m, m!
N	Yea... to this Memorial... Umh... E can maybe explain better... But we understood it's a huge thing in Korea and it's dedicated to the activist, who was...
E	Kim Geun-Tae...
N	... fighting for democracy.
E	(*explaining about Memorial in Korean*) She knows C.
N	Aaa! Because she is from...
Y	She's now in Korea.
N	That makes it so much easier (*everyone is smiling*).
Y	She's not here...
E	No.
Y	But she's the curator...?
E	She's an expert on North Korean art.
Y	Yea... May I have that?
N	... please! By all means.
Y	I am having it anyway! (*smiling*)
N	Please! Do not need to ask... (*smiling*)
Y	Yea, so...
N	And...
Y	... and then the exhibition is going to be in...
E	December.
Y	Yea, ok. December. And you want to present your work there? And...
N	We have a book.
Y	A, ok.
N	We decided to... She... We were invited with the radio-drama. But since we couldn't interview Mrs.P who was originally one of the voices of the radio -

drama, we've decided to… She said this important sentence and then we also…

A Maybe that could be the opening sentence? Like, you open the book and that's the first sentence: I don't want my words to be used by art. (*E smiles*)

N Definitely!

Y You can use that sentence?

N … if she allows. Definitely the title of the chapter. Short description of this work is: When we became aware of these - it's little to say ambiguous - issues, with the work and with the theme, we realised why don't we display this ambiguity? So to make visible the troubles we've encountered while making the work. Because, on a wider level, I am sure, some of the Koreans, from both sides, might relate to some of the problems outlined in the book. And we felt it might be valuable in terms of speaking from the position of Yugoslav experience: look, we've lived through this transition that happened after German unification and dissolution of Yugoslavia, so the consequences for Yugoslavia were devastating. That doesn't mean the same will happen to Koreas. But this is what happened. This is part of the history. So, we are trying to mobilize this experience because somewhere we feel it's important and relevant. Now we are trying to find a place for all these things that we feel are important, by interviewing people and sharing - ok, we have a set of problems. Like, a lot of problems and we are not trying to find a solution in terms of power positions as we know it – no. What we want is to assemble a book that will approach these problems from different sides. The book. The book is a piece for itself. It will be treated as a brick and we will make a wall out of it (*getting up to show the sketches for the work*).

Y So, for me, you interview…

N	I have it here... The drawing. Sorry Y to interrupt you.
Y	So, interview as many people as possible? Or, do you...
N	Just some...
Y	... just have a certain number of interviewees?
N	Not as many.
Y	M, m, m.
N	Not that many. We want some of the people that we thought... how should I say? ... that we thought are...
Y	... Essential, or important, or relevant...?
A	Yea, that have something to say...
N	... reflect ...
A	... have an experience, you know.
N	And you are actually having a boyfriend from Yugo-slavia... (*Y is smiling*: Ya ...) ... which directly relates you to the theme. (*E smiling*) Because, probably, between the two of you, this has also been a topic... Especially with you studying politics.
Y	And, this is a wall of books?
N	Ya.
Y	... random books?
N	No, no, no. This is our book. (Y: A, ok...)
A	Our book will be, sort of...
N	... like bricks... you know? We wanted it to be inter - active in terms of... we will make a shape in the space, with these white cubs underneath as we have not enough money to print enough books to build a proper wall of book alone.
Y	Not supported? (*smiling*)
N	No...
Y	But, the curator...? No?
A	We are, but not... it is not enough.
N	So, we have 800...
E	Euro.
N	And we will use it for the production of the book. We will not go there (*smiling*). Nothing.
Y	Oh, really? You have to pay for the flight ticket and

	everything by yourself then.
N	... We don't have money, so... No. (s*miling*)
Y	So, you are not going there?
N	No. (*Everyone is smiling.*)
Y	What?! E, you are not going...?
E	I don't think so... (*smiling*)
Y	You are just sending your work there, and...
N	Exactly.
Y	... they are going to install everything?
N	Yes.
A	They are going to print the book and install the book.
Y	Wow!
N	So, we have to prepare everything ...
Y	... here!
N	Mhm.
E	Actually, I found a flight... just before I arrived here ... It coasts *sechs*... six hundred euros.
Y	That's affordable.
N	Yea, it is. But it's three of us...
E	With kids! (*Smiling.*)
Y	You are also part of the team...? (*Addressing A.*)
N	Of course he is.
A	I'm androgynous. (*Everyone's smiling.*)
Y	... how to say? You know... Maybe you are responsible for theatrical presentation?

A is smiling.

Y	(*smiling*) I don't know... just making a role... *(N smiling)*
A	Role modelling.
Y	I see...
N	We wanted to offer them to dismantle the wall and get the *book of problems*...
A	A manual.
N	This is what we want to share too. How it's really hard, but necessary. Challenging but also important.

148

In terms of the field of art to talk about these problems but not as someone faking that he is asking (*smiling*)... Never revealing challenges that were causing troubles during the process. Also, life in diaspora in Germany. (*addressing to E*) You told me a lot of people from Korea actually think... that you are like a... super... upper class if you move to Germany. (*Sounds of the late breakfast are rattling in the background.*)

E Ya...

N Whereas you are struggling for life and bare existence. And that's really what I want to be visible... That we are working and making an artwork out of nothing. We don't have anything. And we had to adjust our idea to the lowest of standards. Eventhough our beloved curator thinks our idea is awesome, which I dearly appreciate, the truth is that we are actually working like a working class - we are working some - where else so to be able to finance art. I want this cynicism visible as well as this struggle of working class migrants who are trying to articulate their political position in an attempt to subjectivate within the system which is cruel and cold.

Y It's actually two perspectives, right? So, one perspective is of Korean unification and Yugoslav... not unification but... kind of, division...

N ... related by this one act of *Mauerfall*. There are many perspectives. The relationship between Eastern Germans and Western Germans. Which is for me a class issue. The price of the labour went way down... By second-grading eastern Germans they got cheap labour force. It also reflected on education... And *Wohnung*...

Y Yea, *miet* price.

N There are many consequences...

Y I get the point. But how many people are you going to interview?

E	6 or 7 …
Y	How do we contribute with our story?
A	Experiences…
E	And in dialogue. With us. It would be a text.
N	So how do we do it?
Y	You just record the conversations and…
N	… and then we make a transcript…
A	And then we cut. Let's say it resembles a dramatic structure.
N	Like a theatre. No names. No personalization in terms of revealing someone.
Y	I am fine you use my name…
N	Me too. But maybe some people are not comforable… Like Mrs. P for some reason… That was strange. Or maybe it was only with us. Or with art, maybe…?
Y	So whoever expresses a wish, you are ready to change the name or use a pseudonym or …
E	We should think about that…
N	The process is still young… I don't know what will be at the end but for me the most important thing is that everyone who contributes… that his or her contribution is visible and acknowledged and admired. We must not and we are not allowed to deal with this subject without actually speaking to Korean people. I mean who are we? That's kind of a colonising thing. I mean: hey, we have been fucked up with one break of the wall.

Everyone is laughing…

A	We identified similar problems.
N	When this 'destruction' of the wall happens in Asia and when it happens in Europe, the most wrong thing to say is: this is the same. (*Followed by the sound of clapping hands.*)
A	It also has a lot to do with an attempt to deconstruct

identity politics as such. Because in this sense, Yugoslav model is a good example of how identity politics prevailed over a class politics. What they had in common is class identity, and now – from the '90ties, since the multiparty system came into par – they were suddenly not being addressed as workers, but as members of a certain nation.

N Ethnicity...

A Ethnicity prevailed over class issues.

N Now, the most important thing... Sorry to interrupt you... The most important thing become to express your identity which is how identity became a battle - ground between right and left, too. Because your identity has everything to do with what you are inside as well as what is your position in society. (*smiling*) And if we give away of what is inside – if we give it up in the way we gave up our social positions by 'with-drawing to our individualities' – this is directing capitalism towards its next quest for appropriation. And this is how we get to be commodified inside, too. It sorts of colonises our inner being.

E It's good to hear.

N (*laughs*) Thank you.

E Because this is my... a...

N ... feeling...?

E ... feeling also.

N I read this beautiful sentence by Audrie Lourde this morning. "Yeah, Freedom. It's important. It's the most important thing. At one point you achieve this political freedom. And then you are outside of everything. Outside of society, outside of everything. Hungry. What kind of freedom is that?"

A Hungry freedom. (*smiling*)

N Actually, you may achieve this political subjectivation which then puts you out of society as it is. It is not necessarily that outcome. But in capitalism, if you

are not "the same", you are out. And for me that's devastating because I realise that I internalised this black&white binary which has never been a part of me. But this is how the system operates. And also, I wonder now in terms of this binary: we are divided – that's wrong, we are united – that's right. I think our book wants to try to make people think: let's see if it's like that or if Europeans are colonising us all over again with their own notion of division? Because, why would we compare those things?

Y Is that the main, like, message of your work?

N No, just one of them.

Y I think that is the most appealing and the most interesting for me. I understand from which context you have designed your work. So I know there are many problems: as foreigners, as migrant women, as Koreans, Serbians, Croatians. We are really familiar with these problems. I think you need to narrow down what you want to deliver because this kind of black and white division is obvious, as well, in political sense ... You always have to express yourself as either you are here or there. (*E and N together: Mhm...!*) There is really nothing in between. I have so many problems with it because even liberal, like a Green Party or labour party, you have to always aside with their main agenda, even though I have a different opinion. I can't really express myself because then they kind of, you know, really attack. And that is why I am very cautious in expressing my real opinion in public. Your art could be this: two artists or three met in Berlin by accident... And then they found kind of commonality, like common problems and common view... They want to break this wall by putting individual stories in the book and the purpose of the installation could be to break the wall that always exists in our relationships, in politics.

N Maybe it is also worth mentioning when the wall
 went down here, it was the wall that protected people
 from fascism which is inherent to capitalism. With the
 breaking down of the wall fascism just spread every-
 where. People from DDR think they were devastated
 by not having seven kinds of M&M's. In Yugoslavia
 we got Milka in early '90's, even though we knew it
 existed. But I wonder, what was the price we paid
 for that Milka? So, when the *ECF* asks: Why do we
 have a sudden rise of right-wing politics?, they forget
 one important thing and that is the equating of two
 "totalitarianisms". They claim that communism is
 the same as fascism. And this is exactly how they got
 their right-wingers both in Parliament and marching
 the streets and 'redesigning the public space' with
 populists' protests.

 (...)

*The sound of the kid's voice singing out loud from the back
of the room: "It's a final countdown..." by '80-ies West Ger-
man pop band Europe. Everyone bursts into laughter!*

N This is where I wanted to start. Berlin wall. The
 anniversary is in November, and they somehow – in
 Korean Cultural Centre – connected this wall and
 dismantling of the Berlin wall with dismantling of
 the DM Zone.

U is explaining to Er what is a DMZ and where it is located.

N We wanted to travel to DMZ. So we were like – they
 are probably not going to give us money for that.
 Let's make a more modest idea, but to stay on this
 course. And then it morphed into radio drama. This
 is where we wanted to interview Mrs. P. This is how

we got an idea.

E Do you know who is Mrs. P? (*addressing to Er, and then continuing to explain in Korean*)

N We thought that we could provide the space for her to tell her story, but then... (*smiles*) ... When we came there... it looked as if she changed her mind... In a way.

U So... she changed her mind?

E Ja, ja.

N Mhm... Either because I might have appeared to her as too direct or... English could have been a problem also. I came before E and I came with my kid. (*smiling*) She was really confused. I said why I came and then I realised... She thought I was just a guest so she offered me coffee. (*E says something in Korean and U smiles.*) But then, with time, she realised who am I, because she remembered she had a deal with E for me to come and talk to her. Then she was coming slowly to it. Our story has been mostly concentrated on her kids because, I guess, that was easier. I figured... I am probably not a good solution for her, in terms of conversation. But, the reason for coming to talk to her was not an interview actually. When E offered her the opportunity to tell her the story through this art project, she said two very intriguing things. She said: "I don't want my story to be used by art. And - I don't like how G is..." - please correct me if I am misinterpreting ... (*addressing to E, E: Mhm*)... "I don't like how G is treating North Koreans. (*Everyone: Mhm...*) And for me those were like ... Red alert! Something was wrong... that triggered me. Our work is about this too. Not about us moralizing and theorising whether the occasions of dismantling of the walls are the same, even though we will reflect on that too, but about understanding what the problems are when we address

these subjects of unification in the 21st century. Our problem was, also, that we had no one to talk to as we do not know anyone. Actually, the interface that heled us to better address these issues is friendship. Because... we only have friends.

Brick wall, childrens playing kit, 201●

Chapter 5:
Oh no, now these people from the East will come and they will want something

All laugh

M Never mind... North-South Korea I know only from the position of being there as a tourist. And from the news. There is a weird polarity. In political and military terms. That was during the DDR here as well, but not so much. Because the East was too near to the West, so it could not show all its negative sides. Berlin in particular was, in that sense, soft communist. However, how can I, without knowing about Koran reality, say something about it? Can you imagine? On one side hunger, almost extreme lack of food in the North and in the South the surplus. Then, from an economic perspective, it costs so much money to establish equality. Much money can be earned and good businesses can be done. The same happened in Germany. The West realized that it can sell very good in the East. All those things that, otherwise, it would not be able to sell so easily. Many people became rich. On the other hand, it costs very much to bring them to an equal level. What do I have to do to become part of your world? The economically weaker part stared with big eyes. The stronger part took care that not too much of negative aspects are revealed. But the problem is. Now. When so much time has passed. The East is still unhappy. While I was working at the Opera,

the wall came down. And I said – ok, and I went home. After the second day it was clear that it became normal to travel to the West. We had friends in West Berlin and so it was time now to... to visit them. We thought they would accept us there and we could not ignore it. So we sat in the Trabant - three kids, my wife and my brother. It was very tight and against the law. But it was ok, as the atmosphere in the city was a rather festive one. So we drove over to the *Potsdamerplatz* and that was nice because one could drive a car without obeying any traffic rules. We were orienting our selves according to the 4 cardinal points. There was no navigation system. I was just driving, following the signs on the streets. In the East there were no such signs. I missed the address several times, drove over a pedestrian zone where people were waving and probably thinking "these idiots from East don't even know what are they looking for."

What should be mentioned too, is that the East immediately received money because otherwise it would be a great tension. Here you have nothing and over there, there are these offers and good deals, which we did not have here because of shortage. So the politicians said: "Ok, people first have to get some money". It was... the welcome-money. 100 DM for every person. And for children too! I don't remember how much. And I am not really proud. But, now, looking retrospectively I think it would have been better, if the East Germans did not immediately run for the money and went shopping. Because it was clear it was not the future. These 100 DM.

A It is a bit humiliating.

M Yes, actually yes. But at that time, it really functioned smoothly. Like water. When you look at it, ignoring the spectacle of the border being torn down and the turbulences in all the different systems, divided

country and other landscapes, you always and every where have people. Ordinary people.

A Who are not being asked about anything...

M Yes, but also there is a question of how one is taking part in politics. If not, then they are not to complain. My family was in the church, so there was this re sponse from the state that they belong to the church, and we had peace. Some of the professions and jobs, however, were not possible without the person being a member of the party. For art, that grey reality and boring politics were advantages. Politics was boring, economy was boring. We had the impression that for instance the situation in Yugoslavia was much more advanced at that time. But we also heard that it was already very much westernized in comparison to other states from the Eastern bloc. For us it was hard to get a permission to travel abroad. We were in the real East. With grey houses. Grey shops. Everything boring. But that is a chance for art. If you make something, it becomes more visible. When you make some thing today, the whole city is overcrowded with offers and we are all overwhelmed. Entire reality is so saturated... so much so that I do not have a motivation to do anything. Silence. Like a child that is just about to find a very simple silence...

E And after the reunification, was the orchestra filled and mixed together?

M Yes, through open calls. But even before the wall came down, we had a special role. After the war everything was ruined. Then came the wall, but the director was able to keep colleagues who lived in West Berlin, so they were working with us, but living in the West.

A How did they receive their salaries?

M Part of it they were paid in the West, and part of it in the East. They could buy music scores for very little money. We had very good publishing houses here and

	on the other hand, they were able to bring us goods from the west.
A	Yes, a chocolate from the West.
E	But, the audience was only people from the East?
M	No, no, because people from the West could come to East Berlin.
A	So the West could travel to the East, but not vice versa.
M	It was not so completely divided. As is the case with Korea.
U	It is so beautiful. Scripts from the East and chocolate from the West.

Everyone laughing.

A	But how was it? You could then remember how it was in the Opera before reunification and after. How long have you been working there?
M	Since 1983. I had worked there during the time I was a student, also. The end of '70s. It is hard to answer the question. But I do not want now to say that the East was great and the West is bleak. Once a colleague of mine criticized me because I was sitting there and it was visible that I was not super impressed with what and how we performed. She was relatively new and was very excited. And today we are kind of neu tral. Not showing mistakes, like, don't show that you are weak - *I have no problem.* That is this Western system. But when you ask and talk to colleagues, they are all sick, have mental problems. So, we are some kind of a sanatorium. On the outside we are an orchestra.We make beautiful music. But it is terrible what happens inside. We all have our days. In the end, it is good when you know that everyone is having the same problems. That is now the thing when I think about the division of countries. What does it mean? With regard to Germany, many things have changed.

I think also for West Berlin. It was supported by America, it had its special status. And it always wanted to present itself in the way that it is a dream and - capitalism is the solution! Suddenly the enemy was gone and now everything became diffuse. Everoneis frustrated. Also, people in the West. In such a small universe, like the orchestra, one can see what happens. There are also borders. Artificial borders, between groups of instruments like string and brass instruments. Or the division between the orchestra and the choir, which perhaps is not so rigid, but still is a division. Younger and older. There are some unspoken territories. And finally, the process of application. When young people come and present their playing technique, they are under terrible stress. But that is the problem when you have more musicians than actually working places for them. Yes, well I could tell you now the story for hours. But for the purpose of the interview I will keep it short. I have recently experienced again this situation with a colleague who was on probation period. I came into the room where the others were deciding about her future and, again, I have told them that I think that the probation thing is not good. But nobody wants to get rid of it.

E How was this in the times when you started to work?
M I did not have it. In the East there was no probation period.
E How was the application process then?
M It was like this: If you succeeded passing all three rounds, you would get a permanent contract.

A does not believe his ears!

A ... immediately a permanent contract!?
M Yes, it should be like this. Only then people can learn about each other and develop with each other.

A	Now a good socialist is speaking from your heart.
M	I don't mean it in a political way, though it is political. It is about money. In the sense that money is now the God. And they behave as if they've been giving it from their own pockets, but they are not.
A	Yes... It is a position of power...
M	So you first have to belittle yourself...
E	Yes, Yes.
M	The first year you have to be little... So this theme: different countries; in a poor country there are people who have the strength. They have strength in the shortage. And the people from the West, with them I have always asked myself: How can you make music in such a luxury? Of course, they can afford to buy better violins, but when we have travelled to the West, in smaller cities, I found it very strange. Everything was paved and we had the open ground and stones reaching up to the houses. A perfect tailored city. Then you had the hotel and I see this woman, coming home. And somehow, I felt pity for her. It is like legoland. Everything is already done. What can you do there? But then when the wall came down, and the welcome -money came, and all the men in the East wanted to have their car and then the difference came to the fore: we are the superior, you are the weak ones. And there is this question: Are you still not satisfied? And this still not being satisfied is an interior dissatisfaction. I had a relative who was already old at that time and he always said: this thing with the welcome-money was one wrong decision. The visible life is so much oriented and modelled after consumption. I still remember, when we came to visit our friends in West Berlin, they were teachers, I could sense that they had this idea: *Oh no, now these people from the East will come and they will want something*. But in the end, they were all confused because we did not ask for

anything, instead they were coming more frequently to our place. And it soon became clear, they had a bad consciousness. Because they could see it: What is now the West supposed to do with the East? I was perhaps a bit naïve. But when we did not function completely like the men from the West, they were wondering: You now make good money, so why don't you buy a washing machine?

E How was the salary system before and after the reunification?

M Well, the currency changed. We had to give up the DDR money: one West German Mark = 2 DDR Marks. Then you had... I don't remember it now anymore. But you had this exchange system, until one day only the DM prevailed. The East Deutsche Mark was abolished. You would, then, get your salary in the Western currency. In the beginning it was lower, but then it got 'adjusted'.

A But then in comparison with West Germany, did you get less?

M Yes, but today it is the same. The difference is not so big.

E And I want to ask you more about Korea? How did you become interested in Korea? What is your first experience with Korea?

M Through people. That happened once the West took over. I met Korean musician in the orchestra. Because we had applications from Korea and so I met people. The language was interesting. I started learning it... a bit. It was, however, going very slow. But for a long time, I was preoccupied with it. After five years, I traveled to Korea for the first time and I was so afraid that I will not understand a word. The good thing was that a friend of mine was there at a time.

E Where did you learn the language? In the *Volkschoch-schule* in Berlin?

M Yes, in the beginning. And then in Korea, where I

had a friend who was playing in a youth orchestra. He asked me if I would like to give some lessons to his pupils. That sounded interesting so I accepted it, as I thought I would have individual classes, which I would be able to handle with my poor knowledge of Korean. That was somewhere in the South Korea. But why can't I now remember the city?

U Jinju!

M Yes! Jinju. We came there and there is this woman manager in this small city. We arrived by bus and I still believed, I will be having individual lessons. Then she came, invited us to a big Korean meal, as if I was some kind of an important professor. Then, she handed me the program for the week, along with 20 kids and then another 20. And I was supposed to do a rehearsal with them all by myself. It was like a horror.

Everyone is laughing.

Then, my friend joined and we did it together. The kids were very nice. But I am neither a professor nor a conductor. I went to Korea three times in this way. And then I went only to visit friends. Last time I went to the DMZ. Before that it never interested me. I knew how the border looks from the times of divided Germany. But this border was tougher. Now, I was not very keen to go there as a tourist, but my tandem-partner wanted to show it to me. And I saw this tunnel. And that is interesting. I had a sensation that it is like a theatre. On one side, there is this total absence of joke and everything is being so strict. But then, on the other side, there are parts where you were allowed to take pictures. So it was a bit illogical. Then you get into the tunnel and these people who had to dig it, you felt compassion for them. From the perspective of

someone who, like me, had the experience of living in the East, I could not tell how people in North Korea live, I guess it is much tougher than life in the DDR. But when there is a situation of famine, then one is not able to understand it. Then, it is not just a normal life in a different background.

A Where you have a choice between 5 or 6 products...

M But when the choice is between being alive and not being alive... The same thing is with the war in Yugoslavia. That is something that I can't talk with people because I lack the actual experience. How old were you then?

A 12. I can remember it. Especially because I was living in the city where the war happened.

M Which city?

A Osijek. 20 km from the town, there is this other town - Vukovar which was totally destroyed in the war.

M That is now, again, a different story.

A ... an experience... that... can hardly be communicated... It is either you have made that experience or not... It is like when you speak to someone, who survived the concentration camp.

M They speak rarely about it because they can't find so many people who made the same experience.

A What was interesting for me is that the whole complex of reunification of the two Germanys remains something that has not been reflected in its complexity. Especially from the perspective of East Germany. In my intuition East was somehow colonized by the West.

M Yes, it could be said like that. But it happened willingly, as if the East was shouting – colonize me! For me it is hard to make a generalizing statement. Something like - the German or the Korean... don't exist. Only people exist. Individual people. And this you can see in the orchestra. You need five people with a desire

for power and they can ruin everything. I know many people who were living in the East who became true capitalists. But perhaps they have always been like that. On the other hand, I have a colleague from the orchestra, who is very straight inside and he is some - thing like an East-soul living in the West. But then, you also sense that since they were children, they were raised with this idea in the background, that money *is* existence. And that is not the case in the East. For the people from the East, money stands for the mean and not the value itself. I use to earn 1000 East German Marks at a time and that was enough. Food was cheap, housing too. But if you needed new trousers because the old ones were worn out, you had to plan it in advance. So it was not very comfortable with the money. You were not able to multiply it, as private initiatives were not so well received.

A And how was it with private possession?

M You could have a property with a house, but that was it.

A Unlike today, where one can own 10 or 20 houses...

M No, unless it was somehow connected to politics and the state and they could gain profit out of it. But I really doubt that we can generalize. In that sense, the reuni-fication of countries is very abstract for me. You can remove the division, but finally what happens in terms of quality, really depends on the people involved in the process. I can only think about it in constel-lations of a smaller group of people. If something is developing or not. But already in parties, it becomes difficult. I am not the kind of person that can easily become a part of a political party. The same is for the church community. Though I am not an atheist, I don't really feel at home in a group. On the other hand, I appreciate if people refrain from this indi-vidualistic attitude. That, what I have experienced

in Korea, this thing that people simply do without so much of a protest - identify with the multitude. You can see it in trains, in the orchestra over there and with the youth. They are sitting with such patience... which is unimaginable here. I see this kid there. She is sitting down, waiting for her turn, not showing signs of boredom. A German person would be very irritated. This emotion of: me, me and only me. I like it when this is not so present.

E (*asking U*): How do you feel about the party? What is your motivation?

U I am not in the need of doing myself.

M You don't emphasize yourself so much...

U I need someone...

M You need someone to dive into this society. That has a pleasant side. When one is only sitting at his home and thinks about "I do", "I make", "nobody understands me anyhow", or "I don't have the right audience", then soon, one gets very isolated and very poor.

U I like that type of people who have a strong sense of meaning and make it true.

M You are interested in people. I have heard that she is interested in the Green Party, and that she is a member and also very engaged. Within the procedures of democratic elections, she was very keen to know why there were people who vote in non-valid way. These are not *yes* and *no* positions. Is it only laziness? Or indifference?

A Do they feel addressed to vote? Or, they might be having a sense that them voting can't change anything...?

M It became increasingly difficult with the political parties. We now have elections - in Brandenburg - where I live. You see all the bad faces on the posters. The nicest face was some woman of the FDP party, but that is not a party one could vote for. But then I have voted for left parties. They do not seem to stand a great

	chance, but I am voting for them because - for me - politics should be about justice and equality.
A	That is strange... that the left does not have enough power to enforce these values.
M	It could work as a protest against the capitalist system.
A	I think that people feel that they are still safe.
M	For me... I have a feeling that the majority of people are afraid that their comfort would be jeopardized. That big companies would go down. I think that ego - tism is what is preventing the change. When people from the East now say that they miss this feeling of collectivity, that people, neighbors were more open to each other. This nostalgic affect. We always thought it is strange that when you help a friend to renovate the flat, he either pays you or does the same for you. Or that you have to call someone before you come to his place. That was really totally different in East Germany.
A	That is my experience also from Yugoslavia.
M	But how was it there? Was Serbia economically more powerful than Croatia?
A	No, as Yugoslavia was one economy. However, Croatia was perhaps in a better position because of tourism and the Adriatic Sea. Also, Croatia was a part of the Habsburg empire for centuries. A big part of Serbia has, on the other hand, been a part of the Ottoman empire for five centuries and these have been economic, cultural and religious differences which implied inequality, in a sense.
M	Was someone economically stronger?
A	Yes, Slovenia and Croatia. They are also countries with Catholic majority. So, what you have is this former Habsburg countries, on one side and on the other side you have the Ottoman Empire and also the clash between the Catholic and the Orthodox church. And that was the source of a lot of tension.

M	I assume this comes with a lot of prejudices.
A	Of course. Furthermore, the capital city was Belgrade so that Slovenians and Croatians were not satisfied, like: everything we produce goes to Belgrade. Then problems and conflicts just added up and it ended up with a palimpsest of problems. And when socialism went bankrupt in Eastern Europe, all these contradictions could not be balanced any longer.
M	Yes, they were lacking something that would hold them together. Here things resolved in the form of inter-weaving and there, it all fell apart.
A	Also, in Yugoslavia you had the religious difference and the question of national identity and a bad memory of WWII. In that sense, 50 years was not enough to resolve all these complicated issues. This ideological parole of *brotherhood and unity* did work during Tito's life. After Tito died, everything was gone.
E	How do you identify yourself? I never asked...
A	I always say I am a Yugoslav, which is a radical political statement. Especially in the context where Yugoslavia does not exist any longer. So, when I put it like this, it is a clear statement against the newly formed national ideologies, and against the dismemberment.
M	But what can you do against it?
A	Nothing.
M	I see it in this microcosm of the orchestra. You can come with your arguments but when things are to change, then everyone has to agree and there will always be those people who will say: yes, but.. The problem becomes even more evident when you observe relations between states that have to be modeled and organized through laws. Democracy is a good thing but sometimes it can have bad consequences. My wife sometimes says things should be decided outside of your crazy group. There should be someone who is reasonable enough to make a rational decision. When you have a conductor, somone

who can stop certain things, then things can work.
I think it is necessary to have something like a brake
that can be used against bad democracy. But who can
guarantee that the brake will not be misused? How is this
to be applied in countries where you have so many issues.
In that regard, I ask: Why do you want a reunification?

A For me a really question is what does it mean, when someone says I am German, Croat or... ?

M Yeh, that is...

A I think you have made a good point by saying that all we can do is detect a dynamic within our collective and see what is functioning and what not...

A How many people are there in the orchestra?

M About hundred.

E Hundred?!

M Yes, people from at least 20 different countries.

A ... there has to be tension sometimes?

M Yes, but without a reason. The level of education is high, the democratic principles are acknowledged, so ther is an illusion of order. But what happens in the heads of the people? For instance, this person who just glanced over applicants made a statement: and no Korean applicants this time?! And then... There was a cello player, playing so beautifully just like in a dream. Nevertheless, one other colleague of mine commented: soon we will have only Korean people in the orchestra and you will have to translate for us. What was that supposed to mean? I mean really...
That should be something like humor...?! A bad one in the end, and it seems they really think there is enough of "other people" in the orchestra.

A Something like: the orchestra should become more white... or?

M Instead of that, they should be thinking - why is it like this? Why are they better then our own musicians? If so, then we should go there and learn from them. We

need to make this step. Now, that would be a correct action instead of saying - we have to stop them from coming. Because this idea of stopping them of coming is to express fear about something that no longer exists. That is so sad. These minds are lost. Maybe one should not lose hope, but... and maybe the next generation will be better. It is a generational problem I have experienced that people around their forties, mid-forties, they are problematic and they are - for me - the most uneasy ones. They have this stupid self-consciousness like: *We and We. I have this job, I am in my mid-forties and now it is my time.* In a sense, they are saying: *Now it is my turn to be in a position of power! Before, I was too young, afterwards I will be too old, but right now it is my time to gain power.* Younger generation, on the other hand, is much more pleasant.

An entrance to a Nazi bunker, 2019.

Chapter 6:
They are totally normal people

E Do you know this work?

A Ah, je, je, je... this is the new one... ja.

E Ja. And I feel that this is worth nothing. But with the other object it makes some kind of sense... in that sense...

N I know what you mean.

E ... emotions. So I want to use more sensitive way... or emotions... For example, food can make smell that is so ... (*smiling*)

N What about song?

E (smiling) Je...

N Song! We said the song ...

E A ja, the song...!

(...)

A Aha... ok, ok...here it is!

E Ja.

(...)

N He was singing a song while...

E While he was...

N ... tortured!

A "I would rather stand tall and die, than to live shamefully ... shamefully on my knees."

Sudden silence. Only the sound of typing over keyboard gives a bass line to an outdoor sound of the city that is nowhere near to sleeping. Everyone seems as if they have suddenly drifted away somewhere inside, but the atmosphere feels thick and heavy as an air in the hottest summer day.

- 2 -

A Can we hear it maybe, somewhere? Or...

E I should...

A Just you know... to get the sense of... Because, otherwise I like the... this song which, which you... which the actors were singing in, in, in your piece... it's a...

N It's beautiful!

E Mhm...

A So... when you enter the... our room... that you see the wall and the song...

E+N Mhm!

A Because what I've heard... I was moderating a talk... with one of the dancers... last week at *Tanz Im Au gust*. And in her piece she brings a bit... how do you call it? A... blaster. Sound... you know what I mean... like this old model from '80ies ...

N *Zvučnik?*

A ... cassette recorders...

E+N Aaaaaaa! Ja, ja, ja...

A In her piece... at some point she says: In the DMZ South Korea has made such a wall of noise, such a wall of a... ghetto blaster... to... send some audio impulses...

E *Die Beide!* Both!

A A, so they were fighting with...

E North Koreans make a lot of sounds and South

	Koreans make a lot of sounds...
A	So they were fighting with sounds?
E	Yes!
N	It is like... music!
E	You can see the wall ...
N	I think they were communicating... (*smiling*)
E	(*smiling*) No communication... just... argument on both sides.
A	Sonic fight!
E	... for example...
A	Sonic argument
N	... argument... sonic, like a... music! Music war! War with music!
A	Sonic contest!
E	Just... voice... for example, from South Korea to the North Korean: "Come to South Korea, freedom is here! We can live here as rich and... blah-blah-blah". And the other side - North Korea sends a kind of communist thoughts... (smiling)
A	Oh God...

A is whispering something while searching on the internet. N exhaling in a sharp, loud manner. E spelling out loud in Korean while typing on a keyboard.

| E | So... (*the sound of two surfaces brushing against each other as the laptop turns toward A and N so better to see*)... There are no subtitles but you can just feel ... |

The sound of a random Internet advertisement in German followed by the sound of the sound-blaster wall messages spoken in Korean official tone by a female voice.

| N | Awwww...! |
| E | This is very conservative TV show... (*The sound of the Korean TV speaker runs in the background.*) |

	... so you have 20 km of it ... (*translating from Korean*) "You will hear this Korean sound..." - it's kind of news... very positive news from South Korea, so...
N	It's like... like Guantanamo...
E	Guantanamo?
N	Guantanamo is a prison... where Americans torture people with loud music.
A	*Vidi kako to izgleda*! Look at this! It's amazing!
E	This is DMZ. The...
A	But we don't hear what they are playing in the back?
E	... from North Korea? (*while trying to identify the sound of the song over the internet. N indistinctly murmuring.*
E	(*smiles*) Aaaa... let's see... (*The sound of Korean official speaker is still on and in recognizable form*) So, North Koreans broadcast the radio...
A	Aaaaa...
E	... not through the speakers ... through this heads...
A	Je, je, je...
E	So if we can make a radio channel... We can just... listen to it... in the car...
A	... and they just get their frequency...
E	Yes... This is North Korea... the same as South Korea... These are South Koreans.

N is returning back in the kitchen.

E	And you can see the movie... there is a very well known movie... It describes these situations... from the South Korean soldier and from the North Korean soldier... they both make these sounds... but they also make friendship between them. And the North Korean soldier comes to South Korea, it's a fiction... but it's very... cultural story...

(...)

176

A	Mmm... but I loooove this... no you don't have to... (*mumbles quietly while E laughs*): A, ja... I love these speakers ...
N	They look really powerful... and threatening...
A	It would be great... Could that be somehow... ... subverted by playing music, by playing...?
N	... no... because it's so grandiose...
A	... to play some minimal techno or...

E smiling.

A	Can you imagine that this is played from that big wall: ... (*whistles Internationale*)

E smiling.

N	I can imagine...
A	That would confuse them all... (*smiling*)

- 3 -

E is writing down the expression in Korean. Small concen-
trated silence, filled with admiration, follows the writing
process of every letter. The effort is crowned with joint
laugh. E is explaining sign by sign)

E	Every... (A: Aha...) ... things. (A: Aha...) Divided. (A: ... aha ...)
N	Divided is in the middle. Yet it's the point that is binding. The word divided is inside of the word *every* and *thing*. And it's actually dividing.
E	Everything divided. So...
N	It works perfectly...!
A	But then... we could actually call it this... (*showing the words in Korean*) ... Every – Divided – Things...? I mean, we know that it's Everything Divided... but... We can play with that. How do you say Everything

Divided in Korean?

E A... mo... mo... mode... mode... moden... Moden.
 Moden. Na... nu... O, o, o... djin. Ko, kot, kot, kot,
 kot... tl. (*smiling*)

(All together, repeating out loud): Modn – Nanu-Odjin...

A O-djin...

N Like U...?

E Ja, ja... *genau*! *Ja*... (*smiling*) This is U... (*showing
 the part of the sign which is signifying U's name*)
 Actually...

N Awu... (*E is smiling...*) ... (*N is repeating after E*):
 Nanu-Odjin-Gotl...

A Gotl...

*All of them repeating the correct pronunciation of Go-tl a
few times.*

E Modn – Nanu – Odjin – Gotl ...

N Gotl..

A is smiling.

N It's perfect!

A Perfect!

N It's very nasal...

E ... And we can put this in the books... Every theme
 when we speak about Red People, Red is also divid-
 ed thinking... thoughts. So, divided family... divide
 by class... (*smiling*)

- 4 -

E And the last chapter... the last chapter will have the
 same title but... different people. Because, I have
 been in Prague... It was so, so exciting... It was the
 first time that I met North Korean people (*smiling*).

A Wow!

E 20 people came. There were 8 parts: politics, society, language and there was a part about art and I was in that part. I met music *wissenschaftler* from North Korea and we had a very normally contact. So, my prejudice about North Koreans was broken. They are totally normal people. (*Smiling*) I have learnt about them as monsters...

N Can we have a chapter – They are totally normal people?

E But I think this is a kind of way... how Koreans see people. For example, when we Skype, my mother and my brother immediately notice out loud: You gained weight! Why aren't you wearing *hadjan*? *Hodji*? (*trying to find suitable term in Korean*)... *schminken*?

U But actually...

E Beauty is very important to them.

U But anyway, I want to say the attitude is very different. For example, how European people, think about Asian girl...

A Think about...

U ... think about Asian woman, and how Asian people look at...

A It's super interesting...

U ... white man. This is... they have different attitude.

A I have kept asking this question to all of our friends... How do you see this tension between South and North Korea?

N (*addressing to Er*) U ordered a coffee for you... (*smiling.*)

Er A, je, je, je... thank you very much.

U ... tension between North and South ...

A Do you think it will be possible for the two Koreas to unify or you think it's... not possible. (*E smiling*)

U But my first ...

A	I ask this quite straight from the beginning because I don't know the context well enough to be able to, maybe, articulate it in the subtler, more delicate way.

U	... things... I don't know much about North Korea.

A	Aaaa... interesting.

U	A. I don't know... I don't know.

A	So, but what do you have as an...

U	But I don't have any... *angst*.

A	Any fear...

U	Any fear...

A	Fear of communism.

U	A... (*A is smiling*.)

E	Fear of communism or fear of reunification?

U	Reunification, or socialism or North Korea... I have no fear.

E	Mhm, mhm, mhm...

U	But people who don't know, they have fear and that's why they produce worry...

A	... then they produce stereotypes and clichés. (U: Mhm...)

U	That's why I try not to have this preconception or cliché about North Korea or about socialism because I accept that I don't know well. So I don't have fear.

A	Because that was so fascinating for me when you were telling us that the contact between South Korea and North Korea is almost nothing. People are completely isolated and separated from one another. And that was the first time I really became aware of how delicate and complicated this issue is. And how Koreas are victims of this Cold War mechanism that still somehow operates and in a way determines geo-political constellation. When, just the other day we saw the movie ...

N	... National Security... about Kim Geun Tae...

U	Mhm...

A	Tortured and all...

N How he was beaten... (*E addressing to U repeating the original title of the movie in Korean*)

A And that was the first time when I realise that there is a... somehow the US politics has imported into South Korea this anti-communist hysteria. (E: ja, ja, ja, ja... N: Yes, exactly!) And actually that was the first time I began thinking that this anti-communist discourse is not something that South Korea came up with itself but that it's an instrument that belongs to the colonial, anti-communist discourse, let's say that way.

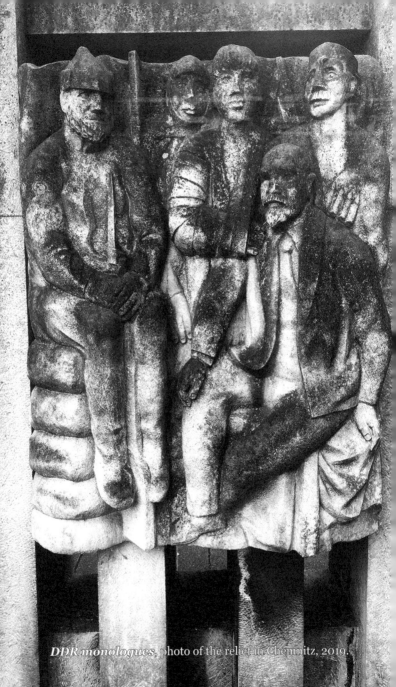

DDR monologues, photo of the relief in Chemnitz, 2019.

Chapter 7:
Double homeland

K Do you want a plate?

A *Alles gut*! Yes, it is strange. With the machine (audio-recorder, ed.rem.) everything becomes so... as if the machine would dress up a uniform.

K and Eu together – Yes!

A ... and the whole event, well... never mind. So, it would make sense if I explain to you what are we doing and then we get into the conversation. We were aiming to make a radio-drama. Something like an audio-artwork, which would deal with the complex constellation between North-South Korea, East-West Germany. At the same time, we wanted to compare and identify similarities and differences with Yugoslavia. What we are interested in is the position of the migrant - people who migrated to Germany... What are they experiencing? How they feel? Can they integrate? How is one accepted by the system? Or is being rejected, for that matter? The project has the title Red people and what we are interested in, let's put it like this, is: red ideology. Communism as an attempt to mediate social differences and set up a more just society. And we thought, that is something like a red threat: in Germany the socialist remembrance is almost suppressed. In Yugoslavia one is confronted with a total censorship of the socialist past and on the

Korean peninsula, there is an ongoing ideological antagonism. North Korea is a communist country and is being demonized by all sides. At the same time, and that's the impression of N and me, in South Korea, socialism is considered in a different way. How would you see this? Do you have sympathies for socialist idea?

K Actually I do (*laughs*) I think I do not represent the majority of South Korean people. My father studied social philosophy in Germany. In the '80s he was a student in Korea and a part of a student's mo-vement which was against dictatorship. He was interested in socialism. That is also the reason why he went to Germany - to study Karl Marx. So, he studied with Jürgen Habermas. Our upbringing was heavily influenced by these ideas because he ex pressed his ideology very openly. He did not teach us about it, he was more of a role model - he was living it. The idea of free market... or capitalism ... that is something, I think, one has to be very cautious about. A system should protect the weak and in capitalism that is not happening and that is not something that is appreciated. Therefore, I have sympathies with socialism, although I do not have any scientific foundation, so I can't really say some thing that could be verified by the scientific dis course. But I can only say how I feel about it. Many people from South Korea would disagree.

E I think you are right. In May we have made a theatre piece that deals with the democratic movement. And there is a scene in which K sings a song. She also told the story about her dad. At her home she listened to such songs. Leftist songs. That is interesting for me. As a kid she did not listen to normal songs, pop songs, but songs that are sung at demonstrations. And it can be said that it is a left

perspective.

K Friends of my father have studied political sciences and philosophy in Germany and shared his view. So, when we moved to Korea, I have noticed that this is not the overall attitude.

A Rather an exception.

K Yes.

A Great, that means we are in the middle of the fight. Did you grow up here? In Germany?

K Yes, I was born here and I have been living here since I was 10. And then we moved to Korea. From there I came back to Germany when I was 24. Since then I have studied and lived here.

A Then you have something like a double homeland. If one can speak of something like belonging. In a sense, you have been born here and I presume you feel this habitus as your homeland. Whatever this strange word means. Meanwhile the term resonates with the right wing ideology. I sometimes think that one should reclaim the term and give it a positive meaning again. It is also a part of the struggle: to think of a homeland not only from a right wing, conservative and traditional perspective. What is your relation to Korea?

He first made an error saying Verhängnis instead Verhält-nis, which means fate or to be doomed. Everyone laughs!

A What do you think of this idea of reunification?

K At the moment I think that it is not realistic. I don't know how North and South Korea could come together... Should they come together? In terms of economy...

A ... Could they come together?

K Yes. We have no insight. We don't know what is really happening in North Korea. How they are

functioning economically? That was already a big problem between East and West Germany. This difference... hmmm... Difference between the rich and the poor. And that became in Germany a regional problem. The new German counties where poorer than the West and that was a big problem. That was the source of many conflicts. We still pay this solidary-money and stuff like that. Similar conflicts could happen in Korea. North Korea is un derdeveloped in relation to South Korea and its regions are not so attractive. Perhaps the difference is even bigger than the one between East and West Germany.

E Where you in Germany when the reunification happened? Can you remember it?

K I can... I can recall it because my father was so happy.

A When the wall came down... it was such an iconic event...

K I think we were at that time still living in Berlin. We moved to Bremen in 1989 and then it happened in Berlin. I remember. My father was so happy. He and his Korean students. They were hoping that a similar process could happen in Korea. The hope: here something happened and it is a step towards the reunification of Korea. Now it is 30 years. And we are still waiting.

A If I got it right, there was something like a hope that the reunification of German would initiate similar processes in Korea?

K Yes, Germany was like a role model for us.

Everyone is laughing. The small child in the background makes loud noises.

A That is interesting. Two years afterwards,

Yugoslavia as a whole, unified country have been disintegrated in the war. That was a process of division.

K Was it not something that people wanted?

A That is the question- from which perspective are you trying to understand or interpret the events. Just look at the facts: there was a country with 22 million people and now they are all divided in Slovenia, Croatia, Serbia, Bosnia, Montenegro, Kosovo, Macedonia. Economically you had one market and now you have borders and people who can't stand each other. From the perspective of the EU, this thing with borders is a stupidity because we see that it is not only about the possibility of free travelling, but also about a cultural production and exchange. Now you can imagine how bad the situation is. If you look back, it seems that although the war is over for almost 30 years, the conflicts are still unresolved. There seems to be no idea of a better future.

K Do many people see it that way?

A I consider myself to be a minority regarding the way I described the things above. Just like you said about yourself. Now is the time, in post-Yugoslavia, to live this national euphoria. I sometimes use this phrase, coined by the German philosopher Helmut Plessner, the Belated Nation. For him that is one of the causes of Fascism and Nazism. His argument is that in relation to France and Britain, which had the chance to fulfill the idea of a national state, Germany and Italy were too late to become unified states. At the same time, they did not partake in the colonial division of the globe as much as other colonial empires did, so in that regard, they can also be considered as belated entities. It only happened in 1871 that Germany got to be realized as a unified country. If you look now at the Yugoslav model,

this figure of belatedness can be applied to under
stand the process of disintegration. In the late '80s,
the narrative that Croatians and Slovenes should
have their own country, started crawling up the
public sphere. It was a time for them to try out
their own idea of an autonomous nation:
one nation = one territory = one's own history.
Utter stupidity! Because these new 'independent'
nation-states nowadays are much more dysfunction
al than they used to be within Yugoslavia.

Stops talking for a moment and eats a piece of banana cake.

A How is it with the people from Korea? Do they con
 sider themselves to be one nation? Or a divided one?

K It is like with the Bavarians, which sometimes
 behave like they are their own country. It is a
 different kind of being proud. I have perceived the
 South Koreans to be discriminative. During
 my school days you could hear: 'we are pure
 Koreans'. It is always about drawing a demarcation
 line. That is how I understood my education. I don't
 think that South Koreans would warmly welcome
 North Koreans just because of reunification. It is
 not that easy. In Germany we talk about discrimina
 tion and racism. And when I meet friends who fled,
 they tell me: it is the others who are to blame.
 Not us.

A Yes. We are (always, ed. rem.) the good guys.

K It is always about this demarcation. I would be con
 cerned, if there would be a reunification without this
 aspect taken into consideration. There will be many
 conflicts. Simply social conflicts.

A For sure, I can imagine that.

K But it is already like that. When you have a Chinese
 worker or Chinese Koreans who come to Korea,

	their working conditions are worse. And they are treated worse. I have a rather pessimistic view. I simply can't imagine the way in which South Koreans could be open towards North Koreans.
E	I believe that normal South Koreans doesn't think that North Koreans actually exist. Like ghosts. There is no such country: North Korea. Only something eerie. South Koreans only think about one Korea: there is only South Korea.
A	I understand. Korea is always, only South Korea.
K	It is completely hidden.
A	Is there a dialogue happening in Korea at all?
K	About the reunification?
A	I was thinking more in terms of a reflection about how do we see ourselves? Is there such a discourse about this problem? About what is happening in the North? Is it a part of the cultural or theoretical debate?
K	That is probably something that you know better (*K is addressing to E*), as you have been the part of that forum. But it is like in an ivory tower. There are some scientists and artists. But I don't know of too many artists. I have always had an impression that it is artists outside of Korea who are dealing with these issues. Within Korea, it is not really a topic that is spoken about.
E	I have noticed that it is the artists living outside of Korea that are interested in this topic. Just because it is a hot topic. Many foreigners are also interested in it. For North Korea not for South Korea. Many people know already about Pyongyang and their president Kim Jong-un but they don't know the president of South Korea.
A	It is interesting to see that in theses societies one encounters the silence. We do not talk about the painful events of the past. For me, that is the

symptom. For instance, when we talk about the German reunification, I almost never hear that people are saying that, in a certain way, the West has colonized the East. With that difference, of course, that the colonizers did not come from another country. It was rather an ideological colonization. And an economic. I think many people coming from DDR have the feeling that they are former/ex people. Similar to the statement when I say: I am an ex-Yugoslav. When I have to write where I was born, I always write: Yugoslavia. Similar to someone who was born in Karl-Marx Stadt. What does s/he now write? Was he (or she) born in Chemnitz, DDR? Or...?

E K worked for two years in Chemnitz.

K Yes, I worked there in the theatre for two years.

A is reacting with a full surprise.

A Really? It is a weird palimpsest. On one side there is this socialist architecture that cannot be ignored and on the other side, there are all this non-site, capitalist spaces, shopping malls and so on... These paradoxes that can be situated spatially.

E Our theme is: Red people. And: Everything divided. We ask ourselves what is divided in this world.

A Yes. How can we reflect on this division? What are the causes and how can we overcome it?

K For me that is difficult. Because a division is important. Young people draw demarcation lines in order to define themselves. I know nothing about Yugoslavia, but for me that was so romantic. So great. Small countries who gained their independence. Very naïve. The same would happen to South - North Korea. Once the war would end. There would be two countries. Like Germany and Austria.

	I think it would be more peaceful if there would be North Korea and South Korea. Without the war. But in communication with each other. I think with an official demarcation and division, much more could be made.
A	Did I get you right? First, they should be divided and then they could come together and live together? We stop the war. Accept the division and that is the first step towards reconciliation and healing.
K	Maybe. Because the division of the Korean penin - sula lasts for a long time now, so ... I was always for reunification. It is difficult relation. Like when you have a sister with whom you have not been living together for 30 years. Now you have to live together. You speak the same language. Look alike. Have same parents. But actually. You have nothing in common. I understand people from South Korea who say: I am not interested in the reunification. Why should I be bothered? Therefore, I consider it to be a difficult issue. The reunification. Because to find a way to deal with each other does not necessarily mean to incorporate the other.
A	That is well said!
K	That's why it is interesting for me to hear that in the case of Yugoslavia things seem to be different...
A	The difficulty with Yugoslavia is that the division was a violent one and it caused a lot of trauma. Similar to the one regarding the war in Korea. What for me was always the question is: was it not possible to find another way to separate from each other? A less violent one? Perhaps like the break-up of Czechoslovakia, which after the end of socialism also experienced a split into two countries. But without a war.
K	Are they now happy with the division?
A	Seems so... At least I did not hear any voices that

would say, let's become one state again. I think with these two titles of the work, we have a nice dialectic: on one side, the red people, with this idea of red ideology that strives to bring people together. I saw this beautiful bust of Karl Marx in Chemnitz. And the statement: Proletarians of all countries unite! That is such a nice idea.

On the other hand, this idea Everything Divided points out to reversed processes. So, how can this paradox be thought?

K What do you mean?

A For me left idea is grounded in the concept of peoples' unity against the class enemy and against injustice. On the other hand, you have the idea of "Us", "Our land" and borders as a clear demarcation lines.

K Aha, you mean when one says - it is our land and this is your land. We cannot be together, we are divided...?

A John Lennon was singing: *imagine there are no countries*. I always had trouble understanding borders. Till now, I did not hear a good argument for the existence of state borders. When my son began to speak, I realized that it was parallel to a process, in which he discovered the concept of pos session. So, it is interesting to see how language is connected to this issue of ownership. And drawing borders.

E That is also an issue about borders.

A It is...

K Also on the playground... you can hear: this is mine! It belongs to me...!

A What are you doing now artistically?

K I am a Mum. (*Everyone is laughing.*) That is a great art.

A DNA sculpture...

K	At the moment I do nothing. I am an actress.
A	How was it for you to study acting? Where did you study it?
K	I studied here. At the Ernst Busch School. It was an interesting experience for me to do it here and in Korea. In Korea I have learned to move and here to think. To think in a bigger picture.
A	And I guess also to understand yourself also in terms of authorship. I could think that this is something that is fostered here. In Germany. The idea that the actor is not only an instrument of the director's concept.
K	It is different here. The director urges you to get to the point, which he could not get to. Since I gave birth, I realized that I am interested in experimenting with this position as an author. Because no matter what role I play, I always play myself.
A	Yes, how much fiction and how much auto - biography?
K	Or, one is oneself?
A	And only from this perspective...
K	Precisely! That can't be changed.
A	Without really knowing who you are, I can imagine that you could make a great solo performance. Something like a monodrama. This story about Habermas and your biography. The actors should not refrain from their biographies...
K	No.
A	Yet the question remains: how to eat cake, so that the audience is not bored by the action? How to per form an authentic experience that is also relevant for 100, or 200 people out there?
K	It is a difficult question...
A	Why is an artwork more successful than some other?
K	I have recently visited a friend. She made a perfor -

mance with other women and the piece was about motherhood. I had to ask myself: Why is this not a topic men are interested in? I think it is hard to talk about motherhood... Although many women are mothers...

A I think it is an urgent theme. Especially in cases like yours, E's or my wife's. You all have this migration background which makes you different. And in addition to this, you are also mothers. There is this threefold Otherness at stake here.

E We already have a title: The Other Woman. That means... N was working for some German women when Germany made this advertisement: German women need invisible hands of these Other Women. We always talk in the beginning about Everything Divided and in the end, we come to the point of *The Other Woman*.

K That is a topic that is present and important.

A It is not easy to be a woman. A worker. And a mother. I became aware of it, when my son was born. I think that was the most intensive moment of my life. Then I realized. As a man, I was restricted to watching. I couldn't take part in it. Not with the body. The man is thus reduced to the eye. The dichotomy that can't be erased. Men are in the head. Women in the body. Am I right or do I talk male nonsense again?

Tries to get a confirmation by looking at the baby boy. But the baby boy does not answer.

K You are right.

A It would be interesting to ask men, how can we get closer and share the experience of motherhood? Is it possible at all? Not to remain in this state of dividedness. What would happen if men would think

	about the fact that they can never be in the position of being a mother?
K	To talk about it?
A	Yes. To say that only a mother can be a mother.
E	We have many issues regarding being divided. Male/Female.
A	We already had this conversation. And we have seen that in our case, the partner is always from East Germany.

Everyone is laughing!

E	We new a few couples that were sharing this commonality – a partner with a socialist back ground. So, we asked ourselves, why do Korean women date East-European men?
K	That is interesting!
E	These three cases are not enough to come up with a thesis. But we can phantasies.

Everyone is laughing. The noise of the baby boy playing are heard in the background.

K	When is the exhibition?
E	18th of December. We don't have too much time.
A	We want to make an installation with books.
K	In the performance I made with E, I was singing a song: "A march for my love".
E	I have shown them a version from Hong Kong. People were singing the song in Chinese.
A	Perhaps, we could make a transcription of the lyrics.
E	In German?
A	No, I thought in English. There must be a translation?
K	I really like your project and I ask myself now, how can it be more connected to South and North Korea? And this definition of Red People. That is important?

A The definition of what?

K Red people. Who feels as being addressed to? Do
 I belong to it too? Or not? That is what I ask myself.
 What should it mean? I have talked today with my
 sister in Korea. And she said, we want socialism and
 not communism. And then, I asked
 myself: hmmmmmmm?

A Interesting!

K But what is the difference now? In terms of politics...

A It could be said that until now, socialism was never
 realized as a political and ideological system that
 abolishes class differences. As we can see today, it
 seems that the whole idea is rather utopian. The
 class-struggle is by far not over.

K And there we are again. Faced with demarcations
 and hierarchies. The class-struggle is important. It is
 the drive of the industrial labor world.

A The problem is also the division of labor. Not all
 have access to intellectual labor. And not all people
 want to be craftsmen. How to make them equal?
 But if we would at least reach a decision that this is
 a problem, that would already be the beginning of a
 solution. Unfortunately, at the moment the
 capitalist discourse is the dominant one. And the
 socialist and communist ideas are present either in
 the form of nostalgia or as a *specter*. A ghost. The
 question is, how can we remodel society? In the
 light of recent elections in Brandenburg and
 Sachsen, the left-wing parties are getting less votes.
 For me the question which arises is: what we have
 to do as artists to move the world in a better
 direction? What is the role of the Left and what can
 be done? How to reach a wider audience? Because
 we live in times when the populist discourse is
 instrumentalized by right-wing politics. For me,
 the urgent thing is to reclaim populism and turn

into a tool for spreading socialist ideas to the deprived masses. As left-wing/red people we are always faced with the danger that we theorize too much. Who is really interested in theories of Marx or Hegel? Outside of a privileged circle of the bourgeoisie...? How to talk to people who don't read Marx and Hegel? And convince them that socialism is the only solution.

K The problem with populist strategies is that they always locate the enemy outside. The Left on the other hand projects the enemy only in the Nazi. In that regard, the Left is trying harder to accept the Other and for me that is the question where we could ask how to act in a more populist way.

E I have recently been to a conference where someone asked about the difference between socialism and communism. And the answer was that communism failed and that socialism is still alive in North Korea. In Russia or East European countries, it failed.

K *Versagt*! In Germany!

Everyone is laughing really out loud.

A Failed communism.

K Do you want more tomatoes?

A No, thank you. But I could use more water. How often do you go to Korea?

K I have been there recently. Have you ever been there? Will you go for the exhibition?

A No, I have never been there. If we find money, we will go. Someday we will go. For sure.

K Would you like to go?

A Totally! Perhaps I have been there already. In my previous incarnation. But that does not count. Or does it?

K If you don't have a memory of it, it doesn't.

E	But he goes three times a month to the Thai-park.
K	What is that?
E	You don't know it? In the Preußen Park?
A	However, there is not really Korean food. Mostly Thai.
K	Is it a Thai community?
A	Yes.
E	It is just a park. And on the weekends Asian people cook their food.
K	Something like street food?
E	Yes.
A	Why don't you come by?
K	Yes, I would like to. Next time we should meet somewhere near your place.
A	Let's do it!
E	I would like to introduce you to N. She is my best friend here and you are my best Korean friend.

Looks at the audio recorder.

| A | Shall I turn it off now? |
| K | Ok, now I will think. What else could I say about... |

Everyone is laughing.

Red People diary book page, 2019.

1985:
titbits for zeitgeist
- excerpt

14. March 1984 - US policy toward Yugoslavia is changed with National Security Decision Directive 133, but aim of policy is shown in 1982 NSDD 54 which is calling for "silent" revolutions in communist countries.

March 1985 in USSR, Gorbachov became president of USSR which will face its fall apart in 1991.

25. May - The Serbian Academy of Sciences and Arts (SANU) created a memorandum as an aledged analysis of the position of Serbian population in SFRY. The Memorandum is largely considered to be one of the main contributors to the dissolution of Yugoslavia in the bloody, fratricidal war. Parts of it have been published in the well-known newspapers Vecernje Novosti in April of the next year.

23. May - 26. May 1985 in South Korea, students were very opposed to President Chun and his government. The Ministry of Education reported on-campus rallies, demonstrations, and disturbances, with nearly half of all of them occurring in the first semester of 1985. Radical student organizations were also formed, including the Sammintu, Sanmin Struggle Committee. They represented the struggle for "national unification, emancipation of the masses, and the establishment of democracy." The organization was branded as pro-Communist and anti-American and they were responsible for the seizure of the USIS library in downtown Seoul.

The MAC report also mentioned an unprecedented humanitarian event which started 8th of September 1984 when the North Korean Red Cross Society offered relief goods to flood victims in South Korea. The delivery of relief goods took place from **29. September** to 3. October 1985.

Ideologies
of information:

For more titbits and further information about zeitgeist, as well as sources used for this research follow the QR code to the Facebook page of the project (www.facebook.com/everythingdivided).

Special thanks:

The authors would like to thank all friends and contributors, participants and collaborators for their selfless support, generous understanding and extraordernary love that bounds us all.

We awe the warmest gratitude to the familly Park (Mum and Sister), Wonhyeong Park, Sandura Park, Soohyun Park, Fedor Mircev, Uhjin Son, Kotti Yun, Youkyung Byun, Matthias Rechenberg, Eric Wellnitz, Garey Park, Monica Gu, Byung-min Kim, Hyeri Yang, Cheol-Jun Park, Mrs. P and Mr. L, Laura Maria Schröder, Florian Strecker and Tanja Markovic.

This would have not been possible without you.

Impressum

Eunseo Yi, Andrej Mircev, Nikoleta Markovic
Everything Divided

All images and texts are made by artists and are thereby protected
by copyright law. The copyrights belong to the authors©2019

Translation to Korean:
Eunseo Yi

Translation German to English:
Andrej Mircev

Proofread German and English:
Eunseo Yi, Andrej Mircev, Nikoleta Markovic

Design:
Nikoleta Markovic

Publisher:
Monika Gu
Le droit de rêver 꿈꿀권리
Seoul, South Korea

First edition is supported by Kim Geun Tae Foundation for
Hanbando Peace & Integration Soul, South Korea

ISBN: 979-11-87153-40-5 03600
2000 copies

No part of this book may be reproduced in any form by any
electronic or mechanical means without the written consent of
the publisher or the authors. December 2019©All Rights Reserved

Everything Divided is a docu-fiction book inspired by true events. It
is concieved as a part of an on-going artistic project **Red People**, by
the same authors and is specially tailored for the purpose of partici-
pation in the exhibition *Community To Come* curated by Garey Park
and Byung-min Kim for the VIII Memorial exhibition of democracy
activist Kim Geun Tae, in Sejong Center in Seoul, South Korea.

모든 것이 나누어졌다 Everything Divided

2019년 12월 15일 1판 1쇄 인쇄
2019년 12월 20일 1판 1쇄 펴냄

지은이 | 니콜레타 마르코비치, 이은서, 안드레이 미르체프
펴낸이 | 구모니카

마케팅 | 신진섭
디자인 | 니콜레타 마르코비치

펴낸곳 | 꿈꿀권리
등록 | 제7-292호 2005년 1월 13일
주소 | 경기도 고양시 일산서구 고양대로 255번길 45, 903-1503
전화 | 02-323-4610
팩스 | 0303-3130-4610
E-mail | nikaoh@hanmail.net

ISBN 979-11-87153-40-5 03600